Research in Art & Design Education
Issues and Exemplars

Research in Art & Design Education
Issues and Exemplars

Edited by Richard Hickman

Series editor: John Steers

intellect Bristol, UK / Chicago, USA

First Published in the UK in 2008 by
Intellect Books, The Mill, Parnall Road, Fishponds, Bristol, BS16 3JG, UK

First published in the USA in 2008 by
Intellect Books, The University of Chicago Press, 1427 E. 60th Street, Chicago,
IL 60637, USA

Series: Readings in Art and Design Education
Series Editor: John Steers

A catalogue record for this book is available from the British Library.

Cover Design: Gabriel Solomons
Copy Editor: Holly Spradling
Typesetting: Mac Style, Nafferton, E. Yorkshire

ISSN: 1747-6208
ISBN 978-1-84150-199-4

Printed and bound by Gutenberg Press, Malta.

CONTENTS

Acknowledgements

I am indebted to all of the contributors, many of whom have spent considerable time in revising their work for this edition. I would like to thank the University of Cambridge Faculty of Education for giving me time and space and also to thank Keith Winser and Kristen Eglinton for dealing with the things I should have been dealing with instead of compiling this book. Thanks are also due to Jo Styles for her technical support.

I am particularly grateful to Anastasia Planitsiadou and Alexander Byron Hickman for reminding me of what is important.

PREFACE

This book is the fifth in a planned series of anthologies dealing with a range of issues in art and design education. The previously published titles in the 'Readings in Art and Design Education' series are *Critical Studies in Art & Design Education*, *Postmodernism and Art and Design Education: Collected Essays*, *Histories of Art and Design Education* and *The Problem of Assessment in Art & Design*. Further titles are in preparation.

The primary – but not exclusive – source of chapters are papers previously published in the [*International*] *Journal of Art & Design Education* and where appropriate these have been updated. It should be noted that any references to the English National Curriculum statutory Orders etc., are to the version of the curriculum current at the time of the original publication.

The *National Society for Education in Art and Design* is the leading national authority in the United Kingdom, combining professional association and trade union functions, which represents every facet of art, craft and design in education. Its authority is partly based upon a century-long concern for the subject, established contacts within government and local authority departments, and a breadth of membership drawn from every sector of education from the primary school to universities.

More information about the Society and its range of publications is available at www.nsead. org or from NSEAD, The Gatehouse, Corsham Court, Corsham, Wiltshire SN13 0BZ, United Kingdom. (Tel: +44 (0)1249 714825).

John Steers
Series Editor

FOREWORD

This is a timely book. In recent years there has been a growing awareness in many countries that the arts have been squeezed out of the curriculum in the pursuit of raising attainment in literacy and numeracy. Both the western and the tiger economies around the Pacific Rim have seen their manufacturing base eroded by the emergence of China and India as producers of cheaper goods. As a consequence, some policymakers have sought to emphasize the importance of developing future generation of pupils who will be creative risk takers, capable of developing new sources of national wealth. The art and design subjects are perceived to be an important means to this end.

Practice, however, often lags behind the best of intentions. In the United Kingdom, for example, research shows that the standards agenda, with the publication of league tables indicating how well schools have done in the National Assessments at primary and secondary level, has resulted in some pupils being excluded from arts and music lessons. In primary schools design has sometimes been restricted to the six-week period following the end of the Year 6 statutory tests in May. In England, it is significant that the attempt to revive arts in schools has been led not from the Department for Education and Skills but from within the Department of Culture, Media and Sport. The latter's sponsorship of the Creative Partnership programme, to the tune of over a hundred million pounds, has marked a resurgence in interest in arts education.

But problems remain. For many decades, particularly before the introduction of the National Curriculum into English schools, there have been artists working alongside teachers in schools. These collaborations have produced some outstanding work but the anecdotal evidence is that once the artist leaves things return to the way they were before the artist arrived in the school. Teachers tend to attribute the high quality work that pupils produce to the fact that the artist is an expert in his specialist medium, whereas the most significant changes tend to involve pupil attitudes and motivation, which in some way must be linked to the artists' pedagogy. Unfortunately, like many experts, their mode of practice appears to be largely intuitive so that the artists are often unable to articulate clearly why they behave in certain ways in their

interactions with pupils. To create sustainable changes in the way that art and design is taught in schools it will be necessary to make explicit what at the moment appears implicit. This will require not only more research in art education, on a larger scale than previously, but the development of new approaches that explore what Andy Hargreaves has described as the *emotional geographies of teaching.*[1]

This edited volume does several things that have a bearing on the above discussion. First the writers provide accounts of the use of different research methodologies and in some cases offer perspectives on new possibilities. Advances of this kind are urgently required if research in the arts is to be recognized as worthy of serious funding. Second, some chapters address topics that have an obvious importance in attempts to improve the quality of art education, for example, chapters that address the issues of pre-service and postgraduate training.

Over the last decade, despite the government's public denials, pupils' attitudes to school and in particular to science and mathematics have declined year by year. A recent survey of secondary pupils found that only 27 per cent said they found school interesting. Yet at transfer from primary to secondary school pupils express a strong preference for arts and design subjects. Improved arts education, therefore, offers a way of rekindling pupil interest and motivation as well as fostering the originality and the entrepreneurial spirit that governments around the world are calling on their schools to implement. This book can make an important contribution to this process of renewal.

Note

1. Hargreaves, A. (2001). The Emotional Geographies of Teaching. In *Teachers College Record* 103:(6), 1056–1080.

Professor Maurice Galton
University of Cambridge

Introduction

Richard Hickman

This collection of papers attempts to give an overview of the current state of research in art and design education, as indicated by their publication in the *International Journal of Art & Design Education* (*iJADE*). All phases of art & design education are addressed – from pre-school to higher education. In addition to those originally published in *iJADE*, several chapters have been commissioned especially for this book, notably those by Kristen Ali Eglinton, Anne Bamford and Rachel Mason, who raise timely and interesting issues about the character and direction of research in art education. The book has two related aspects: one deals largely with 'issues', exemplified by Mason's chapter, while the other presents examples of recent and current practice in art educational research, exemplified by Bamford's chapter.

Although there is much to celebrate, research within art education remains underdeveloped when compared with other cognate areas. There is a dearth of rigorous in-depth research and in particular a lack of empirical studies in art education, with most published work being small scale and largely theoretical, perhaps best described as 'informed musings' about art and its place in education. There are, however, signs of an emerging sophistication and self-confidence in the field, with the particular strengths of art as a way of knowing about and recording the world being acknowledged explicitly from within.

There is a growing interest in art-based approaches to research in art education. Naturally, it makes sense for researchers in the field to employ tools with which they are familiar, and to build upon existing strengths, underpinned by a firm belief in the epistemological status of art. However, Mason cautions against the tendency to embrace such methods (and methodology). Noting that art education research is 'conspicuous by its absence' from general educational research forums, such as the British Educational Research Association conferences, she asserts that

> A firm grounding in rigorous and systematic social science methodology is needed to enable the field to move from small-scale projects developed by a few art teachers studying for research degrees, to the larger funded studies that will contribute to the development of a well-functioning community of art educational practice. [p. 47]

Nevertheless, funding apart, research within the arts generally can be characterized by a genuine commitment to the subject arising from individuals' passionate belief in the power of the arts to describe, record and perhaps explain, the ineffable. In my own contribution, I make a case for the use of art forms as a means of both gathering data and reporting educational research studies; it is a great irony, therefore, that this publication is, for various technical and economic reasons, devoid of illustrations. What is clear is that such prosaic issues are as important to consider as the more profound philosophical issues.

While it is important to celebrate the arrival and growing acceptance of arts-based enquiry within education, it is also important to acknowledge the more traditional approaches, particularly the part played by historical research, which puts all of this into perspective; an example of this is Rafael Denis's survey of nineteenth-century drawing manuals, while Fiona Candlin's chapter traces the more recent historical development of practice-based research in the United Kingdom.

Ethnography remains the favoured approach adopted by many in art education, a tendency described lucidly by Marytyn Denscombe in his paper originally published in 1991; the fact that it is still entirely relevant now is testament to its acuity. Art educators, amongst others, are increasingly adopting the methods derived from anthropology and are developing approaches that reflect their concern for individuals' identities. An emerging theme is the growing concern for genuine collaboration and participation between the 'researcher' and 'the researched', as declared by Nick Stanley:

> ...the distinction between researcher and researched is abandoned in favour of an approach that treats young people as both subjects and experts in their own right. [p. 151]

This is a theme identified by Kristen Ali Eglinton in her work with youth in New York City and the United Kingdom, which has underlined her commitment to re-adjusting the power relationships between the various participants in research studies. This theme is visited by others writers in this book and reflects a growing concern for research that is of benefit to all those involved in the process.

In compiling this collection of papers, I wanted, in addition to giving an overview of the state of current research in art education, to identify possibilities and developments. In so doing, I believe that the chapters in this book reflect both. Although most are written from a British perspective, there is clearly an international dimension, at least with reference to English-speaking nations, with research reports from Australia, South Africa and Canada, for example. Nevertheless, all of the fundamental principles that underpin the individual chapters are of

relevance to researchers in the arts from whatever background. As I indicate in the opening chapter, although this book is specifically dealing with visual art ('art & design' is the accepted term in the United Kingdom), there is much that might be of relevance and value to practitioners in other arts – dance, drama, music, poetry – as well as other 'making' subjects such as design & technology. It is my hope that disciplines outside all of these subject areas within education can also draw upon and be informed by the work presented here.

Richard Hickman
Cambridge 2008

1

THE NATURE OF RESEARCH IN ARTS EDUCATION

Richard Hickman

Introduction

My focus here is on visual arts education, although I have chosen to use the generic term 'arts' in the title as there are overlapping issues and claims made by arts advocates which might be peculiar to the arts in general, but are not peculiar to discrete areas such as art and design. Amongst these claims is the notion that the arts facilitate or employ a particular 'way of knowing'[1]. The arts are said to be concerned with, to some extent, the notion of tacit knowledge and intuitive knowing; I would suggest that such phenomena are not amenable to quantitative investigation. That is not to say that there is no place for quantitative research methods in the arts, but it helps explain the preponderance of qualitative approaches. It could be said also that there might be some reluctance on the part of researchers interested in the arts to be involved with quantitative methods on the basis of a genuine intuitive antipathy towards quantification, as if this in some way diminishes the phenomena being examined.

This chapter has two parts – in the first, I consider the range of approaches that researchers within art education have adopted, describe the key characteristics of particular approaches, define terms and identify examples from the field. In the second part of this chapter, I make an argument for the use of arts-based methodology within educational research, underpinned by the notion that the arts can provide a particular way of understanding the world.

Approaches to Research in Arts Education

There is a plethora of descriptive research in arts education, and a consequent need for clarity in understanding the nature of the research enterprise. An American professor of anthropology and education, H. F. Wolcott[2] has expressed concern about the lack of precision in the use of related terms in qualitative research. Within arts education, Ettinger[3] taking the lead from

Wolcott, compiled a useful taxonomy of descriptive research for art educators and I will draw upon this where relevant.

Research terms are rather like colour theory, with interchangeable and overlapping concepts (like chroma, hue, tone, value and shade). The terms are not always mutually exclusive, for example, a case study (a detailed examination of one 'case') can be a piece of action research (designed to effect social change) using ethnographic research methods (concerned with cultural interpretation), such as participant observation. At this point, it is worth distinguishing between two related terms which litter the field of educational research: methodology and method. For the purposes of this paper, I will use a straightforward definition based on the etymology of the word – methodology at its most basic refers to the study of method; it does, however, go beyond that, referring to the theoretical background to research and its implications for the particular research method employed. For example, one's *methodology* might be interpretive, working within a constructivist paradigm, and one might employ particular qualitative research *methods*, such as interviews and focus groups.

The two overarching approaches, the quantitative and the qualitative, both occur within the arts and social sciences; for the purposes of this chapter, I will focus on the latter. The notion that reality is socially constructed – 'constructivism' – has a particular resonance for those working within the arts and it is within this world-view or paradigm that many, perhaps most, arts educators operate. Qualitative approaches are sometimes known as naturalistic, in that naturalists gather naturally occurring data. However, 'naturalism' can be said to be directly connected to scientific method and it implies being able to study the social world as one would study the natural world, with the implicit assumption that the researcher is detached. Strictly speaking, 'qualitative' can be seen to be more of an 'umbrella' term, in that it refers simply to the use of non-numerical data. Lincoln and Guba[4] have written authoritatively on 'naturalistic' approaches and have drawn up a useful list of five axioms, contrasting positivistic with naturalistic world-views. The first of these is concerned with the nature of reality (ontology): while positivists believe that there is a single (measurable?) reality, naturalists believe in socially constructed and therefore multiple realities. In terms of theory of knowledge (epistemology), in view of the positivists' ontological perspective, the knower and the known are each independent of the other, while naturalists believe the two to be inseparable. The role of values in inquiry (axiology) is another area of friction, with naturalists (as defined by Lincoln and Guba) believing that all research is value-laden, while the positivist stance is that research can be value-free. The 'generalizability' of research is often an issue and in this area too there is the positivist belief, not shared by naturalists, that generalizations can be made that are independent of context. A final area of profound disagreement is that of 'causality': naturalists believe that it is impossible to distinguish causes from effects while positivists believe that there are real causes that precede effects (and can presumably be hypothesized about, examined and measured).

Mixed Approaches
In stating fundamental differences in such clear and divisive terms, Lincoln and Guba[5] have perhaps over-emphasized the notion of paradigm purity, a position where if one belief is held, then it is not possible to simultaneously hold another opposing belief. However, a pragmatic

position has emerged which acknowledges the fact that in the day to day reality of gathering data and investigating phenomena, both qualitative and quantitative approaches can be used. This gives rise to what is commonly known as 'mixed method', sometimes also known as 'hybrid'. Mixed approaches to research are becoming more popular, probably because they work, combining both quantitative and qualitative approaches in a practical way.[6]

A recent example in the field of arts education is the UNESCO project on the impact of the arts in education.[7] Professor Anne Bamford compared data received from key people involved with arts education from around the world. Apart from a quantitative analysis, case studies of 'arts-rich programmes' in more than 35 countries provided further data. The use of a combination of quantitative data and descriptive narrative in the report provides information which highlights particular issues in a meaningful way. It is interesting to note, from a methodological perspective, the link between the nature of the arts and the nature of educational research. Bamford asserts that

> Like a good artwork, there are no simple predictable patterns [...] Just as one would not judge a song against the same criteria one might judge a watercolour painting, the nature of the reporting process should align to the characteristics of what is being studied. (p. 25)

And later:

> We contend that the value of the arts is most likely to be revealed through approaches that accord most closely to the creative nature of artistic expression. (p. 45)

This quotation seems to reveal that although the 'hybrid' approach of mixing both quantitative and qualitative methodology is compelling, research within art education is more comfortably located within the naturalistic paradigm: the 'nature of artistic expression' is often defined by the centrality of the individual and the individual's perceptions, and, therefore, multiple constructions, of reality.

Interpretive Approaches

Notwithstanding the importance of the individual in art-making, artistic events, like educational events, can be seen to be intrinsically social and both lend themselves to interpretation. It is to be expected then that much research in arts education is characterized by interpretive approaches. The art (and for that matter, science) of interpretation is known as hermeneutics. There is, however, a subtle distinction to be made between a hermeneutic approach and an interpretive one: the former is strictly speaking concerned with the interpretation of texts (which can include artworks) while the latter is more concerned with the interpretation of social phenomena. Within the field of arts education, Maitland-Gholson and Ettinger[8] have investigated hermeneutic methodology with regard to its use in (visual) art education.

The discipline of anthropology provides the source for several approaches which have been adopted by researchers in arts education. Perhaps the principal methodology derived from this source is ethnography. Ethnography is concerned with cultural interpretation and is a naturalistic

approach which seeks to uncover and interpret the shared practices of a particular cultural group (this can be distinguished from ethnology which is used to compare differences between groups). A characteristic of ethnography is the primary importance of observation, usually participant observation, where the researcher is totally immersed in the phenomena observed. Non-participant observation is less concerned with immersion and more with detachment, but the issue of the researcher's influence on the data collected is still important. There is a need for ethnographic researchers to acknowledge this with considered, analytical reflection on the role and influence of their presence. In arts education, it is common for researchers to engage actively and creatively with their respondents and this can be seen as a strength in terms of 'getting on the inside' of the observed phenomena and achieving some kind of empathy with the other players; this is known as an 'emic' approach. Emic knowledge is considered essential for an intuitive and empathic understanding of cultural phenomena, and it is essential for conducting effective ethnographic fieldwork. It can be contrasted with an 'etic' approach which uses data that is expressed in terms of the conceptual categories that are regarded as meaningful and appropriate by the scientific community. An etic construct is correctly termed 'etic' only if it is in accord with the epistemological principles deemed appropriate by scientific method, that is they must be logical, replicable and observer independent.

An interesting example of ethnographic work in the arts is John Finney's study[9] which set out to interpret and understand pupils' experience of learning music and their teacher's experience of teaching music in their weekly music lesson. A class of pupils, in their second year of secondary schooling, together with their music teacher, were observed and interviewed over a two-term period, 'creating an ethnography of their classroom musical lives'. Finney refers to the 'unfolding story' which showed pupils giving meaning to their music lesson; such a description – that of an unfolding story' is characteristic of ethnographic work of this kind, where, like an anthropologist, the educational researcher is immersed in the phenomena observed and reports on the emerging issues in a narrative style, often in a creative way.

Phenomenological Approaches

Phenomenological approaches to research have a particular attraction with arts educators because phenomenology is concerned principally with individuals' lived experience, focusing on individuals' consciousness and how it influences their relationship with the world. For example, a researcher interested in the creative process might look introspectively into their own creative processes, setting aside prejudices and examining phenomena as they occur, free from preconceptions. As in ethnographic approaches, an awareness of the impact that the researcher (as an individual with a particular social and cultural identity and associated prejudices) has on the researched is of central importance in phenomenological approaches; this awareness is known as *reflexivity*.

An early example of phenomenological research in art education is Paul Edmonston's doctoral dissertation; Edmonston examined his own creative studio practice through self-critical introspection and examination of his creative output.[10] Phenomenology, in its concern for understanding subjective knowledge, also embraces the concept of intuitive or tacit knowing; it is in this respect that it has a direct link with the arts. Indeed, some phenomenological enquiry

is in itself reported as an art form. Take, for example, Mary Stokrocki's description of her doctoral dissertation:[11]

> My dissertation research structure was based on a play format that included setting, characters, opening scene, subsequent acts, climax, and denouement [...] In this way, I was able to reveal the unfolding of my own and my co-students' comprehension of our pottery class.[12]

Stokrocki, in writing about the 'future of qualitative research' in art education, goes on to urge researchers to 'translate your research into some qualitatively visual and verbal art form'.[13] There is potential in this approach for very rich and diverse ways of reporting. If we claim an epistemological status for arts activities then it follows that art forms in themselves can convey forms of knowledge and understanding; this is considered further below.

The Arts as a Way of Knowing

The notion that the arts provide a particular way of knowing has been around for some time; a particularly pertinent debate took place in the pages of the *Cambridge Journal of Education* in 1973 and 1974; I reviewed this debate in a more recent paper[14] and reproduce some of it here. Professor Paul Hirst opened the debate with a paper on literature and the fine arts as a unique form of knowledge.[15] It seems to me that any discussion about the nature of art should be underpinned by a definition of art which is broad and inclusive, such as the institutional conception of art which accommodates, even welcomes, idiosyncratic and individual contributions into its scope, and is characterized by fuzziness and flexibility. Hirst's conception of art, however, is limited and rigid, seeing art as a language which is a conduit for a form of knowledge; moreover, the form of knowledge is simply knowledge of art. The idea of art as a form of language is challenged by Peter Scrimshaw's response to Hirst[16] where he points out that, while Picasso's *Guernica*, for example, was not painted in 'English' it was also not painted in a language called 'artistic', merely awaiting a translator, noting that 'such translations are not possible because there is no initial linguistic entity to be the subject of such an enterprise'[17] More forcibly, later in the article, Scrimshaw asserts that

> Works of art are not statements in the language of art, for they are not statements, and there is no such language for them to be statements in.[18]

Louis Arnaud Reid's rebuttal of the same paper[19] is more complex and also puts forward an alternative view of art as 'a unique form of knowledge'. The curriculum is often said to be too concerned with propositional knowledge; Hirst's paper does nothing to challenge this and, in fact, by referring to art as a language which carries knowledge about (only) art, it reinforces this narrow view. Reid, however, introduces the notion of the importance of audience – the concept that, while a work of art might have a status independent of any audience, such a status is inadequate and is only fully realized when there is an interaction between the art object and an appreciative observer. This notion also introduces the related idea of there being a crucially important fluid, organic and dynamic aspect to the arts which makes them different from other areas of knowledge (and, therefore, different areas of the school curriculum).

Following on from this, I would argue that while art is not a language in the formal sense of the word, some aspects of some artworks can be seen to be analogous to language, but, more importantly, the arts offer a way of understanding the world which goes beyond language; the arts can reify the ineffable. It is in this sense that the arts can be seen to be an additional tool in educational research.

Graeme Sullivan, in his book *Art Practice as Research*,[20] presents a lucid argument for studio art practice to be seen as a form of research and, indeed, there is a burgeoning of courses which recognize the value of research through art practice. However, I am advocating here the use of the arts not only as a tool to research within the arts, but to research within the arts, humanities and social sciences in general.

The Arts as a Vehicle for Educational Research

Arts education research is necessarily a sub-division of general educational research and as such shares many of its characteristics. However, because of the distinctive nature of the arts – such as the value accorded to expression and the significance of form (the importance of intuition and the central concern for imagination and creativity are common attributes of the arts but not unique to them) – there might be a case for a distinctive approach to research within the area.

There is a useful analogy to be made here: arts education can be seen to be concerned with both education in the arts and education through the arts; research in arts education can be seen to be both research in the arts and, more controversially, through the arts. This takes us out of the domain of educational research and into a broader field

The making of art and the appreciating of art offer complementary ways of understanding the world. Elliot Eisner developed the idea of using 'connoisseurship' in educational research from the work of art critics, linking the art of appreciation and the act of disclosure.[21] The complex and multi-layered character of a painting, replete with significance, is echoed in the multi-dimensional character of the classroom. This being the case, I contend that the multi-dimensional character of the classroom can be captured within a complex and multi-layered painting, so the art of making (in this case painting) is linked to disclosure. Fundamental to Eisner's view of the relationship between art activities and research is that the primary aim of research is to advance understanding and that many artworks make understanding possible.

In writing about 'arts-based educational research', Barone and Eisner[22] identify seven features which typify this form of inquiry:

- The creation of a virtual reality
- The presence of ambiguity
- The use of expressive language
- The use of contextualized and vernacular language
- The promotion of empathy
- Personal signature of the researcher/writer
- The presence of aesthetic form

It can be seen from this list that Barone and Eisner are referring to verbal rather than visual reporting, albeit of a 'creative' nature. The essential feature of this kind of research reporting is the relationship between form and content – like an artwork, the whole is significantly more than the sum of its component parts; it is in this way that 'aesthetic form' can be seen to be present. In Barone and Eisner's words, the format and content of art-based educational inquiry text '…serve to create a new vision of certain educational phenomena.' People reading such a text 're-create that vision […] new meanings are constructed and old values and outlooks are challenged'.[23] I propose to go further and put forward the notion that visual art forms (and performance) can serve a useful purpose in educational research by conveying 'truths' about educational phenomena which are intuitively felt, expressed and communicated. One problem, of course, is the need for particular skills in communicating through an art form. Eisner notes that

> If students do not possess the skills they need, say of producing a video or a film, of writing a poem or creating a visual narrative, the content they wish to represent is simply not likely to emerge. Representation requires the skills needed to treat a material so that it functions as a medium, something that mediates content.[24]

However, this can also be said of traditional research reporting – that to be of value the writing needs to be done skilfully. The use of art as a medium for research reporting will invariable entail more work on the part of the audience; the consumer of the research is an integral part of the research process in the same way that the audience is an integral part of understanding an artwork – there is a three-way dynamic interaction between artist/researcher, art object/ research report and audience. It is clear then that genuinely arts-based educational research is likely to be very demanding upon both the researcher and the consumer of the research.

To re-iterate an earlier point – if the arts offer a way of understanding the world and they can be seen as forms of communication, then it follows that the arts can be used in themselves as research tools. By this, I do not mean the use of art forms by respondents, which is common practice, but by (educational) researchers. This is not to be confused with, for example, the use of drawing as a research tool; I will deal with this separately. In practice, I could envisage, for example, the following:

- a photomontage of an educational event;
- an abstract (non-representational) painting reflecting the nature of the relationships within an educational setting;
- a poem about an individual pupils' learning strategies;
- a musical composition on the theme of children's play.

Of course, making theory concrete in this way – by providing examples – is a dangerous thing in that it offers very easy targets for demolition. Nevertheless, I am offering these as practical suggestions to help clarify my main point which is to consider the value of using arts-based approaches in educational research. Arts-based approaches can be used in both the data-gathering phase and the reporting phase, but in the latter there is the added complication of audience

interpretation. However, this could be seen as a strength, in that the 'artist' is not always conscious of the complexity, richness and hidden significance of everything that is created in a given artwork. As I have indicated (see note 15), the audience plays a significant part in the nature of any art phenomenon and it is this factor which can add another valuable dimension to the interpretation of the 'data'. If we take a naturalistic stance with regard to reality, believing it to be not immutable but socially constructed and dynamic, then an artwork can be seen to be an appropriate way of not only recording events but interpreting them in a way which exposes a greater reality.

Drawing as Research

I am considering drawing separately as, although it has close associations with art activity, drawing is not necessarily *art*. It is, however, an interesting example of an alternative medium through which one can conduct research and can be seen as a medium through which feelings and ideas can be expressed and as a tool to convey information. Drawing is sometimes said to facilitate thinking, in the same way as someone can talk themselves into understanding (i.e. clarifying thought by articulating it). In this way, drawing can help researchers focus their thoughts. It is also a way to enhance perception; through drawing a social phenomenon (such as a classroom), the researcher might well perceive things which would be overlooked if simply observing and taking written notes.

An exhibition in 2006 at Kettle's Yard Gallery, Cambridge, entitled *Lines of Enquiry*, looked at drawing as an exploratory and explanatory tool. The exhibition aimed to show how people use drawing to think through problems, visualize concepts, order information and communicate to other people. The important thing to bear in mind is that artists do not have a monopoly on drawing; the exhibition included drawings by physicists, geologists, architects, engineers, zoologists, archaeologists, paleontologists, geneticists, surgeons, historians, philosophers and composers as well as artists. For example, among the drawings exhibited were Sir Roger Penrose's visual reinterpretations of Einstein's relativity equation, Sir John Sulston's genome explorations, Sir Colin St John Wilson's original ideograms for the British Library, Tariq Ahmad's drawings for plastic reconstruction surgery, and Sir Harry Kroto's discovery of the C60 carbon atom. Educational researchers have begun to make more of this human facility; for example, Potter[25] describes an innovative visual approach to analysis, similar to what has become known as 'mind mapping', reflecting her dominant thinking style, that of thinking in pictures.

Concluding Remarks

I have attempted to give an overview of ways through which inquiry in arts education can be conducted. In doing so, I have introduced the notion of researching (art-) education through non text-based reporting, in other words, through art itself. If we are to have a field that is vibrant and dynamic, then it is necessary to explore new ways of engaging with it.

There is a growing acceptance of not only the possibility of arts-based inquiry but the desirability of it. For example, the American journal *Studies in Art Education* devoted a whole edition in 2006 to arts-based research.[26] Postmodern ways of thinking eschew traditional conceptions of the world and human beings' place in it; a natural development of the reaction against positivism has been a desire for research methods which draw upon individuals' personal

intuitive knowledge and which can express profound insights in ways that audiences can access directly. Diamond and Mullen, in their book *The Postmodern Educator*[27] refer to the 'prosaic writing style and reporting conventions of much social science' and put forward the positive aspects of 'artistic research' that can be characterized as 'evocative, metaphorical, figurative, connotative, poetic and playful' (p. 43). However, Diamond and Mullen are paraphrasing Tom Barone[28] and, as noted above, are referring here to *language*; my argument is that art forms such as painting can stand on their own as vehicles for recording, reporting and interpreting educational phenomena.

The arts are essentially areas of human experience that can provide new ways of perceiving the world; it makes sense to harness the power of the arts as a vehicle for recording the human condition and as an endeavour that reveals new truths, to help explore educational experience, not only in the arts, but in all areas of teaching and learning.

Notes

1. See, for example, Reid, L. A. (1986). *Ways of Understanding and Education*. London: University of London Institute of Education.
2. Wolcott, H. F. (1982). Differing Styles of on-site research, or "If it isn't ethnography, what is it?" *Review Journal of Philosophy and Social Science*, 7(1 & 2)" 154–169.
3. Ettinger, L. F. (1987) Styles of on-site descriptive research: a taxonomy for art educators. In *Studies in Art Education*, 28(2): 79–95.
4. Lincoln, S. and Guba, E. G. (1985). *Naturalistic Inquiry*. Beverly Hills, CA: Sage.
5. See, for example, their later publication: Guba, E. G. and Lincoln, Y. S. (1994). Competing paradigms in qualitative research. In N K Denzin and Y S Lincoln (eds.) *Handbook of Qualitative Research*. Beverly Hills: Sage Publications, 105–117.
6. Of particular note is: Creswell, J. (2003). *Research design: Qualitative, quantitative, and mixed methods approaches*. Thousand Oaks, CA: Sage Publications.
7. Bamford, A. (2006). *The Wow Factor – Global research compendium on the impact of the arts in education*. Munster: Waxmann.
8. Maitland-Gholson, J. & Ettinger, L. F. (1994). Interpretive decision making in research. In *Studies in Art Education*, 36(1): 18–27.
9. Finney, J. (2003). From Resentment to Enchantment: What a Class of Thirteen Year Olds and Their Music Teacher Tell Us About a Musical Education. In *International Journal of Education and the Arts*, 4(6).
10. Edmonston, P. (1961). A Methodology for inquiry into one's own studio processes. (Doctoral Dissertation, Ohio State University, 1961). Dissertation Abstracts International, 22A3.
11. Stokrocki, M. (1982). Spheres of meaning: A qualitative description and interpretation of an art learning environment (Doctoral dissertation, The Penn Sate University, 1981). *Dissertation Abstracts International*, 42 (08), 3394–A.
12. Stokrocki, M. (1997). Qualitative forms of research methods. In La Pierre, S.D. & Zimmerman, E. (1997) (Eds.) *Research Methods and Methodologies for Art Education*. Reston, Virginia: NAEA.
13. *Ibid.*, p. 51.
14. Hickman, R. (2007).
15. Hirst, P. H. (1973). Literature and the Fine Arts as a Unique Form of Knowledge. In *Cambridge Journal of Education* 3(3): 118–142.

16. Scrimshaw, P. (1973). Statements, Language and Art: Some comments on Professor Hirst's paper. In *Cambridge Journal of Education* 3(3): 133–142.
17. *Ibid.*, p. 137.
18. *Ibid.*, p. 140.
19. Reid, L. A. (1974). The Arts as a Unique Form of Knowledge. In *Cambridge Journal of Education*, 4(3): 153–165.
20. Sullivan, G. (2005). *Art Practice as Research*. London: Sage.
21. Eisner, E. W. (1976). Educational connoisseurship and criticism: Their form and functions in educational evaluations. In Journal of Aesthetic Education, 10 (3), 135–150. Connoisseurship in educational research is derived from Art Criticism and brought into the educational area by Eisner. A good early example within arts education is Alexander, R. R. (1977) Educational Criticism of Three Art History Classes. (Doctoral Dissertation, Stanford University, 1977). Dissertation Abstracts International, 38/09A.
22. Barone, T. & Eisner, E. W. (1997, 2nd ed.) Arts-Based Educational Research. In R. M. Jaeger (ed.) *Complementary Methods for Research in Education* pp.73–116. Washington, D.C.: AERA. (pp. 73–78).
23. *Ibid.*, p. 78.
24. Eisner, E. W. (1993). Forms of Understanding and the Future of Educational Research. In *Educational Researcher*, 22 (7) 5–11. (p.9). Eisner, E. W. (1995). What Artistically Crafted Research Can Help Us to Understand About School. In *Educational Theory* (Winter 1995) 1–6. http://www.ed.uiuc.edu/EPS/Educational-Theory/ Contents/45_1_Eisner.asp (accessed 10 August 2006).
25. Jacqui Potter (2001). Visualisation in research and data analysis. In Dadds, M and Hart, S (eds) (2001) *Doing Practitioner Research Differently*. London: RoutledgeFalmer.
26. *Studies in art education* volume 48, number 1.
27. Diamond, C. T. P. & Mullen, C. A. (1999). *The Post-modern Educator. Arts-based inquiries and teacher development*. New York: Peter Lang.
28. Barone, T. (1987). Research out of the shadows: a reply to Rist. *Curriculum Inquiry* 17(4): 453–463. See also Barone & Eisner op. cit.

2

THE ART OF RESEARCH: ART TEACHERS' AFFINITY WITH ETHNOGRAPHY

Martyn Denscombe

Introduction

Classroom research was once the province of 'experts'. It was undertaken by educationists located outside the school – experts from schools of education who visited the schools to collect their data and then returned to their own home territory to sift through the information and analyse the results. The visiting researcher, of course, remains a feature of school life today. But there is a growing involvement of teachers with research in their own classrooms, as the papers in this book testify. Increasingly, teachers are being exhorted to conduct their own classroom research. With added emphasis on school-based curriculum development and programme evaluation, teachers themselves are being required to engage in action research as part and parcel of their professional duties.

There are certain factors, however, which may inhibit them from embracing the role of researcher in their own classrooms. This chapter outlines such factors and argues that, in the first instance, there is a disjuncture between the approach to classroom life which forms part of the practical skills of the experienced teacher and the approach to classroom life demanded by the research enterprise. Specifically, attention is focused on the situation of art teachers. Art teachers, perhaps more than most others, are likely to view the prospect of conducting research in their own classroom with misgivings because the research enterprise appears to require a radical shift in their knowledge and understanding of classroom life. The experience of introducing art teachers to research methodology has shown me the value of ethnographic research for bridging the gap between art teachers' professional dispositions and those of the conventional research tradition of the social sciences.

The Contrast Between Positivistic Research and Teaching Skills

The use of systematic observation, attitude testing and opinion surveys have become well-established forms of classroom research, especially in North America. They form a style of classroom research which Eisner calls the 'social science' approach and which he sees as having established itself as an orthodoxy in classroom research until recent years. Such scientific research may be regarded as inquiries that use formal instruments as the primary basis for data collection, that transform the data collected into numerical indices of one kind or another and that attempt to generalize in a formal way to some universe beyond.[1]

Typically, this style of research models itself on the natural sciences and has adopted 'positivistic' assumptions about the events being investigated and the methods employed to observe those events. Positivist research emulates the natural sciences first in its quest for the discovery of laws governing the relationship between phenomena – a basic premise of positivism is that things do not happen at random and that the purpose of research is to discover the causes of events.[2] Positivism emulates the natural sciences, second, in terms of the methods it employs in the search for causal explanations of events. In effect, it uses methods adapted from sciences like physics and chemistry in which, as Hammersely and Atkinson stress, 'every attempt is made to eliminate the effects of the observer by developing an explicit, standardized set of experimental or interview procedures'.[3] As Oakley points out in relation to the use of interviews in field research:

> The paradigm of the 'proper' interview appeals to such values as objectivity, detachment, hierarchy and 'science' as an important cultural activity which takes priority over people's more individualised concerns. Thus the errors of poor interviewing comprise subjectivity, involvement, the 'fiction' of equality and an undue concern with the way in which people are not statistically comparable.[4]

At the risk of over-simplifying both the nature of teaching and the nature of research, there appears to be a marked difference between the kind of approach to classroom life which is necessary when using the positivistic research paradigm and the kind of approach to classroom life which is associated with the experienced teacher. Experience in the classroom tends to develop in teachers a vision of their role and expectations about their behaviour which become an integral part of the culture of teaching. Despite differences of subject discipline, schools and personal biography, the experience of schooling has certain strands which affect the vast majority of those in the profession.[5] Amongst these common elements there are four which have a direct bearing on how comfortable practising teachers will be with adopting a research perspective on classroom life.

First, the role of teacher has an inherent tendency to put teachers 'in the thick of the action'. Teachers, whether directors or facilitators of activities, see themselves as focal points of the routine activity in classrooms. They are responsible for the activity in the classroom and have a personal stake in the success of what is going on. They are, in every sense, involved in events. Their involvement, indeed, is encouraged as part of the job and comes to be regarded as an expected part of the role. Positivist research, on the other hand, requires quite the opposite

stance. It requires an air of detachment from the proceedings. Rather than being caught up in the melee of classroom interaction, the researcher is expected to be a sideline observer, impartial and not involved in the events unfolding before his or her eyes.

Second, the role of the teacher is one that largely hinges on matters of subjectivity rather than objectivity. The role emphasizes the importance of interpretation and calls for decisions based on intricate and subtle qualities and emotions. It requires teachers to use discretion and make judgements based on feelings rather than clear facts. By contrast the research role emphasizes the importance of a dispassionate approach to events in classrooms. Whereas the teacher role is inherently 'personal', the researcher role is quite the opposite. It is impersonal in the sense that it requires of the researcher the willingness and ability to avoid, so far as is possible, personal judgements, personal preferences, personal prejudices, personal interests and personal knowledge.

Third, the teacher role in classroom life centres on the immediate and the particular rather than the abstract and the general, yet it is precisely the latter to which the research role plays homage. Particular pupils and specific events, pressing problems and pragmatic solutions are the order of the day. Deliberation and reflection geared to long-term universal solutions are not the usual concern. As Hatton argues, teaching is actually a form of intellectual 'bricolage':

> ...a response to contingencies in which there is no attempt to develop or seek new theoretical structures which provide greater understanding, underwrite greater technical competence, encouraged new approaches to problems etc.[6]

Fourth, the teacher role in the classroom carries with it the occupational hazard of being the 'resident expert'. Even where the teacher prefers to be a facilitator in the classroom there is still pressure from pupils to conform to the vision of the teacher as the person who has the knowledge. The research role assumes the opposite. When engaged in field research the researcher is essentially the learner, the gleaner of knowledge rather than the imparter of knowledge. In terms of the classroom context, this means that whereas the teacher role encourages the vision of the teacher as expert, the researcher role encourages the vision of researcher as receiver of knowledge. Put rather crudely, the teacher who adopts a researcher role needs to listen rather than talk, observe rather than give directions.

The teacher role and the research role, then, would appear to adopt different approaches to understanding events in the classroom. In a nutshell, the research role requires teachers to stand back from involvement in classroom affairs, to lose their role of leader and expert, and to divest themselves of any emotional commitment to people and events in the classroom. From being an affective leader they are required to become a dispassionate outsider. We should not be surprised, then, if experienced teachers feel rather uncomfortable when confronted with the need to adopt a research role based on a positivist approach.

Teachers' Affinity with Ethnographic Research

In recent years, a different style of classroom research has gained credibility and acceptance, a style not so closely wedded to the dispassionate, cold, objective approach of positivism.

'Ethnographic' research has become established as a viable, intellectually respectable form of research in the field of action research, curriculum development and programme evaluation techniques.[7]

The methods of ethnography differ markedly from the positivistic approach. To the consternation of those from the science tradition there is less concern with testing hypotheses and using pre-ordained representative samples.[8] The emphasis is much more on 'feeling your way' and following-up avenues of enquiry through a variety of field research techniques. In the words of Delamont and Hamilton:

> Ethnographies involve the presence of an observer (or observers) for prolonged periods in a single or a small number of classrooms. During that time the observer not only observes, but also talks with the participants [...] In addition to observing classroom life, the researcher may conduct formal interviews with the participants and ask them to complete questionnaires. Usually, to record his observations, the researcher compiles field-notes or, more recently, field recordings. Compared with the results produced by coding interaction with one of the published schedules the initial data gathered by the ethnographer are open-ended and *relatively* unstructured.[9]

Such ethnographic research tends to have a far greater resonance with the teacher role than positivistic approaches to research. In the first place, this resonance stems from the fact that ethnography has at its core a concern to describe the experiences of the participants in a given situation. It shares with the teacher role a concern with trying to understand how people think react and feel. It encourages empathy and interpretation and is sensitive to the intricacies of social interaction. Its focus on personal experiences, in essence, gives it a warmer, human face which is more akin to the practical classroom ambitions of teachers than the clinically objective stance of positivistic research concerned with measuring behaviour. As Eisner argues, scientific approaches are of little value because:

> What one needs [...] to deal with educational questions are not certain or near certain answers or foolproof methods, but a sensitivity to context, an appreciation for nuance, a set of skills that one can use with both virtuosity and flexibility, and a variety of intellectual frameworks that allows one to see the situation from different perspectives.[10]

Second, the methods of doing ethnographic research have certain practical advantages. The methods permit the teacher to resolve practical problems potentially generated by efforts to combine the teacher and researcher role. Participant observation, the most favoured of the approaches within ethnography, for instance, allows the teacher to stay 'in the thick of things' within the classroom whilst at the same time engaging in research. It allows the teacher to combine the roles of teacher and researcher in a way which is practical (given the pressures of classroom life) and which is also justifiable in terms of research rigour. Interviews are feasible as well, although in a different way. Interviews can be arranged for occasions outside active class time and so do not jeopardize the teacher's control of the classroom. It is important to recognize that the attraction of participant observation and interviews is not simply a practical

one. At a more abstract level both techniques resonate with the teacher role by allowing the teacher to retain the position of controlling events and being the expert. Doing the research, in other words, does not require the teacher to temporarily ditch his or her identity as leader in the classroom.

Third, ethnographic research frequently employs a case study approach. Again, at a practical level this is attractive to teachers and meets the needs of classroom-based research. The pressure to conduct research on representative samples drawn from a variety of settings is lifted. In its place there is a rationale for focusing on specific contexts – delving in depth rather than spreading the net wide. And again, the benefits from the teachers' point of view are not simply practical ones. The demand for detailed knowledge of the situation being studied tends to accord with the teacher role and its emphasis on particularized knowledge of the setting rather than generalized knowledge covering similar settings elsewhere.

Art Teachers' Affinity with Ethnographic Research

Distinct from the generic qualities associated with being a classroom teacher, there is another factor which is likely to influence teachers' willingness and ability to adopt a research perspective on classroom life; a teacher's discipline background. A teacher's discipline background can serve to aid the adoption of the research perspective, or to make it more difficult.

Experienced art teachers' preference for ethnographic approaches to classroom research appear to owe much to the way ethnographic styles of research match their existing predisposition stemming from their teacher role. But, more than this, to the extent that their training in art emphasized the importance of feeling, emotion and interpretation, it appears to reinforce in art teachers a degree of antipathy to positivistic styles of research. Art teachers' training seems to give them a further affinity with ethnography based on three things.

First, the adoption of ethnographic methods obviates the need to develop statistical skills. The focus on small-scale, case-study type research means that the numbers involved tend to be both too low for meaningful statistical analysis, and sufficiently low to allow data processing without the need for learning how to use computers for number crunching. For teachers from a maths, science or design background the prospect of using computers for statistical techniques to handle the data may prove to be no hurdle. The essential skills may already exist as part of the subject discipline background of the teacher. In fact, the possibility of using statistical techniques might actually entice teachers from such subject backgrounds to prefer research methods which emulate the natural sciences. But for art teachers there is unlikely to be such support arising from subject training and background. The immediate attraction of ethnographic research, then, is obvious.

At first glance the art teachers can avoid the demand to develop a whole new range of skills for processing data in addition to those new skills involved with actually conducting the research.

Second, ethnography has a particular point of contact with the discipline of art in terms of the phenomenological premises they share. In essence, art and ethnography both accept the point

that 'perceiving reality' is a far more complex process than the positivist approach might suggest. They recognized that there is 'reflexivity' entailed in the act of observation. As Hammersley and Atkinson note:

> ...we are part of the social world we study [...] This is not a matter of methodological commitment, it is an existential fact. There is no way in which we can escape the social world in order to study it.[11]

Both ethnography and art recognize that the act of observation draws on suppositions brought with the observer as part of his or her intellectual baggage and share the view that perceiving the world is a creative activity rather than just a matter of simply receiving information. The epistemological concerns of ethnographic research – its concern with the role of the researcher as the creator of findings rather than the reporter of findings – fall on receptive ears in the case of art teachers.

Third, the institutional position of art teachers also helps them to identify with ethnographic styles of research. Traditionally, art teachers have found themselves somewhat marginalized within the institution of the school. Their specialist training, their physical appearance, their career ambitions and professional identity, and their physical location within the school have tended to provide mutually reinforcing factors making art teachers 'the outsider'.[12] As such, the anthropological elements of ethnography tend to be attractive. There is some instant rapport with the idea of standing back from a phenomenon and viewing it from the perspective of a stranger – temporarily suspending common-sense beliefs in 'the obvious' and attempting to view the object from some alternative perspective.

Ethnography as a Bridge to Learning Research Rigours

Art teachers' affinity with ethnography means that ethnographic research can provide a useful platform from which to introduce research methods. It offers an approach to classroom life which, in certain key respects, is in touch with the teachers' role in classroom life and, specifically, is congruent with the subject discipline training of art teachers. Ethnography, to this extent, offers an easy bridge between the teacher role and the researcher role. There are, however, potential dangers involved.

An initial danger exists where the closeness between the teacher role and the ethnographer/ researcher role leads the would-be researcher to believe that the research endeavour is really nothing different than the teacher role. Focusing on the points of contact, the art teacher might come to regard the research endeavour as nothing other than the application of personal experience and expertise to the interpretation of classroom life (rather than artworks) and the production of an evaluation based personal judgement. They might mistake what Eisner calls 'educational connoisseurship' for research. Educational connoisseurship, according to Eisner, is based:

> ...on leading ideas from the work that critics of the arts do when they appraise the efforts of writers, painters, film makers, producers, actors, dancers, and others who make, direct or perform works of art.[13]

Educational connoisseurship shares with ethnography a concern with meanings and experience rather than overt behaviours. It shares with ethnography a general lack of interest in predicting results and controlling events. And it shares the belief that the writing up of findings need not adhere to a strict formula of presentation in which 'any sense of the personality of the investigator [...] is to be neutralized'. But, the art teacher who relies on educational connoisseurship for evaluation in education as envisaged by Eisner will be perhaps too little concerned with certain rigours of research, including the rigours of ethnographic research. As Eisner points out, in educational connoisseurship:

> ...the canons of test reliability and sampling do not apply [...] Artistic approaches to research are less concerned with the discovery of truth than with the creation of meaning.[14]

Connoisseurship relies on very individualized and personal sources of knowledge which do not lend themselves to checking by others. Emotion and personal feelings are more significant than the testimony of recorded interviews or written field notes in terms of the data to be presented as 'findings'.

It is important to recognize that ethnographic research should not be regarded as a substitute for research rigour, but as an alternative approach to classroom research. Texts dealing with ethnography, and classic ethnographic research itself, indicate quite emphatically that there is every need for research in this tradition to be thoroughly systematic and thoroughly rigorous. It is not 'the easy option'. Introducing research via ethnographic studies, then, does not skirt round the rigours of research because ethnography, properly conducted, involves its own set of rigours. These rigours, though, are not of restricted relevance – they have relevance for research methodology in general. Indeed, the special value of using ethnographic studies is that they point the direction to significant research issues, not that they sidestep them.

For example, ethnographic research quite explicitly focuses on the epistemological problems of conducting social research. Epistemological problems are not peculiar to ethnography. As philosophers of science are quick to point out, such problems lie behind natural science and positivism as well. Ethnographic research, however, provides illustrations of the implications of epistemology in a form which is tangible to the newcomer to research.

Ethnography is also particularly useful in the way it highlights ethical issues involved in research. The ethical issues associated with field research have been a major concern of ethnographers, especially where the research has involved participant observation, and there are interesting ethnographic studies which illustrate the difficulties and dilemmas facing classroom research. Again the issue of ethics in research covers all approaches to research and the value of ethnography is that it offers a good platform for considering the implications in relation to, for instance, animal experimentation or the misuse of computer databases.

Contrary to first impressions, ethnography also involves a heavy emphasis on the need for systematic inquiry and meticulous record-keeping. Good ethnography is more than simply a

matter of writing up first-hand impressions of a situation – though this is the image it is in danger of conveying. Students who are referred to the texts on ethnography[15] or who read significant studies[16] may be surprised by the rigour of ethnography. The need for such systematic inquiry and meticulous record-keeping in terms of making the research accountable to others, if not actually repeatable, is an essential feature of good research. It is not something scientists do and ethnographers ignore. It is a common skill of research which, again, can be introduced via ethnographic studies.

Another issue common to ethnographic and positivistic modes of field research is the resource implications of conducting research. When contemplating any investigation the researcher has to weigh up the likely expenses of the approach in terms of hours, work, travel and postage costs, processing time etc. Ethnography permits these issues to be highlighted in a very clear fashion.

And finally, ethnography's use of the case study provides a platform to consider the basic issues of the representativeness of the data and the degree to which the research can make valid generalizations from the data collected through the research. It does not ignore the issue. A key component of any valid case study is its consideration of the unique and the general features of the case in question and its evaluation of the limitations these place on the possibility of generalizing from the data.

Conclusions

Newcomers to classroom research are faced with the prospect of learning new practical skills concerned with conducting field work and new conceptual skills in terms of their approach to the situation being investigated. In their own right, these are a considerable challenge. But where professional experience, both as classroom teachers and as art specialists, seems to contradict the assumptions underlying research there is a particularly difficult hurdle to overcome.

Introducing research methods via ethnographic research goes a long way to reducing the hurdle because of the congruence between the underlying assumptions of ethnography and the perspective on classroom life evolved through experience as a teacher. As a consequence, ethnographic studies have a particular value as a means for introducing research training for teachers. The value of such studies, it is important to recognize, is not that they justify a neglect of research rigour. Care needs to be taken that the newcomer to research does not regard such research as 'the easy option'. The value of introducing research methodology using ethnographic studies is that art teachers can relate to them more easily. The key issues in research methodology can then be developed using this affinity for ethnography.

Notes

1. Eisner, E. W. (1985). *The Art of Educational Evaluation: a Personal View*. London: Palmer.
2. Giddens, A. (ed.) (1975). *Positivism and Sociology*. London: Heinemann Educational Books.
3. Hammersley, M. & Atkinson, P. (1983). *Ethnography: Principles in Practice*. London: Tavistock.
4. Oakley, A. (1981). Interviewing women: a contradiction in terms, in: Roberts, H. *Doing Feminist Research*, p. 38. London: Routledge.

5. Denscombe, M. (1982). The 'hidden pedagogy' and its implications for teacher training, *British Journal of Sociology of Education*, 3(3) pp. 249–266.

6. The idea of teachers' work as 'bricolage' is developed by Hatton, E. (1990). Teacher Education and Bricolage, unpublished PhD thesis, University of Queensland, and draws extensively on the work of Levi Strauss, C. (1974).*The Savage Mind.*

7. The growth in popularity of ethnography in recent years is documented, *inter alia*, by Hammersley, M. (1980). Classroom ethnography, *Educational Analysis*, 2, pp. 47–74 and Smith, L. (1982). Ethnography, in: H. E. Mitzel, *Encyclopaedia of Educational Research*. New York: The Free Press.

8. Glaser, B. & Strauss, A. (1967). *The Discovery of Grounded Theory*. New York: Weidenfeld & Nicholson.

9. Delamont, S. & Hamilton, D. (1984). 'Revisiting classroom research', in S. Delamont *Readings on Interaction in the Classroom*, p. 18. London: Methuen.

10. Eisner, E. W. (1985). *The Art of Educational Evaluation: a Personal View*, p. 179. London: Palmer.

11. Hammersley, M. & Atkinson, P. (1983). *Ethnography: Principles in Practice*, pp. 14–15. London: Tavistock.

12. The significance of the outsider as a methodological position is indicated in the social phenomenology of Schutz, A. (1967). *Collected Papers 1*. The Hague: Nijhoff. The role of the artist as marginal to mainstream values is outlined by Silvers, R. J. (1970). 'The modern artist's associability: constructing a situated moral revolution', in: J. D. Douglas, *Deviance and Respectability*. New York: Basic Books.

13. Eisner, E. W. (1985). *op. cit.*, p. 279.

14. *Ibid.* 191, 198.

15. See, for example, Agar, M. A. (1980). *The Professional Stranger; an informal Introduction to Ethnography*, New York: Academic Press, Spradley, J. P. (1979). *The Ethnographic Interview*. New York: Holt, Rhinehart & Winston, and Spradley, J. P. (1979). *Participant Observation*. New York, Holt, Rhinehart & Winston.

16. See, for example, Spradley, J. P. (1970). *You Owe Yourself a Drunk; an Ethnography of Urban Nomads*. Boston, MA: Little Brown.

3

Systematic Reviewing: Lessons for Art and Design Education Research

Rachel Mason

Introduction and Aims

The discussion in this paper arises from my experience of carrying out two systematic reviews of research in art and design education for the *Evidence for Policy and Practice Centre* (EPPI-Centre) between 2002 and 2006. The paper begins with a brief overview of the evidence-based research movement in education. It then describes and critiques the four stages of the EPPI-Centre review process as they were applied to our second review. After briefly commenting on the results, conclusions are drawn about the methodology and the implications of systematic reviewing for research and research training in the specialist field.

The Evidence-based Educational Research Movement

There has been public disquiet for some time about the quality and utility of British educational research in general; as is evident in numerous Government documents over the past 30 years stating the case for reform. Prior to the 1980s the criticism of educational research promoted by organizations such as the Schools' Council and the Assessment of Performance Unit was that it failed to share and utilize the findings and was limited in scope to school-based action research, aimed at improving local and individual practice.[1]

With the advent of the legislated national curriculum in the 1980s, few resources were provided for research or evaluation because government was of the opinion that continuous assessment and mechanisms for accountability would effect educational improvement.

By the middle of the 1990s it was becoming apparent to government that implementation of the educational reforms was more complex than expected and there was an effort to characterize teaching as a research or evidence-informed profession. There was criticism of the method of

funding research through the Higher Education Funding Council for England (HEFCE) because it encouraged research that did not impact on practice nor inform policymakers.[2]

Following recommendation from Hillage et al.[3] the National Education Research Forum (NERF) was established in 1999 to encourage greater collaboration between funders and provide strategic direction for educational research.[4] Their National Strategy for Systematic Reviews in Education (NSSRE) identified systematic reviewing previously developed by the Cochrane Collaboration as a move towards basing policy and professional practice on sound evidence of effectiveness. Their aim was to reduce the potential bias they claimed is inherent in traditional 'expert' literature reviews, which only examine a small part of the research evidence.

The Department for Education and Skills (DfES) funded the EPPI-Centre as a centralized resource for external groups wishing to undertake reviews of education research to inform policy and practice. A literature review is understood as a piece of research and explicit methods purported to produce valid, reliable results.[5] A systematic methodology has been developed, particularly suited to non-intervention research, with strategies for integrating different kinds of data and a manual that outlines the procedures for carrying out reviews. A review question identified by so-called 'user' members of the research field and methodology is described in a protocol, which must be approved by EPPI. Specialist computer databases are used for extensive searching to locate and identify potential studies, published or un-published, and for storage and retrieval purposes. Previously agreed inclusion and exclusion criteria are used to ensure each study addresses the review research question. Key wording and mapping these studies descriptively is followed by an in-depth review of each study, weighting their quality and synthesizing the results. Two reviewers data extract each study independently and negotiate final results. Individual team members attend training workshops and named officers support the work of review groups. Each step in the review process is subject to monitoring and quality assurance by EPPI officers and protocols and final review reports are peer reviewed.

Art and Design Reviews

Roehampton University Centre for Art Education and International Research (CAEIR) was included as part of the third wave of EPPI-Centre reviews. In 2002 CAEIR set up a review group in collaboration with National Society for Art and Design Education (NSEAD). Membership of this group included art educators from four universities, international experts from the Netherlands, Australia and the USA and user members (art teachers, parents, head teacher, examiner, art adviser and representatives of QCA and Arts Council England). A research assistant was appointed on a part-time basis attached to CAEIR, and the project director and co-directors worked closely with smaller teams of art educators to carry out the reviews.

The focus of the first review was assessment in secondary education and the review question was, 'What are the effects of assessment practices in formal examinations on art and design curriculum content and pedagogy in secondary schools?' The report 'The effect of formal assessment on secondary school art and design education: a systematic map or description of empirical studies' was published in September 2005.[6] The second review enquired into art and

design and cultural learning and asked, 'How does art education contribute to cultural learning defined as understanding self and others?' The report 'A systematic review of the contribution of Art and Design education to cultural learning in students aged 5–16' was published in April 2006.[7]

User members of the Council of the National Society for Education in Art and Design (NSEAD) selected these topics on the basis that they are pressing policy issues facing the field. The NSEAD had documented teacher dissatisfaction with English art and design examinations and concern about their 'wash back' effects on curricula and courses for students at National Curriculum Key Stage 3 (11–14 years) for some time.[8] Since large sums of public money are currently being spent on culturally based artist-led initiatives and projects targeted at cultural understanding, the review group identified a need to establish what kind of learning is going on and how it occurs.

The majority of the work was carried out at Roehampton University. The project directors and research officer (the core team) coordinated the review process, including searching, data storage and retrieval. Whereas EPPI-Centre estimated the duration of a review to be one and a half years, they took much longer. Writing up a review in accordance with EPPI-Centre directives is a complex procedure that is very closely monitored and controlled (like doing a doctoral thesis under very tight supervision.) The more detailed description of the methodology that follows uses examples from the second review.

EPPI-Centre Review Process
Developing the protocol
The first step in a review is writing a protocol that specifies the review question, defines key terms and conceptual issues and locates the review topic in policy, practice and research. Regarding methodology, the protocol has to specify 'inclusion and exclusion criteria' and a 'search strategy' for identifying potential studies. Our second protocol took three months to write and the questions were reformulated four times before they were approved. Responses to drafts were invited electronically from the larger review group and user members. The final draft (over 30 pages) was sent out for peer review and approved by EPPI-Centre officers in March 2005.

Refining the research question
As is the case with any research, the original question had to be redefined. Refining it for the second review necessitated extensive deliberation about definitions of cultural learning: The National Advisory Council on Creative and Cultural Education suggests four different curriculum strands: namely, self-understanding (of cultural identity), understanding others; participating in culture change (art practise); and heritage transmission.[9] We chose to focus on cultural identity formation.

Definitions and conceptual issues
Defining the terms 'art' and 'art education' proved difficult also. In the second review, we decided to limit the search to studies involving visual arts (not drama or dance, for example)

and art pedagogy carried out for general educational purposes (not art therapy, vocational programmes for industry or professional training of artists for example). Whereas we excluded studies dealing with design, commercial and industrial arts, we included installation, video and computer and popular arts together with traditional art forms and media. We were particularly concerned to identify curriculum and teaching-learning strategies fulfilling aims such as 'providing personal fulfilment for all citizens' and/or 'nurturing social consciousness'.[10]

Drawing on sociological and anthropological theory, cultural identity was eventually defined as the 'aspect of self that is shaped by a sense of real or imagined affiliations with specific cultural, racial or ethnic groups'. Our aim became that of seeking for research-based evidence of ways in which learners' cultural ethnic, racial or national identifications are shaped through involvement in the language and practices of art education. We decided to limit the search to studies of art education targeting learners of compulsory school age but not necessarily to schools. We elected to distinguish between expressive-productive, analytical-critical and historical-cultural art curriculum domains[11] and used 'Western expressionism' as a point of reference also.[12]

Explaining the policy practice and research background
We justified the review topic by arguing that although culturally diverse education is mandated in many national curricula it is poorly understood. We noted a growth of policy initiatives and projects in and outside schools using art to address issues of national, local and regional culture, ethnicity and race. Whereas we were aware of the paucity of research in art education in general, we anticipated governments might be commissioning studies to investigate the cultural participation of learners in the collaborative projects they were funding involving artists, arts institutions and schools targeted at improving social cohesion. We anticipated that relevant studies might be found in a wide range of educational literature engaging with issues of equity, conflict resolution, citizenship and multicultural education, for example, and in literature on cognitive and artistic development and anthropological and sociological literature dealing with culture and culture change. In this we were wrong.

Developing inclusion/exclusion criteria and a search strategy
A protocol specifies inclusion and exclusion criteria for identifying potential studies for review and a search strategy. For a paper to be included in our database we decided it would have to fulfil six criteria related to the subject (art education); learners and learning environments; focus (cultural learning); type of study (research) time frame and language. Comprehensive descriptions of these criteria can be found in the final review report. Briefly, we decided to exclude papers that were not about visual art education or carried out for general education purposes, not about learning in schools or community settings or targeted at learners aged 5–16, not about cultural learning understood as formation or exploration of cultural identity and understanding of difference, not research reports, not published between 1980 and 2004 and not in English, Dutch, French or Russian.

Final review question
The main question we finally arrived at was: How does art education contribute to cultural learning (understanding self and other)? Sub-questions were:

- What kinds of institutional strategies and content are operationalized to facilitate this aim?
- Which cultural artefacts and practices are selected and why?
- What kinds of cultural identifications and clues are young people encouraged to express and represent in their art?
- Is there any evidence that culturally based art content and strategies can change learners of self and other?

Searching
After the protocol was approved, the core team created a list of 'search terms' in discussion with other team members. These had to fit the review rationale as outlined in the protocol and be appropriate for database search engines. A decision was taken to apply three groups of terms: 'art education', 'learning' and 'culture' and limit the total number to 57. Strategies for identifying studies from a range of electronic databases were developed through objective analysis of occurrences of words in their key wording systems. Once their performance had been tested against their sensitivity to the content, the terms were applied to searches for studies in educational databases such as ERIC, Bids and Digital Dissertations. In the event, possible citations were identified from a variety of sources using both electronic and manual methods. In addition to indexes, websites, databases and journals, the core team searched databases of unpublished research in progress, registers, printed books and journals, references and bibliographical lists, annotations in already identified reports and members of the larger review-group identified studies. The total of 2,474 possible references finally identified were stored in an EndNote library folder and coded to keep track of their progress through the different stages of the review.

Screening
Six members of the review team working in pairs conducted a two-step screening process to identity relevant citations. In the first stage, screening was based on information available in titles and abstracts (where available). Each citation was rated as 'include', 'exclude' or 'more information'.

Where a citation was marked by either reviewer as 'include' or 'more information' a full text of the report was sought. In all cases the criterion against which a study failed was recorded. All studies found to meet the criteria (a total of 234) were imported into another database for a second stage of screening. The full texts of these studies were obtained mainly through inter-library loan contacts or, in some cases, purchased online. The five studies that survived the full document screening were transferred to a new EndNote library folder in preparation for a full review.

It is worth pausing to consider why so many studies were excluded. One explanation is that it is difficult to locate potential art education studies accurately by electronic means because the search terms are notoriously difficult to define. We used the term 'art' as a proper noun to denote a subject in the school curriculum, but many databases are unable to make this distinction and in the studies located it most often appeared as part of an adjectival clause (e.g. 'art of mathematics education'). The search term 'art and design' proved unhelpful because it is specific to the British

education system and identified large numbers of studies focusing exclusively on design. Some study titles lacked specificity and focus, and the quality of the abstracts was poor, rendering identification of potential studies from the initial database difficult. Finally, many promising citations had to be excluded because they were policy documents specifying curricula or specific instructional guides for teaching and did not qualify as research.

Characterizing and describing studies – key wording
The five remaining studies were key worded using the EPPI-Centre *Core Key wording Strategy.* EPPI key words are designed to provide basic descriptive information about educational studies. Key wording involves pairs of reviewers using a checklist of predetermined options to record the following information about a study: (i) the source of a short-listed report, publication status, language and country of origin; (ii) locating it in a number of possible educational topics and curriculum areas; (iii) recording details of the target population, age of learners, educational settings and type of research. The review team created and coded another set of key words specific to this particular review also. After lengthy consultations with EPPI officers and the larger review group, we arrived at the following: (i) art forms/techniques; (ii) art curriculum domain; (iii) art instructional strategy; (iv) focus of cultural learning; (v) types of visual cultural resource; and (vi) policy orientation to culture (for a full explanation, see the final report of the review). Pairs of review team members applied both sets of key words to the studies electronically, after which their coding was compared and discussed until consensus was reached. Once EPPI officers had approved the entire key-worded studies, they were added to the EPPI-Centre database (Reel) for other people to access via the website.

For the most part EPPI core key words were self-evident other than those for 'types of research'. Here the classifications differ from those in standard educational research method texts in that studies are coded as either 'descriptive', explorations of relationships', 'evaluation studies naturally occurring' or 'evaluation studies researcher manipulated'. In both reviews the majority of studies located were 'descriptions' or 'evaluations naturally occurring'. There were no examples of 'explorations of relationships' and only one 'researcher manipulated evaluation'. However, inadequate reporting of methodology made it difficult to determine these study types. The balance of studies in relation to our review sub-questions was problematic in the second review in that only one focused directly on the effects of curriculum content and strategies on learners' cultural perceptions and there were no experimental research designs.

Mapping studies
The next step was to produce a 'map' describing the range of research activity on our review topic. EPPI-Centre offers an online facility for comparing key-worded studies and creating descriptive charts/tables of results. Our map described the characteristics of the five studies under the following generic headings: country in which it was carried out, curriculum area, population focus, age, sex and cultural backgrounds of learners, educational settings and methodological characteristics. It also described art/cultural learning in terms of types of art curriculum domain and instructional strategies, participants' objectives for cultural learning, cultural content and curriculum orientation towards culture. The following tables show results for geographical location of studies, population focus and visual arts forms and techniques.

Tables showing results for geographical location of studies, population focus and visual arts forms and techniques.

Number of included studies by country

Country	Number of studies
USA	1
Canada	4
Total	5

Number of included studies by population focus
(N=5, not mutually exclusive)

Population focus	Number of studies
Learners	4
Senior management	1
Teaching staff	4
Parents	2
Other population focus	1

Number of studies by art form/media/technique
(N=5, not mutually exclusive)

Art form/media/technique	Number of studies
Painting drawing & printmaking	5
Craft-based media	2
New Media 2	2
Performance	1
Mixed	1
Other	3

Criteria for the in-depth review were developed on the basis of this map in order to identify which research the studies could answer. The review team chose to emphasize two issues framing the inclusion criteria; namely, the adequacy of reporting results and the relevance of the definition of cultural leaning for this review. Since the five studies met the above criteria they were all included in an in-depth review.

In-depth Review

The studies were analysed in depth using the EPPI-Centre's 'data extraction' tool. This tool is a questionnaire with over 100 questions organized into eleven section headings. Questions in the first section deal with administrative details. The next two sections deal with study aims, rationale, questions and policy practice; then there are four sections on methods. Finally, two sections evaluate the quality of a study (quality of study reporting and study methods and data). This enables reviewers to scrutinize the quality of events in a systematic way as well as record details of aims, design, samples, data sources, methods of data collection and analysis. Two review team members data-extracted each study independently using the guidelines supplied by EPPI-Centre to help them fill in the questionnaire electronically. The EPPI-Centre provides electronic facilities also for reviewers to moderate and synthesize their responses once they have answered all the questions and agree on a final result.

Review team members found this part of the review process difficult and time-consuming. Completing the questionnaire online took at least seven hours per study. As the summary description above suggests, the bulk of questions included in the tool are about research method. Whereas the five studies reviewed were considered to have adequate reporting of this at the key-wording stage, once they were scrutinized in depth it became clear they fell short of what is required. Because important details were missing, some study findings were not substantiated by evidence. Several review team members became disillusioned with systematic reviewing at this point.

Assessing the quality of studies and weighting the evidence
At the end of each data extraction, reviewers evaluated the quality of evidence in studies using the criteria provided below. Weights of evidence as included in EPPI-Centre education reviews are based on the following:

A: Soundness of studies (Internal methodological coherence) based upon the study only.
B: Appropriateness of research design and analysis for addressing the questions, or sub-questions, of the specific review.
C: Relevance of particular focus of the study (including conceptual focus, context, sample and measures) for addressing the questions or sub-questions of this specific review.
D: An overall weighting taking into account ABC and D.

Reviewers found this part of the process difficult also. They grappled with questions enquiring into reliability and validity of data collection methods and analysis in the data extraction tool and were reluctant to weigh the overall quality of studies this way.

Synthesizing the evidence
Once the data extraction process was complete the core review team synthesized the data sets to bring together studies that answered the review question and sub-questions and met the quality criteria. The first stage was to create detailed summary descriptions of each study by downloading and combining the information from the data extraction questionnaires. Then they identified and synthesized the results as they related to each of the four sub-questions. The last

stage in the process was to summarize the main findings of the various stages in the review process, and consider the strengths and weaknesses of the reviews and implications for policy, practice and research. Since the focus of this paper is on systematic reviewing, the findings of the art and design reviews are summarized very briefly and the paper concludes with a discussion of the strengths and weaknesses of the methodology together with the implications for art and design education research.

Brief summary of findings from art and design reviews
The initial round of searching in the first review elicited 2,945 titles and abstracts. Of these 2,837 were rejected because they did not constitute research, or did not meet the inclusion criteria. Eventually eight studies meeting the inclusion/exclusion criteria were mapped by applying core and review specific key words. It was not possible to synthesize the findings so as to provide secure answers to the review question, however, because the studies were so disparate and important details of study method and results were missing. Therefore, only a map of the identified studies was generated, that described their aims, research methodology, including data-collection methods study samples, data collected and general findings.

The second review identified 2,474 studies of which only five eventually met the criteria. The results of this review were synthesized and, in so far as possible, conclusions for policy, practice and research in art and design education were drawn. Whereas all these studies provided some evidence of the manner in which art education contributes to cultural understanding as defined in the review, there were variations in the amount and quality of evidence provided in relation to each sub-question. The sample of studies was small-scale, therefore, the findings could not be generalized.

Taking the reviews as a whole, the majority of studies (9) were carried out for doctoral degrees and only two were funded. All the studies, with one exception, applied qualitative methodology. Whereas seven of the eight studies in the first review had been published as research reports, all five studies in the second review were unpublished. All the studies in the second review and three in the first review were carried out in North America. The expectation that these reviews would access publicly funded research was not realized. The majority of studies were teacher-based and focused on practical examples of curriculum reform.

Critique of methodology
All research begins with a review of literature. Oakley *et al.*[13] have criticized 'traditional' literature reviews on the grounds that the range of studies they identify is often 'selective, subjective, opportunistic and discursive' and the method lacks transparency because there is no audit trail and almost no weighting of evidence. They suggest systematic reviews are more comprehensive and less biased since more than one reviewer is involved, and more transparent and replicable. The evidence-based movement arose in part from increasing scepticism about 'professional expertise' in educational research, and the feeling that the majority serves the interests of academia rather than policymakers, providers and users and confirms what is already known about the specialist fields to which reviewers are sentimentally attached.

Critics of systematic reviews on the other hand find them overtly dependent on experimental research designs and statistical evidence. Booth[14] protests that EPPI-Centre criteria for good reviews are almost entirely determined by quantitative methods and a 'big as beautiful' approach to study identification. For Fitz-Gibbon[15] 'thick description' and case study are preferable to large-scale educational research, which often leads to erroneous conclusions. The small number of empirical studies our reviews identified surprised EPPI officers but was consistent with our perception of a field preoccupied with visual rather than verbal modes of communication and favouring theorizing over empirical research. The criticism that the evidence-based approach does not allow for exploration of the wider social, philosophical or ethical issues implicit in educational research seems especially relevant to a field like art and design in which the majority of studies do not confirm to a 'traditional scientific model of research'.[16] But the teams found the EPPI-Centre classification of study design types helpful, even though they excluded some research modes.

As Oakley et al. point out, systematic reviewing is challenging. The relatively underdeveloped state of electronic social science databases is a concern.[17] Our review teams experienced difficulty applying search strategies electronically because some search engines had poor sensitivity. (The search engine of the Index to Theses databases, for example, retrieved about 400 references for each search in our second review but only a few were found appropriate to the actual words used.) For this kind of search process to be fully effective, the sensitivity and power of many educational databases needs to be improved. The Endnote database did not produce filters for importing some references and the large numbers of studies identified with potential to provide evidence and, as already pointed out, the low numbers meeting the inclusion criteria was a concern. Whereas it may really be the case there are very few empirical studies in the field, it was virtually impossible to track down Masters' dissertations electronically and, North America excepting, systems for recording and accessing PhD theses are unreliable. A great deal of time and effort is needed to retrieve references this way and there may be more effective methods of finding studies.

The review group judged the teamwork and emphasis on user perspectives in selecting review topics and disseminating results to be positive aspects of the methodology. But securing team members with commitment to systematic reviewing was difficult. Systematic reviewing demands good IT skills and the involvement of a director and co-director in managing these reviews was crucial in ensuring their completion. It is important to point out that EPPI-Centre methodology assumes some knowledge of social science research concepts and methods whereas art education theory and practice (at least in its European manifestation) tends to be arts- and humanities-based.[18]

Participating in systematic reviews functioned as research training for the majority of team members. The methodology as a whole helped with the practicalities of question formation and appraisal of the quality of research and research reporting. We learned a great deal about and how to access and search databases and judged the protocol a useful tool for reducing bias and ensuring literature reviews are not overly influenced by study results. Some team members have used the EPPI-Centre key-wording and data extraction guidelines to train

postgraduate research students to carry out literature reviews to good effect. Where systematic reviewing is incorporated into initial research training and/or professional development, it has potential to combat the over-reliance on the experience of 'experts' characteristic of the specialist field and make the research process more transparent and democratic – always providing learners have some knowledge of social science research.

The paucity of studies about anything other than curricula led to the conclusion the significance of the model for the field lies in its potential to map teacher-based studies and to identify issues art educators ought to consider in planning research. The majority of screened studies offered practical examples of curricula content and pedagogy that teachers could replicate. As Cordingley et al. point out [19] dissemination of summaries of studies of best practice on the EPPI-Centre website is advantageous for teachers because they do not have the same access as higher education staff to online and bibliographic databases. User members of our review group responded very favourably to the detailed descriptions of curriculum development/research studies in the review reports. The details of research method included in the technical reports of reviews published on the EPPI-Centre website are informative for beginning researchers.

Over time it is possible that the EPPI-Centre initiative could contribute to the development of a more effective research-based climate amongst art educators. However, only if the methodology is able to accommodate a wider range of inquiry modes and addresses methodological weaknesses, like the prescriptive and somewhat inflexible and labour intensive approaches to formulating review questions, identifying studies and extracting data. Even if these problems were overcome, the systematic review movement needs to be supported by national initiatives targeted at ensuring education (and art education) research is recorded in a systematic way electronically and improving electronic databases.

Implications for Art Education Research

Because our reviews found very little evidence that supports policy decisions, they highlighted the worrying possibility that most publicly funded policy in the field is without any significant evidence base. Art and design policy and practice clearly needs to become more research-based. That the majority of studies reviewed were carried out by teacher-researchers is indicative of practitioners' desire for research evidence to guide them on these matters, however.

It came as no surprise the majority of studies were North American. The difficulty the core team experienced finding other team members willing and able to commit time to reviewing made us painfully aware that the critical mass of art educators with an interest in research in the United Kingdom is extremely low. The absence of empirical studies by well-known experts on the topics under review was a surprise.

The reviews identified worrying inconsistencies and weaknesses in the quality of research and research and reporting in the specialist field. The predominance of descriptions and naturalistic evaluations indicates a need for more studies exploring relationships using quantitative methods

and researcher-manipulated evaluations. The criticism by the DfEE[20] that education research fails to report difficulties and is over-optimistic about results applies to art education. All the studies reviewed except one considered, by implication, that art education will de facto have a beneficial effect upon learners. The field needs more studies that are neutral and/or sceptical and there appears to be a considerable amount of unsupported theory or rhetoric in the specialist literature masquerading as research. The review teams support the argument that systematic reviewing has potential to reduce researcher bias and over-reliance on 'professional expertise'.

The review group were unable to secure additional funding for art and design reviews (review teams in other fields were more successful). In view of the uneven distribution of financial support among educational subjects,[21] it is not surprising that the majority of studies in the specialist field are by first-time researchers, the range of research topics is limited, and many projects fail to build sufficiently on previous studies and engage with the broader picture of ongoing research; and that they leave many questions unanswered.[22] However, the Organisation for Economic Co-operation and Development (OECD) has identified such weaknesses as endemic throughout European educational research.[23]

The finding that the majority of studies were doctoral theses is evidence of the significant role higher education degrees play in art education research. However the weaknesses identified in research reporting and, in particular, the absence of information about methodology (research contexts, sampling, data collection instruments, data analysis procedures, quality assurance mechanisms etc.) has implications for their provision of research training.

Over the past decade the largest public funding initiative for art education research in the United Kingdom has come from the Department of Media Culture and Sport (DCMS) and been distributed through the Arts Council of England whose mission is to support art and professional artists (thus, the artist teacher tradition persists). There is also a growth in opportunities for art educators to research and develop their own artwork modelled on practice-based doctoral degrees awarded by university departments of design and/or fine art. The theoretical basis and methodology for such explorations is, according to Hammersley,[24] incompatible with the development of knowledge through educational enquiry. One reason is the majority are dependent on a shared repertoire of cultural resources arising during participation in artistic tasks that are tacitly understood so cannot be communicated effectively to those without this kind of experience; another is that the researchers tend to prioritize practical and political agendas over research requirements.

Art education research is conspicuous by its absence from annual conferences organized by British Educational Research Association (BERA) and other mainstream educational bodies like the International Congress for School Effectiveness and Improvement (ICSEI) and research findings rarely filter into schools. Those that do are usually practice-based, thus encouraging art teachers to adopt an 'artist-as-teacher' role. At the time of writing, it appears that art education research in the United Kingdom is moving towards the Arts and Humanities Research Council (AHRC) rather than the Economic and Social Science Research Council (ESRC)

model.[25] Opportunities for art teachers to engage in postgraduate degrees underpinned by social science theory and educational research methods are few and far between. Whereas some art educators are arguing strongly for a synthesis of artistic and educational research methods, we are concerned that the almost exclusive funding of art education research through the Arts Council at present will skew research in the United Kingdom too much towards the arts and humanities paradigm. Allison[26] has argued that the sciences provide a better model of research training than the arts and humanities. A firm grounding in rigorous and systematic social science methodology is needed to enable the field to move from small-scale projects developed by a few art teachers studying for research degrees, to the larger funded studies that will contribute to the development of a well-functioning community of art educational practice.

Acknowledgements

This is an amended version of a joint paper written with Dorothy Bedford for a general education audience. I wish to thank the co-directors, research officers, review team member and the larger review group for their participation in the reviews; and Nicholas Houghton and Mark Newman at the EPPI-Centre for assistance in writing the reports.

Notes

1. OECD (2002). *Educational Research and Development in England*. Paris. CER/CD Report.
2. See the following: Hargreaves, D. H. (1996). *Teaching as a Research-Based Profession: Possibilities and Prospects*. Cambridge Teacher Training Agency Annual Lecture; Tooley, J. & Darby, D. (1998). *Educational Research: an Ofsted Critique*. London, Ofsted; Edwards, A. (2000). Responsible research: Ways of being a researcher. *British Educational Research Journal*, 28(2): 157–168; Davies, P. (2000). The relevance of systematic reviews to educational policy and practice, *Oxford Review of Education*, 26(3–4): p. 365. (Accessed through EBSCO host 28/04/05.)
3. Hillage, J., Pearson, R. & Tamkin, P. (1998). *Excellence in Research on Schools*. Research Report No. 74 for DfEE by the Institute of Employment Studies. London: HMSO.
4. Morris, A. & Peckhman, M. (2006). *Final report of Educational Research Forum*. Working paper 9.2. National Education Research Forum http://www.nerf-uk.org (accessed 28/11/06).
5. EPPI-Centre What is a systematic review? http://eppi.ioe.ac.uk /EPPIWeb/home.aspx?page=/reel/about_reviews.htm (accessed 20/4/2005).
6. Mason, R., Steers, J., Bedford, D. & McCabe, C. (2005). *The Impact of Formal Assessment on Secondary School Art and Design Education: a Systematic Description of Empirical Studies*. Research Evidence in Education Library, London: EPPI-Centre, Social Science Research Unit, Institute of Education, University of London. Accessible at: http://eppi.ioe.ac.uk/EPPIWebContent/reel/review_groups/art/review_one/Art_rv1.pdf.
7. Mason, R., Gearon, G. & Valkonova, Y. (2006). *The Contribution of Art and Design Education to Cultural Learning in Students Aged 5–16*. Research Evidence in Education Library, London: EPPI-Centre, Social Science Research Unit, Institute of Education, University of London. Accessible at: www.eppi.ioe.ac./EPPI/Webhome.aspx.
8. Steers, J. (1988). Art and design in the national curriculum, *Journal of Art and Design Education*, 7(3): 303–323.

9. The definition of cultural learning was pedagogy in art that seeks to enable young people to (i) recognize and understand their own cultural values and assumptions, (ii) embrace and understand cultural diversity by bringing them into contact with attitudes and values of other cultures, (iii) understand the evolutionary nature of culture and processes potential for change and (iv) encourage a historical perspective by relating contemporary values to processes and events that have shaped them (see National Advisory Council on Creative and Cultural Education (1999) *All Our Futures: Creativity, Culture and Education*. Sudbury: Suffolk).

10. Chapman, L. (1978). *Approaches to Art in Education*. New York, Harcourt Brace Jovanovich.

10. Allison, B. (1982). Identifying the core in art and design, *Journal of Art and Design Education* 1(1): 59–66; Eisner, E. (1972). *Educating Artistic Vision*. New York: Macmillan. Both authors maintain the separation of art learning into domains helps to clarify an extremely complex set of relationships even though they are interactive.

12. It is widely agreed that throughout much of the twentieth century art education was guided by modernist principles that celebrated innovation freedom, personal expression of the artist and the autonomy of the art object from social, moral and political concerns. See Russell, R. (2004). A beginner's guide to public art. *Art Education* 57, 9–24.

13. Oakley, A., Gough, D., Oliver, S. & Thomas, J. (2005). The politics of evidence and methodology: lessons from the EPPI-Centre, *Evidence and Policy*, 1(1): 5–31.

14. Booth, A. (2001). Cochrane or cock-eyed? How should we conduct systematic reviews of qualitative research? Paper presented at *Qualitative Evidence-based Practice: Taking a Critical Stance Conference*, Coventry University, 14–16 May. http://leeds.ac.uk/educol/documents/00001724/htm (accessed 28/04/2005).

15. Fitz-Gibbon, C. T. (2003). Milestones en route to evidence-based policies, *Research Papers in Education* 18 (4), 313–329.

16. Candlin, F. (2000). Practice based doctorates and questions of academic legitimacy, *International Journal of Art and Design Education*, 9(1): p. 98.

17. Oakley, A. et al., op. cit.

18. Until very recently, training in art in European systems only existed outside universities. According to Ricardo Marin there are four dominant modes of teaching in the European academy tradition based on different interpretations of the nature and purposes of art. Their distinctive feature is common agreement on the central role of studio practice in art based teaching and learning. See Marin, R. (1998). Four historical models of art education, in Cahiers, *Art and Education*. Brussels: Hogheschool Sint Lukas, 8–30.

19. Cordingley, P., Saunders, L. & Evans, D. (2002). Bringing teachers and research closer together: the GTC's 'Research of the Month', paper presented at *Annual British Educational Research Association Conference*, University of Exeter, September.

20. Hillage, J. et al. (1998). Op cit.

21. Leask, M. (1989). Teacher evaluators: the missing link? In D. Hopkins (1989). *Evaluation for School Improvement*. Milton-Keynes, Open University Press, 90–93.

22. Zimmerman, E. (1999). Background briefing paper, in: Association for Education in Art Commission on Research in Art Education, *Creating a visual arts agenda towards the 21st century*, Reston Virginia, National Art Education Association; and Allison, B. & Hausman, J. (1998). The limitations of theory in art education, *Journal of Art and Design Education*, 17(2): 121–127.

23. Wolter, S., Keiner, E., Palomba, D. & Lindblad, S. (2004). OECD Examiners' report on educational research and development in England, *European Educational Research Journal*, 3(2): 510–526.
24. Hammersley, M. (2005). Countering the 'new orthodoxy' in educational research: a response to Phil Hodkinson, *British Educational Research Journal*, 31(2): 139–155.
25. The Arts and Humanities Research Council (AHRC) supports research in a wide range of subjects such as history and modern languages and the creative and performing arts. http://www.ahrc.ac.uk. The Economic and Social Research Council (ESRC) describes itself as the leading United Kingdom agency addressing economic and social concerns. http://www.esrc.ac.uk (accessed 28/11/2006).
26. Allison, B. (1988). Research in art and design: research problems, programmes and databases, paper presented at the *Matrix of Research Conference*, Central School of Art and Design, London (March 1988).

4

Using Participatory Visual Ethnography to Explore Young People's Use of Visual Material Culture in Place and Space

Kristen Ali Eglinton

Introduction

In this chapter, I discuss aspects of a 'multi-sited'[1] ethnographic study in two 'localities'[2]: an after-school club in New York City and a remote community in the Yukon Territory, Canada. Generally, I employ ethnography to explore some of the ways in which young people between the ages of ten to fifteen years use visual material culture in their everyday lives. Of particular interest is the ways in which 'place' and 'space' might intersect with young people's use of these forms. For purposes of this research, visual material culture (or vmc) refers to all human-made objects, images and events to which people attribute meaning including, for instance, 'fine art', popular media representations, films, websites, clothing and the like.[3] 'Use' refers to the ways in which visual material culture is appropriated, employed or 'brought into play' in everyday life. For the moment, place and space can be defined as the material and symbolic aspects and/or social narratives found in certain sites (a site might include, for instance, New York City). I will come back to place and space later in this paper.

While the aim of this paper is to provide a general overview of the project, I focus most heavily (though not exclusively) on the theoretical rather than the technical aspects of the research. Moreover, rather than simply providing a description of the study and underpinning theory, I use this paper as a space to think about ideas and concepts arising through the research. More specifically, in the first half of the paper I highlight some issues in visual arts education, provide a rationale for the study and, describing some of the concepts guiding this research, argue for

a dynamic understanding of culture, place and space: one that offers a holistic and relational understanding of young people's use of vmc. The second half of this paper is dedicated to a discussion of methodology; here I focus closely on ethnography, weaving in ideas about participation and the use of visual-based methods. Finally, I use this paper as a way to begin thinking about the nature of young people's engagement with visual material culture, the role of place and space, and about how we might access the local 'lived space(s)' where young people, visual material culture and place and space intersect. Connected to this, I begin to play with the idea of participatory visual ethnography as a means of connecting young people's use of visual material culture to pedagogy and theory in visual arts education.

Making Connections: Art Education, Youth Experience, Culture, Place and Space

Telling stories

To begin making connections I start with a personal narrative. A valuable ethnographic tool, narrative can convey overarching themes, stretch the imagination of the reader, and even communicate moral (and immoral) accounts.[4] More prosaically, in this instance, I use it to describe one of my first days as an art teacher: after graduate school I decided to take a job as a visual arts educator in what administrators considered the longest 'failing school' in the South Bronx area of New York City.

The story: imagine, if you can, a large inner-city junior high school. A school identified by a number, not a name; a place where metal detectors and armed guards meet you at the door. A building covered in graffiti and purposeless scaffolding, a structure which people often mistake for a long abandoned factory. The school served 5,000 young people in grades seven, eight and nine (generally between the ages of eleven and sixteen, depending on various circumstances). My classroom, up on the third floor, had three chairs and one table. There were three windows, and I actually took comfort in the fact that the main window, which had a hole shot through it, was padlocked shut: I was told in the interview that the last art teacher was dangled out this third-floor window by a group of upset students. So, though the rain could come in, I couldn't be dangled out. To start the year, I was given a big roll of white paper, a few boxes of used crayons and a couple of dried-up glue sticks.

Well prepared to teach over 2,000 of the young people in the school, my hope was to somehow make the visual arts meaningful to all students. In preparation for the year, I sketched a programme where I aimed to include all forms of visual material culture from paintings found in museums to popular cultural forms such as television programmes and comic books. I decided the first project would look at graffiti; my clichéd equation here, I am ashamed to publicize: New York City youth equals graffiti.

As the first class pushed through the door, I felt relaxed. Graffiti was something I got. After all, I had seen the Jean-Michel Basquiat show at the Museum of Modern Art, and, in a more embodied fashion, years earlier I permanently inked an area of my torso with a trademark character by graffiti artist Keith Haring. After a brief introduction, I explained the project. The idea was that we would produce our own 'tags' (i.e. letters/images representing ourselves),

and, then, in conjunction with the other 1,967 young people I was to teach, we would create a mural of tags on the back wall of the classroom (which I covered with the roll of white paper). The task set, I launched into a discussion about the 'graffiti movement' in New York City.

The image still haunts me: there I was, a twenty-five-year-old White woman from downtown Manhattan telling 33 thirteen- to fourteen-year-olds from the South Bronx about the meaning of graffiti: 'enlightening' young people to Haring and Basquiat; positioning myself as an authority. If pedagogy can be characterized as 'interactive productivity' – a dialectic involving teacher, learner and knowledge – this was not pedagogy.[5] Without an understanding of the ways in which youth were actually engaging with graffiti in their everyday lives, without any real ethnographic or 'thick'[6] understanding of, as Stuart Hall might ask, how or what young people 'feel, think or say' about their visual material world,[7] I could not meaningfully engage the young people – in short: I had no way in.

I relate my narrative not because it is singular but because it begins to illustrate some timely issues in visual arts education. Specifically, in response to the well-known idea that young people are more likely to engage with popular forms of visual material culture rather than those forms typically found in museums, and in reply to a cultural shift from a text-based to a visual or visual material culture, where human engagement with, for instance, images now has primacy over linguistic or textual models of culture, a 'visual culture art education' is gaining popularity.[8] Visual culture art education (or VCAE) seeks to both expand the canon of study to include popular cultural forms such as film, websites and media representations as well as to develop an approach to pedagogy which focuses on critique: for example, supporting young people in recognizing that visual material culture is laden with influential sociocultural meanings.[9]

A visual culture art education is important. Since that first day in the Bronx, I have worked as an arts educator with thousands of young people – from New York City to England. Along the way I have come to learn first-hand that young people are living in and through a visual material culture. However, while I believe it is vital to expand the contents of study to those objects and images found in young people's lives, and though I advocate an approach to pedagogy which forefronts critique – which supports Maxine Greene's idea of 'break[ing] through the frames of custom'[10] – I would argue opening up the canon and employing a more critical form of pedagogy is not as straightforward or uncontroversial as it may sound. Freedman proposes visual culture in education is an area in need of theoretical and empirical investigation.[11] Indeed, my own teaching and research experiences, such as my story from the Bronx, push into relief a number of tangled issues around theory, pedagogy and empirical research (or lack thereof) which I suggest need to be examined in order appropriately to expand the canon and engage in a kind of pedagogy which is relevant and connected to the lives of youth. I look at some of these issues in the following section.

Forging links: theory, pedagogy and empirical research
Starting with theory, I would argue that philosophical assumptions guiding practice in visual arts education (i.e. visual art education's implicit theoretical frameworks) cannot support an

understanding of people's experiences with *all* forms of visual material culture. Unsurprisingly, and with some exceptions, visual arts education is typically underpinned by aesthetic theories involving people's engagement with works considered 'fine art'.[12] However, these theories are both limited and limiting as they are often 'dualistic' and 'non-relational' separating, for instance, context and culture from individual, body from mind, individual from society. For example, many aesthetic theories postulate that experiences with art (i.e. aesthetic experiences) happen solely in the mind, rather than being something that is lived, embodied or involving desire or pleasure.[13] Moreover, reflecting a non-relational understanding of culture, context and individual, there is an 'aspatiality' and 'placelessness' to these theories. In fact, with a few exceptions,[14] I would argue that place and space has been largely left out of visual arts education. While these theories and assumptions perhaps served their purpose, I believe it is safe to argue that experiences with popular forms of culture are often fuelled by pleasure, are embodied and lived in social interaction in place and space.

Moving on to pedagogy, as a consequence of the limited scope of visual art education's theories, the inclusive study of visual material culture draws on other fields to guide practice including visual culture studies, British media studies, critical pedagogy, cultural studies and related perspectives such as feminism. Though diverse in their focus, these areas are united by a critical perspective which questions 'taken-for-granted' or 'common-sense' meanings and representations. While these fields might not address exactly the same issues as visual arts education, their emphasis on critique, representation and cultural meanings suggests they could provide valuable input.

However, a thorough reading of the literature from these perspectives indicates that many of them are beset with their own limitations and conflicts. A conflict of great importance to visual art education is a disconnection between the theories and approaches used to engage young people in the examination of visual material culture and the ways in which youth *actually are* engaging with these forms. Illustrating this point, Buckingham[15] writes of a discrepancy between media education's theories which include primarily '"modernist" conceptions' of young people's media use and postmodern developments which constitute a change in both media itself and the ways in which youth engage with these forms – a discrepancy reminiscent of visual art education's own limited frameworks.

The gap 'between [an] ideological analysis and lived experience'[16] rings throughout the social science literature and has, I propose, tremendous implications for pedagogy in visual arts education. Drawing too heavily on ideological critique, without taking into account the lived local experiences of young people, risks making our pedagogical practices in visual arts education, paradoxically, ideological. The argument here is that cultural practices – including the ways young people use vmc in their everyday lives – are contextual, constituted of place and space. Without knowledge of how youth are using the cultural forms around them, the meanings we 'help' young people 'uncover' will most likely be based upon our own subjectivities and/or on the theory underpinning the approach. As Dimitriadis puts it:

...without [...] an understanding of young people and their lives [...] we will always be limited in our analyses [...] in ways that reinforce our political predilections[17]

Finally, contributing to the chasm between theory, lived experience and practice is the fact that there is little empirical research across disciplines – and most pointedly in visual arts education – which examines young people's everyday use of visual material culture as inextricably linked to place and space. While there is research which examines young people's consumption practices, taking a 'macro' perspective, engaging in 'armchair analysis' and/or treating youth as a 'homogeneous' group or 'consumer band', there are few studies which look at what young people in local places are actually doing with visual material culture in their daily lives – research that elicits the perspectives of youth as active cultural producers living with/in and (re) making their sociocultural world. It is this paucity at the level of empirical research which reinforces a disconnect between young people's experience with visual material culture, theory and pedagogical practice.

Taking as my subject and starting point the lives of youth, living with/in and through local places, engaging with, using and drawing on visual material culture in their everyday lives, my research asks in what ways do young people use visual material culture in their everyday lives? And, how is place and space implicated or entangled in their use of these forms? My overarching aim is to bring the lives of youth, as cultural producers and contextual agents, into the discourse on (mainly popular) visual material culture and pedagogy in visual arts education.

To examine research questions and to begin to work towards this aim, in conjunction with fieldwork, I knit together a conceptual support to understand some of the core elements the study. Though I use a number of concepts in my research (including, for example, identity), in this particular paper I focus on culture and place and space.

Conceptualizing culture, place and space
The theoretical work for this study seeks to do two things: first, overcome some of the aforementioned dichotomies or dualistic assumptions underpinning much visual art education research and pedagogy and, second, provide a more dynamic and relational understanding of the social world and of young people's use of vmc.

Beginning with culture, I use diverse perspectives from, for example, cultural psychology, anthropology and human geography to overcome binary thinking. Culture is both 'rooted', or 'in-place', as well as 'a flowing stream of disembedded meanings and practices'.[18] Moreover, it is not bounded, but open, fluid and relational. In this sense, '"culture" is spatial': it creates space and is made up of the social relations of space.[19]

Culture can only be understood in relation to the social, material and historical context (i.e. in relation to place and space and time). Indeed, culture is inextricably linked to place and space. Human geographers have long argued for the 'centrality of space' in understanding the sociocultural world.[20] In the social sciences, as Soja highlights, there is a developing 'awareness

of the simultaneity and interwoven complexity of the social, the historical *and the spatial*. . . '.[21] With this awareness, place and space has been considered through multiple perspectives; in this study, I use the work of Massey and others,[22] who advocate space as constituting and constituted of the flows of social, cultural, political and economic relations. In this model, space and the social world constitute each other.

Place, in this understanding, is interrelated with space; places are not coherent or settled, but dynamic and productive; importantly, as Massey points out, places are still particular and specific.[23] So, for instance, while on a small-scale an area of New York City might be a place, this place is made up of the unique manifestation of spatial relations – or mix of narratives which constitute, say, what it is to be poor, Puerto Rican and/or 'a man' (i.e. constructions of class, ethnicity, gender). It is easy to see how in this formulation individual identities are implicated; here we find that through cultural practice (including the use of vmc) as we make place and space, place and space make us – as Keith Basso writes, 'the place-worlds we imagine'.[24]

There are two points I highlight here. First, important for this research, is the idea that the mutual constitution of person and place is both a discursive and non-discursive practice. Nigel Thrift imagines people's interrelation with the place as embodied, performative and creative.[25] Connected to this, people's 'local knowledge' is an embodied sensory knowledge which is both anchored and performed in interaction with place in everyday life.[26] Crucially, I note that while people's engagement is embodied, the senses are, in fact, cultural.[27] Ruby writes with regard to cultural performances that 'embodied and sensory knowledge' reside 'at the core of culture'.[28]

The second point, which is both theoretically and analytically significant, refers to the concepts highlighted by Soja, who, drawing on Henri Lefebvre, describes aspects of space: 'Firstspace', which includes the material aspects of place and space, 'Secondspace', generally, referring to the imagined world, and 'Thirdspace', which he relates to Lefebvre's 'lived space', where, among other characteristics, material and imagined spaces come together.[29] Though the concept 'Thirdspace' has been used frequently in geography and anthropology, it is Lefebvre's notion of lived space that I appropriate in this study as a productive nexus: a site where young people, visual material culture and place/space come together in and through discursive and non-discursive practice.

Yet, empirically it is difficult to get at this lived space where interaction is embodied, where the non-discursive 'affective' or 'emotional'[30] aspects of life are played out, and where culture is always in the process of being (re)made. Engaging with this limitation in the second half of this paper, I describe some of the tools that I used in this ethnography in an effort to think about this space. In particular, I highlight a selection of theoretical and empirical aspects of the participatory visual ethnography which I carried out from November 2005 through October 2006 in two different localities.

'New' Ethnographic Forms, Participation and the Use of Visual Methods
Examining 'new' ethnographies
Firmly committed to 'the analysis of cultural forms and practices'[31] ethnography is both a practice – often characterized by participant observation, interviews, and other qualitative methods, and

a product – as exemplified in the final 'text'.[32] What sets ethnography apart is its aim to make sense of people's experiences, to describe and understand the social and cultural practices and processes enacted in everyday life with/in wider cultural contexts. While it is this commitment to the empirical investigation of the everyday, to the lived spaces, and to the fashioning of substantive theories based on local realities that drew me to ethnography, I also argue that the perceived gap in visual arts education between youth cultural experience on the one hand, and the pedagogical practices, including theories guiding those practices, on the other, might be addressed through the empirical and theoretical work of ethnography; I will come back to this idea again.

Where traditional ethnography rests, for example, on the implicit belief that the ethnographer is separate from the social reality s/he is studying, 'new' ethnographies problematize the authority of the ethnographer as objective observer, and shed light on, among other points, 'the essentially interpretive nature of the ethnographic enterprise'.[33] Where a traditional ethnography might be characterized by a researcher using a series of tools, to (objectively) observe, describe, and interpret the 'way of life' of a discrete group of people, postmodern, or what I will interchangeably refer to as experimental, or 'new', ethnographies critique the objective authority of the ethnographer, and respond to the changing ontology of culture from a stable unit to a dynamic shifting process.[34]

Important for understanding youth cultural practices with visual material culture in place and space, 'new' ethnographies start from a critical perspective, recognizing the situated, historical, and political basis underpinning all social science research; they seek to:

> ...deal with multivocality and multiple agency, with fragmentation and movement, and with the complexities of positioning and identity in social worlds which are at once local *and* global ... [35]

There is an understanding in 'new' ethnographies that participants *and* ethnographers are active producers of ethnographic knowledge. Because of this, underpinning these ethnographies is 'reflexivity',[36] where there is a constant introspection on the part of the researcher: examining, questioning, and looking critically at their role in the research – in both collecting and in fashioning representations.

Located within these 'new' ethnographic perspectives, this project was framed around Marcus' concept of 'multi-sited research';[37] the concept of 'participation';[38] and on the use of visual ethnographic forms[39] where the production of images was used to generate ethnographic knowledge. I now bring the study into a discussion of these three aspects of the research.

A multi-sited ethnography
Marcus argues that ethnographic fieldwork and theorising should include the multiple 'sites' which intervene in phenomena being studied. His concept of a 'multi-sited' ethnography enables me to not only imagine, but ethnographically conceive through empirical study the complex, pluralistic, and dynamic nature of young people's cultural practices through both fieldwork and analysis.

The two sites selected in this study including an after-school club in New York City and a remote sub-Arctic town in the Yukon Territory of Canada, were selected for theoretical and analytical, as well as social and personal, reasons. Theoretically and analytically I argue that two diverse sites will push into relief the role of place and space: 'acknowledging the fundamental differences in local epistemologies that inform everyday practice, experience, and emotion'.[40] Moreover, I am interested in various dialectics including: 'local-global', 'centre-periphery', 'urban-rural', and the implications of these dialectics for a visual arts education which privileges the cultural lives of youth. More personally I believe, when possible, social science research should seek out the voices of those often unheard or, sometimes, silenced. My experience is that all youth, but more specifically urban and rural youth, and in particular, urban Black and Hispanic youth, and rural First Nation (Aboriginal Canadian) youth, face various forms of exclusion from mainstream contexts. Bringing these threads together, I proposed a state-funded after-school programme in the Greenwich area of New York City ('Village after-school'), with a majority of Black and Hispanic youth, together with the town of Barlow in the Yukon Territory, which, despite having more advantages than most small communities, has a remote setting and high population of First Nation youth; I felt that each community would benefit from this project.[41]

In both communities I carried-out a participatory ethnographic study. I was in the 'Village after-school' for just under seven months and in Barlow for just over three months. Visual methods (I will come back to these methods later in the paper) and participant observation were used throughout: laden with camera equipment, which I readily lent to youth, I spent almost every day (and evenings in the midnight sun) 'hanging out' with young people wherever they were: in Barlow this included in the art classroom of the local school, at community events, skateboarding by the river or biking on the dirt roads. In New York City I worked with youth at the Village after-school club. Housed in a large high school in Greenwich Village, most of my time at the after-school club was spent sitting around cafeteria tables talking with young people, listening to music, and/or browsing through magazines together. Sometimes we would go outside and run around the basketball courts, jump-rope, or sit on the benches watching other kids play basketball. Open-ended interviews were also carried out. During these conversations we covered diverse topics from likes and dislikes, to values and beliefs, to friendships, identities and futures. At the core of the research sat concepts of participation, 'relationality', and reciprocity; I now touch on participation.

Participating in ethnography
Various aspects of participatory inquiry inform this study, I describe three of them here.[42] First, participatory inquiry extends epistemology to include 'experiential knowledge'.[43] Sensuous experience, the body and its engagement with the world (both natural and constructed) become both the conduit for and a way of understanding the relationship between self and world (or other). Based on my discussion in the previous section on our embodied relation with the world and on my experience in the field, I argue that recognizing bodily experience as a form of knowing is vital to understanding how visual material culture is used and appropriated by young people in their daily lives.

Second, participatory inquiry, also extends 'what *counts* as an epistemology' to include otherwise silenced and/or 'non-dominant, non-majority, non-Western ways of knowing'[44] (my emphasis). These include for instance women's knowledges, knowledges from various racial and ethnic peoples, and I would include the voices and knowledges of young people, particularly those who are at once part of these larger categories as well as part of their own non-dominant, and often silenced group. This opening of epistemologies reflects the idea that participatory research is by nature egalitarian research; as such it addresses power relations threaded through research, and breaks down the dichotomous relationship between the researcher and the researched. To further this thought, a participatory approach promotes the views of the young people I work with in this study: young people are given primacy, and their experiences are central in the building of locally grounded open-ended theoretical constructs.

Third, participatory perspectives place importance on practical knowledge (i.e. 'knowing how to do something'); I suggest practical knowledge enacted with/in the research process might be considered a form of praxis: a coming together of tacit theory and practice.[45] Connected to this I have started to think about the possibility of participatory ethnography as a transformative practice, which not only generates knowledge, but transforms both researcher and participants.

Thoughts around praxis and transformation bring me back to the idea I touched on earlier about participatory visual ethnography as a possible link between youth cultural experience and pedagogical practices in visual arts education. Now expanding on this, on a very general level, it is hoped the generation of ethnographic knowledge produced through this study will bring the perspectives and practices of the young people into sharper focus, ultimately informing (and transforming) visual arts pedagogy/theory.[46] On a more imaginative level, I would suggest participatory visual ethnography itself is a form of pedagogy – a pedagogy driven by youth practices and perspectives; a pedagogy which can bring together through practice ethnographer, young people, and local knowledges. For both participants and ethnographer, as new knowledge is produced, old knowledge is transformed, and there is a continuous integration of theoretical perspectives and raw sensuous cultural practices.

The mention of practice and transformation is the perfect segue into the final section of this paper where I discuss several aspects of the visual methods used in this study. In particular I suggest expressive image making is a way into the lived spaces of youth cultural production

Bringing in the visual
While there is great variation in how the visual is approached within disciplines, the use of visual modes of research (in the generation and/or representation of data) has always been contentious.[47] The aesthetic nature, ambiguity, expressivity, and subjectivity of visual materials are believed to be in tension with the tacit need for realism and objectivity in social inquiry.[48] Deeply engaging with these tensions and debates in my research for purposes of this paper I make two interconnected points.

First, importantly, I suggest the permeating nature of the visual in this study, most pointedly in the research focus, justifies the use of visual modes of research (in this project and in various forms of visual arts research more generally). Thinking again about people's interaction with the environment, about local knowledge being, in part, non-discursive and embodied, and about the difficulty in accessing lived space – again, the meeting point of youth, vmc, and place and space – I propose participatory expressive visual-based methods are potentially fertile tools.

Augmenting this idea of the expressive, I make the second point: instead of adopting an approach that objectifies, I draw on postmodern ethnographic work and visual researchers, theorists, educationalists, and artists who posit a reflexive, collaborative, integrative view of the visual, and who construe visual modes of research as potentially expressive, imaginative, participatory aesthetic practices. Rather than using the visual simply 'as a mode of recording data or illustrating text',[49] I capitalize on the expressive (and sometimes ambiguous) nature of visual material forms in the production of ethnographic knowledge. Specifically, I bring together anthropological and artistic forms of knowledge and draw on my own experience as a visual artist in the generation of ethnographic images; moreover, throughout the study, using participatory visual methods, I engaged young people in the production of visual forms which went beyond simply documenting life, and into an area where both the young people and I, as Hickman might argue, 'create aesthetic significance': where create connects to 'inventiveness', aesthetic refers to the senses, and "significance" is associated with meaning and 'signs' that are highly expressive and invite attention'.[50]

Focusing now on practice: throughout this ethnography visual methods were used in three ways including, first, image and object-making by the researcher: as a social researcher/visual artist – I shot images and generated video in an effort to understand the richness of the sites and dynamic nature of culture and place, as well as to interpret social relations, and critically explore my own subjectivity. Second, pre-existing materials were used to generate ethnographic data: images, music videos, wrestling DVDs, and, for instance magazines were often used in casual discussion and in semi-structured interviews to elicit young people's perspectives, cultural experiences, and other concerns arising throughout the study. And, third, a central method in this study was participatory image-making or the production of visual form by the young people themselves. These three categories are not discrete – in practice they are almost inseparable. On a very basic level, many of the images produced by me in this study were directed by the young people. At the same time I would often hand a camera to a young person asking him or her to photograph something I was unable to access (e.g. their city block or a night out by the river with friends).

As participation and young people's local cultural practices with vmc are key aspects in this study I found participatory image-making central to the research. Seeking to offer youth the tools needed to discuss and document their lives, interests and personal meanings, young people engaged in various forms of image making including self-representational film-making, photography and collage. Because of the significant role participatory methods played in the research I touch on two of the methods used here: film-making and still photography.

Beginning with film-making, young people wrote, directed, produced, filmed, and edited a series of digital videos (I assisted in filming and editing). The aim of the videos was to illustrate the personalities, interests, styles, and cultures of the film-makers. All videos were shot using the most basic equipment – a few digital video cameras and free editing software. These films were approximately six to twelve minutes each, and a total of sixteen compelling videos were produced across both sites. Final themes from the videos ranged from documentary-type discussions about individual lives to extreme sport-style broadcasting, fantasy viruses and wrestling round robins to gangland deaths. Woven through almost all of the videos is humour and the overarching categories of belonging, survival and power.

These videos were screened for the communities at the end of each project. In participatory film-making there are varying degrees to how much training participants will receive. While some researchers[51] will teach participants the skills needed to make their own videos after they vacate the site, others offer their expertise, but do not necessarily train participants. Believing young people should have the skills to continue to contribute to their visual material world, I trained young people in filming and editing, and in one site I donated my video camera so young people could continue producing films.

Young people also used still cameras, both digital and disposable, to engage in various projects – some planned, others impromptu – throughout the research. Giving young people cameras so they can use photography to create, for example, self-representational images, or document important aspects of their social and physical world is a popular form of collaborative or participatory inquiry commonly used in postmodern ethnographic research.

In this study self-representational portraits were entirely collaborative: young people would pick the place and pose, and either I or one of the young people would take the photo. Later these photos were downloaded into my laptop and the young people could (if they chose to) select a different background from the Internet, animate themselves engaging in an activity or, for example, integrate text into the image. More spontaneously, still photography was used throughout the project in unplanned ways. Young people would often take my cameras the moment they saw me and run off shooting images of their friends, events and, of course, themselves.

The participatory visual methods used in this research were intended to offer young people a chance to work with various media, reflect on their lives and their identities, and understand and aesthetically convey their symbolic and material world. At the same time, these methods offered me, as a researcher, a source of data which will ultimately be used to construct an understanding of youth cultural experiences, from the perspective of youth themselves.

That being said, while the intention is not to compare young people, but rather to understand the ways in which vmc is used in local places – looking at the visual material culture produced by youth, one cannot help but stumble upon broad themes. Moving from the fairly prosaic: for example, wanting to express through dance, to the more universal: say, wanting to belong, at various levels these themes and narratives reflect central human experiences and help me begin

to understand the sources of power motivating individual and collective cultural production – including the making of self, the making of other and the making of our local and global worlds.

Concluding thoughts

We do not merely see visual material culture: we live in and through a visual material culture. Yet, despite the centrality of visual material culture to contemporary life, indeed to the making of cultural life, across disciplines (and most notably in visual arts education) there is little empirical research which actually seeks to understand from young people themselves, the ways in which they, in a specific time and place, are using – that is, are living with, in and through – a visual material culture.

I have used this paper as a space to begin threading together some of my thinking about how a dynamic and relational perspective of young people's cultural practices coupled with participatory visual-based ethnography might provide insights into the discursive and non-discursive lived space(s) where youth, visual material culture and place and space intersect. I have also started to engage with the ways we might forge a link between the local lived experiences of youth and pedagogical practice – how ethnography, which makes expressive use of the visual, and which takes seriously place, space and the cultural lives of youth, might support a more relevant and youth-centred education in and through the visual arts.

I close with this: through my experience in the field, and as the data are analysed, it now seems profoundly evident that young people are contextual agents who, through local cultural practices, actively produce, navigate and use a visual material culture to shape both themselves and the world around them. Indeed, on a rather grand level, through the empirical work of participatory visual ethnography, I am convinced that for all of us – young and old (and in-between) – each moment, as we engage and interact with our world – with all forms of visual material culture and with each other – we not only transform and (re)create our visual material world, we continuously (re)create ourselves.

Acknowledgement

Financial support provided by a Northern Research Endowment Grant from the Northern Research Institute, Yukon College.

Notes

1. Marcus, G. E. (1998). *Ethnography through thick and thin*. Princeton, N.J.: Princeton University Press.
2. Hubbard, P., Kitchin, R. M. & Valentine, G. (2004). 'Editor's introduction'. In P Hubbard, P; Kitchin, R. M. & Valentine, G. (eds.) *Key thinkers on space and place*. London: Sage Publishers, p. 5.
3. While many authors separate 'visual culture' from 'material culture', I put them together to signify that all material culture is always visual, that our engagement with visual culture is not purely visual but often experienced through many modes. See Duncum, P. (2001a). 'Visual culture: Developments, definitions, and directions for art education'. *Studies in Art Education*, 42(2): 101–112; Duncum, P. (2002). 'Clarifying visual culture art education'. *Art Education*, 55(3): 6–11; Mirzoeff, N. (1998).

'What is visual culture?' In Mirzoeff, N. (ed.). *Visual culture reader.* (Chapter 1). London; New York, Routledge; Bolin, P. & Blandy, D. (2003). 'Beyond visual culture: Seven statements of support for material culture studies in art education. *Studies in Art Education,* 44(3): 246-263; Freedman, K. (2003). *Teaching Visual Culture.* New York: Teachers College Press, pages 1-2; Keifer-Boyd, K., Amburgy, P. & Knight, W. (2007). 'Unpacking privilege: Memory, culture, gender, race, and power in visual culture'. *Art Education,* 60(3): 19-24, p. 19.

4. Charmaz, K. & Mitchell, R. (2001). 'Grounded theory in ethnography'. In Atkinson, P., Coffey, A., Delamont, S., Lofland, J. & Lofland, L. (eds.). *Handbook of Ethnography.* (160-176). London: Sage (see pp. 169-170).

5. Lather, P. A. (1991). Getting smart: Feminist research and pedagogy with/in the postmodern. New York: Routledge (see p. 15 citing Lusted, 1986).

6. Geertz, C. (1973). The interpretation of cultures: Selected essays. New York: Basic Books.

7. Hall, S. (1997). 'Introduction'. In *Representation: cultural representations and signifying practices.* Hall, S. (ed.). London: Sage in association with the Open University (see p. 3).

8. See, for instance, Mirzoeff, N1(1998), pp. 3-5 and Duncum, P. (2002), (2005a) *op. cit.*

9. See, for example, Duncum, P. (2005a). 'Visual culture art education: Why, what and how?' In Hickman, R. (ed.). *Critical studies in art and design education.* (Chapter eleven, p. 154). Bristol: Intellect.

10. Greene, M. (1995). Releasing the Imagination: Essays on Education, the Arts, and Social Change. San Francisco: Jossey-Bass Publishers: p. 56.

11. Freedman, K. (2005). 'Location, location, location: What is the place of research in a period of change?' *Studies in Art Education,* 46 (4): 291-292; see also Hickman, R. (2004). 'Diverse directions: Visual culture and studio practice'. In Hickman, R. (ed.). *Art Education 11-18.* (2nd ed.), (chapter 10). London: Continuum.

12. Efland, A., Freedman, K. & Stuhr, P. (1996). *Postmodern Art Education: An Approach to Curriculum.* Reston: NAEA.

13. (Duncum, P. (2001b) *op. cit.,* Duncum, P. (2005b). 'Visual culture and an aesthetics of embodiment'. *International Journal of Education through Art,* 1(1): 9-19.

14. For example, Lai, A. & Ball, E. (2002). 'Home is where the art is: Exploring the places people live through art education'. *Studies in Art Education,* 4(1): 47-66 and Neperud, R. (2000). 'Personal journey into the participatory aesthetics of farming'. *Journal of Multicultural and Cross-cultural Research in Art Education,* 18: 67-73.

15. Buckingham, D. (2003). 'Media education and the end of the critical consumer'. *Harvard Educational Review,* 73 (3), 309-327, see, in particular, pp. 316-317.

16. Buckingham, D. (2003). *Ibid.* p. 316.

17. Dimitriadis, G. (2001). *Performing identity/performing culture: Hip hop as text, pedagogy, and lived practice.* New York: P. Lang (p. 120).

18. Barker, C. (2003). *Op. cit.* p. 41.

19. Mitchell, D. (2000). *Cultural Geography: A Critical introduction* Oxford: Blackwell Publishers, p. 63, emphasis in original.

20. Hubbard, P., Kitchin, R. M. & Valentine, G. (2004). *Op. cit.* p. 2.

21. Soja, E. (1999). 'Thirdspace: expanding the scope of the geographical imagination. In Massey, D., Allen, J. & Sarre, P. (eds.). *Human Geography Today,* (261-278). Cambridge: Polity Press (p. 261, emphasis in original).

22. Massey, D. (1995). 'The Conceptualization of place'. In Massey, D. & Jess, P. (eds.). *A Place in the World*. (Chapter 2). Oxford: Oxford University Press in association with Open University.

23. Massey, D. (1993). 'Power-geometry and a progressive sense of place'. In Bird, J., Curtis, B., Putnam, T., Robertson, G. & Tickner, L. (eds.). *Mapping the futures: Local cultures, global change*. London: Routledge. See chapter 4, p. 68.

24. Basso, K. H. (1996). Wisdom Sits in Places: Landscape and language among the Western Apache. Albuquerque: University of New Mexico Press. (Page 7, emphasis in original).

25. Thrift, N. (2003). 'Performance and....' *Environment and Planning A* 35 (2019–2024); see also Thrift, N. & Dewsbury, J. D. (2000). Dead geographies – and how to make them live again. *Environment and Planning D: Society and Space* 18 (411–432). Alvesson, M. & K. Skoldberg (2000). *Reflexive Methodology*. London: Sage

26. Warf, B. (2004). 'Nigel Thrift'. In Hubbard, P., Kitchin, R. M. & Valentine, G. (eds.). *Key thinkers on space and place* (pp. 294–300). London: Sage Publishers. (Page 298).

27. See Mark (2000) in Pink, S. (2006). *The Future of visual anthropology: Engaging the senses*. London: Routledge. (Page 53).

28. Ruby (2000) in Pink, S. (2006) op. cit., p. 49.

29. Soja, E. (1999) in Massey et al., op. cit., (see pp. 264–267).

30. Thrift, N. (2003). Op. cit., p. 2020.

31. Thomas, H. (1997). 'Dancing: Representation and difference'. In McGuigan, J. (ed.). Cultural methodologies (p. 142). London: Sage.

32. Macdonald, S. (2001). 'British social anthropology' In Atkinson, P., Coffey, A., Delamont, S., Lofland, J. & Lofland, L. (eds.). *Handbook of Ethnography*. (page 60) London: Sage

33. Fontana, A. (1994). 'Ethnographic trends in the postmodern era'. In Dickens, D. *Postmodernism and social inquiry*. (Chapter 9, p. 207). New York: Routledge.

34. See Faubion, J. (2001). 'Currents of cultural fieldwork' In Atkinson, P., Coffey, A., Delamont, S., Lofland, J. & Lofland, L. (eds.). *Handbook of Ethnography* (pp. 45–48). London: Sage.

35. Macdonald, S. (2001). Op. cit. p. 72 (emphasis in original).

36. Lather, P. (2001). 'Postmodernism, post-structuralism and post (critical) ethnography: of Ruins, aporias and angels'. In Atkinson, P. et al. (2001) op. cit., p. 477.

37. Marcus, G. E. (1998). Op. cit.

38. Heron, J. & Reason, P. (1997). A Participatory Inquiry Paradigm. *Qualitative Inquiry*, 3(3): 274–294.

39. See Pink, S. (2001). *Doing visual ethnography: Images, media and representation in research*. London: Sage; Pink, S. (2006) op. cit.; Banks, M. (2001). *Visual Methods in Social Research*. London: Sage.

40. Pink, S. (2006). Op. cit., p. 134.

41. For confidentiality all names (including town names and school/programme names) have been changed.

42. Though a participatory world-view often underpins action research, I do not claim to have carried out action research, but rather draw liberally on the underpinnings of participatory research to frame this ethnographic study.

43. Heron, J. & Reason, P. (1995). Op. cit. p. 276.

44. Lincoln, Y. (2001). 'Engaging sympathies: Relationships between action research and social constructivism'. In Reason, P. & Bradbury, H. (eds). *Handbook of action research: Participative inquiry and practice*. See p. 128.

45. *Ibid.*, p. 129.
46. Lincoln, Y. (2001). *Op. cit.*, p. 128; Heron, J. & Reason, P. (1995). *Op. cit.*, p. 281.
47. Pink, S. (2001). *Op. cit.*, p. 7.
48. See Edwards, E. (1997). 'Beyond the boundary: A Consideration of the expressive in photography and anthropology'. In Banks, M. & Morphy, H. (eds). *Rethinking Visual Anthropology*. (Chapter 3). New Haven: Yale University Press.
49. Pink, S. (2001). *Op. cit.*, p. 11.
50. Hickman, R. (2005). *Why we make art and why it is taught*. Bristol: Intellect, p. 103, emphasis my own.
51. Such as Grace, D. J. & Tobin, J. (1998). 'Butt jokes and mean-teacher parodies: Video Production in the Elementary classroom'. In Buckingham, D. (ed.). Teaching Popular Culture. London: Routledge.

5

'WHEN IS YESTERDAY COMING AGAIN?' THE IMPACT OF ARTS-RICH PARTNERSHIPS IN EARLY YEARS' EDUCATION

Anne Bamford

Introduction

The title of this report, 'When is yesterday coming again?', comes from a quote from one of the young participants at Greenfields Children's Centre. The child asked the teacher the question, 'When is yesterday coming again?' as she did not know the word for artists, nor could describe in language the collection of experiences that the artists brought with them into the environment, she just knew that when 'yesterday' (the two artists and the activities they did) was within the centre it was something exciting and something definitely to look forward to. We hope that the pilot project, *Creativity Matters*, continues within early years settings to ensure that 'yesterdays' are a key feature of the tomorrows of all young children.

Creativity Matters is a partnership project between Ealing Council and The Engine Room, Wimbledon College of Art, University of the Arts, London to determine the impact of embedding creative professionals in early years' education.[1] Initially, it involved four settings, but in its second phase this has been expanded to include a total of nine settings plus associated partners. In each setting, both teachers and artists receive professional development into issues surrounding children's creativity and the multiple languages of children. An artist (or team of artists) is placed in each setting for approximately two days per week to work with teachers, children's centre professionals, the children and their families and communities.

Aspirations and endeavours

Creativity Matters promotes the creative capacity of children, increases the children's and community's access and engagement in the arts, whilst providing high-quality participatory arts

and promoting children's cultural citizenship. Involvement in the project acknowledges the experiences, skills, passions and gifts of children, practitioners, artists and other creative and education professionals.

Creative expression and the arts are ideally suited to providing the means for children's cultural citizenship and educational potential to be developed and extended. The project gives high priority to issues of future literacies, communication technologies, community acceptance and involvement at a personal, local and national level. Furthermore, high-quality arts involvement in the early years appears to have positive benefits on children's transition into formal schooling and improve educational outcomes. While international research[2] highlights the significance of high-quality arts and cultural education, there has only been limited research into the effectiveness of young children's creative engagements in child-centred arts activities and the way the arts operate within the lives of young children to support and sustain social connections. These connections between learning, family and culture are considered vital for the development of sustainable future communities.

Creativity Matters redresses this gap within arts and educational research. Through the combined effort of researchers, practitioners, artists, community and creative professionals – in the fields of the arts, education, architecture, design and curators and museum educators – *Creativity Matters* provides an excellence model for arts and cultural-based learning involving an integrated 'partnership' approach to programme policy and development locally and at a wider level. Within *Creativity Matters* the learning environments and programmes are designed in partnership with creative professionals and place creativity at the centre of early childhood learning. To accompany these programmes, an extensive practitioner-led and family learning research model is employed to document the benefits and outcomes of children's creative and playful engagements. In particular, the research tracks the impact of high-quality creative partnerships within early years' programmes and analyses the practices, pedagogies and processes that generate innovative and interactive creative programmes for young children. Key to this research are the principles and philosophies for engaging and acknowledging children's ideas and voices in creative programmes and policy.

The arts should be an important part of the education of every child and that this should involve all types of education, not just that available through the formal school system. Research conducted within the primary and secondary schools, both within the United Kingdom and internationally, demonstrates that the arts can inform and support other sectors of the community and, in so doing, build social and cultural capital.[3]

The contention of *Creativity Matters* is that creative expression and the arts are ideally suited to providing the means for children's cultural citizenship and educational potential to be developed. *Creativity Matters* acknowledges the differences and similarities in experiences and outcomes according to gender, race, cultural background and age. For example, while there is widespread acknowledgement in the field of differences in working with girls and boys, there is very little research on this issue and it is rarely acknowledged or addressed in programmes designed for young children.

It is recognized that for changes to occur in young children, there needs to be impact on family, teachers and/or community change. Through the combined effort of researchers, teachers, artists, community and creative professionals in the fields of the arts, education, architecture, design and curators and museum educators, *Creativity Matters* develops a model based on an integrated 'partnership' approach to programme, policy and development by educators, community, artists, businesses and local government.

Key tenets

The following set of key principles are applied to all aspects of the project from design of physical spaces and learning environments, through to the programmes initiated, teacher professional development and the research conducted:

- Mass media and interactive communication impact on the lives and identity of all children and their community
- In a rapidly changing world, everybody needs to be agents of change
- Generative tensions and risk-taking build critical thinking skills and imagination
- Working across boundaries and breaking the rigidity of boundaries prepares people to learn and change
- Democratic and flexible learning environments promote individual and cultural learning goals
- Artists and creative professionals are collaborators and colleagues in the educative process
- Creativity occurs in a climate of partnership, not spectatorship
- Learning is joyous
- Meaningful play develops inventiveness, problem-solving and creativity
- Creative people communicate in fresh, new ways
- Creative experiences build social cohesion
- A process of cognitive and affective transfer occurs when engaging in the arts and creative explorations
- Partnerships build leadership and vision
- Effective planning is part of learning
- Sustainability is built through broad-based community representation
- Public awareness and communication is part of sharing discoveries
- Learning is site-specific and context driven
- Time and space is needed to develop strong and lasting learning partnerships and
- Reflective journals hone critical thinking skills.

Context

Creativity Matters exists in a global context where efforts are being made to enhance the quality of early childhood education by building creativity. Quality education implies more than the cognitive development of the child. Effective early years' programmes should build values and attitudes of responsible citizenship by nurturing creative and emotional development.[4]

To achieve this development, children need to be placed in creative learning environments and supplied with resources and opportunities that encourage play, critical thinking and risk-taking. They also require programmes that are child-friendly and provide occasion for guided practice and independent learning. Furthermore, early childhood programmes seem to be most successful where there are strong links between government and community bodies and the child is placed at the centre of service provisions.

UNESCO[5] identifies a number of enabling inputs that enhance the quality of early years' provisions. These include teaching and learning methods, physical learning environments, human resources and management and administrative structures. This broader view of early childhood provisions acknowledges that learning takes place in a social and political context. There is also strong evidence to support the view that better early childhood programmes lead to improved cognitive and social outcomes and greater educational achievement. This is particularly the case with children from disadvantaged backgrounds. Research undertaken by the UNESCO Institute for Statistics indicates that children from the poorest backgrounds benefit most from quality early years' programmes, and yet they are most likely to be excluded from it.[6] Quality early years' provisions tend to be biased towards more affluent households. Associated with this is the issue of teacher qualifications. The UNESCO study also found that well-qualified early years' teachers and workers who received ongoing professional education were likely to be the most effective practitioners and have the greatest impact on the children's learning. UNESCO further suggests that certain policies build better quality programmes in the early years. These include an inclusive design that supports diverse learners; teaching practices that are structured but child-centred; strengthening of knowledge flow and creative partnerships; cultivating teacher professional development and leadership management and sustained evaluation of quality and impact. Placing the learner at the centre, UNESCO offers a model where effective learning and teaching emerges from an enabling environment and effective education policy.

Internationally, education has turned its focus on the of role creativity in enhancing learning. Partnerships between schools and artists animate and enrich learning and place creativity at the centre of the learning process. By working with creative professionals, children and educators gain self-confidence and enjoy being creative.

Ken Robinson[7] argues that in order to meet the challenges of the future, children will require a creative education that builds their capacities to generate original ideas and actions and enables them to engage positively with the growing complexity and diversity of ways of living. He further contends that creative education is most effectively achieved where curriculum stresses the arts and humanities and teachers are mentored in creative and cultural education through partnerships with creative professionals.

Economic activity in the future is likely to be driven by innovation and knowledge and the ability to be creative will prepare us for change. The All Our Futures report[8] sets out a vision for education that places creativity at the heart of learning. Studies in both the United Kingdom and internationally have shown that programmes centred around creativity and involving

creative professionals increased the standard of academic achievement, built children's self-esteem and confidence, improved school attendance, developed language, promoted desirable student behaviour, supported different learning style and improved community links and perceptions of education.[9]

Studies conducted within United Kingdom schools[10] indicate that where artists and creative professionals form part of the learning community, the children are seen to be: confident; focused; independent; open; excited; proud; enthusiastic; aesthetically and bodily aware; socially cohesive; and cooperative.

These indicators have been widely reported from the school sector, but there is less research to confirm that the same impacts are likely with young children. It is often anecdotally reported that early years' settings may be better at reaching creative learning outcomes than formal school processes. Once again, though there is little evidence to either confirm or deny this perception. Within policy for early years and school-age education, creativity is a widely reported desirable outcome. Unfortunately, though, it would appear that often the lip service given to creativity within curriculum statements is rarely matched by high-quality 'coal face' practices within early years' settings or school classrooms. Perhaps the gap between planning an implementation is explained, at least in part, by the confusion surrounding notions of creativity.

What is Creativity?

The *All Our Futures Report* defines creativity as being imaginative activity producing outcomes that are both original and of value.[11] It is assumed that all people are creative and capable of creative achievement if they are placed within conditions that encourage them to acquire the disposition, skills and knowledge to act creatively. The creative process can be considered as a two-phase process. Generative thinking creates a range of options which are then assessed and enacted through evaluative and reflective judgements. Creativity can exist in all forms of learning, but is particularly developed within and through the arts. Being creative is an emotional and intellectual undertaking. The best creative work occurs in an environment where there are no right or wrong answers.

In England the curriculum for Nursery provision is based on the curriculum guidance for the foundation stage devised by the QCA (Qualifications and Curriculum Authority). The QCA is a non-departmental public body, sponsored by the Department for Education and Skills (DfES). Creative Development is defined in the Foundation Stage Curriculum as one of the six areas of learning. The curriculum gives an introduction into the importance of Creative Development, stating in the first sentence that 'Creativity is fundamental to successful learning'.[12] While clearly apparent in policy documents, it is less clear the extent to which sets of actions that would promote creativity are enacted within the early years and foundation settings.

Creativity Matters is certainly not a lone voice in prompting the creative development of young children. There are several approaches to early childhood learning – both within the United Kingdom and internationally – that have directly influenced the structure and design of

Creativity Matters. These philosophical and methodological influences can be summarized as follows:

Aspects of the Reggio Emilia approach evident in the design of *Creativity Matters* include:

- Recognition of the importance of environment as a 'teacher'
- Acceptance of multiple forms of symbolic languages to communicate meaning
- Detailed reflective documentation as assessment, impact research and as advocacy
- Sustainability through long-term projects
- Teacher and child as researcher and
- Strong parent/community/school relationships.

Aspects of the Montessori approach evident include:

- Acknowledgement of a child's responsibility as an active learning creator and
- Importance of the provision of suitable learning resources within a child-centred environment.

Aspects of the Effective Early Learning Programme evident include:

- Systematic and rigorous evaluation
- Extensive documentation from a variety of sources
- Action planning based on data collection and
- Ongoing reflection and quality assessment.

Arts Play (Australia) is an early childhood museum project that influenced *Creativity Matters* through:

- Valuing the role of family and the community in creative learning
- Purposefully designed and created physical environment and resources
- Sustained longitudinal evaluation and
- The use of arts-based and family learning methods of data collection and evaluation.

Within the United Kingdom and international context several linked projects have been undertaken with school-aged children. These projects have informed the design of *Creativity Matters.*

Creative Partnerships UK has informed the design of *Creativity Matters* through:

- Working with creative professional as true partners in the learning process
- Establishing clear aims and objectives
- Advocating context specific programme design
- Articulating clear descriptions of the roles of the creative professionals

- Sustainable resourcing
- Building of long-term creative relationships and
- Mentoring of teachers and artists.

The Chicago Arts Partnership in Education CAPE (UK and USA) influenced the design of *Creativity Matters* through:

- The involvement of professional artists as partners in the educative process
- Detailed documentation and reflection and
- Centring of the arts in the learning process.

The Education and Arts Partnership Initiative EAPI (Australia) influenced the design of *Creativity Matters* through:

- The involvement of high-quality professional artists and creative practitioners from a range of cultural backgrounds
- Context specific programme design
- Collaborative planning models
- Leadership and professional development
- Centring of the arts in the learning process
- Holistic assessment and
- The use of reflective journals.

Methods

The *Creativity Matters* project in Phase 1 involved 260 children; seven artists, forty teachers and early years' professionals, three researchers and research managers, sixteen young people as research documenters, two Borough administrators and officials and many community members and parents. Currently, a further nine settings are involved as part of the Phase 2 research. As Phase 2 is underway at the time of writing and not yet subject to full impact measurement, it will be the results of Phase 1 that will be the focus of the observations contained in this chapter.

At the heart of the project lies the need for collaborative, reflective approaches where educators, creative professionals, children and families can explore, take risks, permeate boundaries and share ideas as part of the creative process. Embedded in the philosophy of the four centres where the research is based in Phase 1 is acknowledgement of the value of each individual child with the shared commitment to see him/her reach their full potential. Each centre recognizes that for changes to occur in young children, there needs to be impact on family, practitioners and/or community change, and this has been a core component to the planning of the project implementation.

The research methodology is multi-focal and multi-vocal, thus allowing multiple points of view to be explored. Of particular interest continues to be the views and voices of children, parents, artists, practitioners and policymakers. A mixed-methods approach is used to collect and collate

the data. Quantitative data has been collected to provide information about demographics (age, gender, ethnicity, home language and suburb) and perceptions (preferences, likes/ dislikes, attitudes, values) and to track impact. Qualitative data has been collected to provide rich descriptions of arts and play engagements of *Creativity Matters* participants.

Conceptually, the research was framed within ideas of communities of learning and family research practice. Everyone within the project was a learner, a teacher, a researcher and an artist. This philosophical underpinning impacts on all participants and the research team in terms of the way authority and positioning is negotiated, especially in terms of foregrounding children and artists as active researchers and creators of meaning. The involvement of children and the young people as documenters enables significant data to be uncovered and acts as a catalyst for a number of artistic and learning opportunities to occur.

Both social science and more innovative, artistic approaches have been used to gather data. Traditional approaches include the use of interviews, questionnaires, surveys, photographic documentation and policy/literature reviews. The more innovative approaches include the use of new technologies and co-researcher activities in gathering data, documentation and data analysis, including artistic approaches such as photography, drawings, dramatization, digital animation and film-making. Technology such as digital cameras and electronic whiteboards are used in the recording process and artists are key documenters through photography, video and animations.

All participants, including young children are given the opportunity to create visual, verbal and/ or written reflective journals. The project framework includes the involvement of creative practitioners as a way to foster young children's cultural and recreational engagement. The term 'creative professional' has been used – in place of the more usual 'artist' – to imply the 'embeddedness' of the artist as a totally contributing member of the early years' setting team. This differs from what is generally described as 'artist-in-residence' type projects as the artist is not there with the main aim of producing artefacts or to work solely with the children, but is rather considered to be an early years' team member and part of the total operation of the setting. The creative professionals adopt the mantle of artists, educators, researchers and learners at different times throughout the programme. The artists are active researchers and documenters, sharing creative approaches with children, families and staff. Conversely, early years' staff actively develop more 'educational' orientations towards the inquiries of artists and the children.

Evaluative Research Design

The distinctive qualitative, visual and reflexive research and evaluation design builds partnerships between artists, teachers and researchers to extend knowledge in three important areas:

- Building a detailed understanding of the impact of education and arts partnerships within an early childhood context;
- Ascertaining benchmarks and evaluative parameters in education, arts and cultural programmes;

- Providing a benchmark for future longitudinal studies into the educational and cultural benefits of arts programmes for children.

Furthermore, the use of practitioner research, reflective journals (including children's visual journals), arts-based methodologies and community research:

- Provides a different type of evidence and analysis to that available in existing studies;
- Explores narrative and visual methodology in a practice-related context;
- Develops research methodologies for conducting qualitative studies of young children's engagement in the arts and creative learning;
- Builds the professional learning and reflective capabilities of early years' teachers and workers.

Evaluative research of this kind is significant because data may provide indicators of sustainable effects of innovative community engagements on children and families, and aligns with national/international trends focusing attention on children's engagements with art, play, recreation and culture.[13] Data gathered provides baseline information about policies and practices of early childhood programmes and reveals a range of information about participants (artists, educators, children, families, policymakers). This project and the associated research enables the establishment of a core databank of information about long-term changes in personal, cultural and social engagements through sustained civic cultural activity as part of early childhood.

Creativity Matters adopts an ecological perspective whereby children are viewed as part of dynamic social and cultural systems (i.e., family, community, society and global). Within this framework, the following seven key research questions form the core of the design and implementation of the project:

How do creative partnerships nurture and promote children's cultural citizenship?
What are the broad benefits and outcomes for families, school and communities of young children's creative engagements?
How do child-centred practices support and sustain social connections?
How do early years' programmes develop and sustain dynamic creative partnerships?
What are the practices, pedagogies and processes that lead to innovative and interactive early years' programmes?
What are the principles and philosophies for engaging and acknowledging children's ideas and voices in research, programmes and policy?
How does a partnership of arts and education agents affect innovative arts and cultural policies and practices?

Preliminary findings

The preliminary findings indicate that substantial benefits were received by the children, young people, practitioners and artists with some impact on family and community; each is reported separately below.

Impact on Children

Creativity Matters increases the children's levels of curiosity especially in terms of their initiative and ownership of ideas. The improvements in levels of curiosity resulted in increased sharing of learning with parents. This is evident in a number of comments from parents such as 'the children are getting more curious about the clay and its texture and why it is soft etc. I have gotten more involved over time and there is a lot to talk about and explain, and the children get involved and ask questions'. Related to this, the children participating in the project show marked improvements in their levels of confidence as indicated through initiative and engagement in making experiences. This confidence is demonstrated through increased interactions with adults and initiating collaborative experiences with each other. The children make connections between experiences including the memory of previous experiences and the linking together of ideas and concepts.

The children are engaging in an increased amount of making at the Nursery and in the home and are more purposeful in their making. Before the project they had independence within a directed task, now they are planning and designing the task. It also provided opportunities for children to be more fully engaged in their learning, regardless of background or ability as indicated in the following comment:

> We have become so excited about the project, anticipating and waiting. The children are getting so much out of it. For example, Jasleen in ten years' time will probably take on something in design. I watched her in the project. Watching them being engaged – the language and the skills – and they are very confident. Their [the children's] confidence is evident in their interactions with the artists and how they ask about it the next day. I can see it in the children's discussions with the artists. Jamie, for example, has had speech and language difficulties. His language is progressing and he is very engaged in the project.

There have been changes identified in children's use of multiple languages and their community understanding as indicated through an increased sense of cultural understanding and diversity. The project has provided collaborative experiences for children to develop their sense of self and an understanding of their peers. In particular, the children's sense and exploration of space has developed. The following comment from a practitioner shows the way the children are expanding their modes of creative work and the influence this is having on changing the practitioner's view of the nature of creative practice:

> I am seeing more collaboration between the children and the sharing around the resources. The children are given opportunity to explore more, using adult materials more, not reducing our work to a catalogue. It's about opportunities. It is about resources, learning where the artist gets these from and sustaining this.

While not initially considered at the outset of the project, the children have demonstrated high levels of concentration in their participation in the project. It was previously thought that very young children would lack the length of concentration needed to engage in sustained art-

making, but this has not been the case, with children pursuing their art-making over a prolonged time, as indicated in this observation made by an artist:

> Their memory is good, and I have been very surprised. They remember things we did a long time ago and we had talked about where the structure would be and they also remember things from the initial visits and the walks that we did.

The children demonstrate an increased ability to remember previous experiences and to link together ideas, making connections. This is reinforced through the increased amounts of sustained shared thinking and collaborative art-making conversations that are occurring.

Impact on the Adolescents Documenting the Project

Documentation of arts projects can be a challenge. The tendency is for those involved in the project to become so enthusiastic about doing the project that documentation is neglected. Anyone who has been involved in any sort of innovative arts or educational experience will relate to this problem! *Creativity Matters* was no exception. While practitioners, artists and children were all intended to be active research documenters, it is reasonable to say that this process was intermittent. The more exciting the aspects of the programme were, the more likely it was that documentation would be overlooked in favour of deep involvement in the creative task. This is entirely understandable and perhaps even desirable, but to address this issue, South Acton Children's Centre developed a very innovative addition to the *Creativity Matters* programme.

The highly successful strategy was to engage teenage students from the local high school as research documenters. This involved a group of students who were undertaking the 'media studies' course photographing and documenting the children's participation in the project. These young people were generally not high-achieving students and were marginalized learners. The positive effect is clear within this reflection from one of the early years' practitioners:

> I would have like to have gone to the high school and worked with them. It's important that they [the young people] have people that respect them; it's not a miracle cure to their challenges but could have an influence. I felt this project would have been good for children who have been excluded.

The output of the work included wonderful photographs, an exhibition and a large format book. Their involvement resulted in clear changes to their personal demeanour and approach to learning. They greatly improved in terms of confidence and preparedness for work; developed advanced photographic skills; and, increased their aspiration levels for both education and employment. The experience of the local high school students has evoked a desire to have their art-making critiqued professionally, seeking advice on how to improve.

The links with the local high school provide a tangible, cost-effective relationship between the two educational institutions and supports the opportunity for role modelling and 'sense of

community'. As some of the high school students had siblings in the early years' setting or had themselves attended the centre, family learning and multi-age learning emerged from their involvement. The group of adolescent researchers and documenters contained both boys and girls. In this way, the links with the local high school has positively challenged perceptions of gender at the centres involved, as indicated in the following comment:

> The boys here need more play; one practitioner felt that this was important that the high schools students be involved as gender is a big issue in our schools. She felt that practitioners should do more of the interacting with the high school children and they were so very polite I thought. These were all children that had been excluded. When they arrived I would greet them. By the end they could greet us and look at adults and basic sense of things that made them feel proud. We called them by name. I think that generally they are not treated very nicely in school.

The involvement of the young documenters led to a number of discussions related to masculine role models within the arts and early years' provisions and positively highlighted the gendered nature of many educational practices by opening ideas about kinaesthetic learning and male-oriented learning styles, such as is evident in this comment by a secondary schoolteacher who accompanied the children to the setting:

> At the other centre the boys who were involved were very liked by the children and were walking around with children attached to their legs.

The young people reflected negatively on their own 'school art' experiences and how the more flexible nature of documenting the project opened up new creative possibilities:

> [Names school art teacher] tells us we have to go and do our own ideas, and then comes and tells us to change it and then does it for us! Here we are free. She [artist] told us what to get pictures of and we made our own decisions.

The young people valued more creative ways to work, saying that 'if there wasn't creativity everything would be a boring plan'. Similarly they commented on how their own school experiences could have been improved: 'I would tell teachers to interact with the children better and not to shout at the children.'

Impact on Practitioners

In early years' settings there is a range of highly qualified, semi-qualified and unqualified staff. There tends to also be differing ages, skills levels and roles within the settings. The inclusion of the artists within the settings and the promotion of an art-rich programme in most instances led to a blending of these roles and provided informal professional development at all levels. In particular, *Creativity Matters* initiated a re-igniting of the practitioners' self-interest in the arts and practitioners' own approach to creativity within and across the curriculum. This is evident in this comment from a practitioner:

I have thought of things myself and make things myself and have brought them in to work with the children. It has made me used more tools at home like saws and drills that I wouldn't have. From seeing Liz [artist] I thought 'I really like this'... I was creative before but didn't think I was allowed to, or thought of it. Now I can do it and I love making stuff.

Staff demonstrated increased enthusiasm to initiate, offer and implement creative ideas and support and collaborate with each other. Some changes were also identified in the way practitioners view the availability of resources. A significant outcome of *Creativity Matters* was the manner in which working collaboratively with artists impacts on the way practitioners see and relate to – and plan for – the children. The early years' setting staff acknowledge that 'artists' have a different way of seeing the children.

The early years' practitioners viewed the project as a successful and connected means of delivering early years and foundation curriculum. To support this view, across all centres there was a unanimous preference to employ an artist over a practitioner (teacher) if given the choice. In line with what international studies of school-based programmes suggest, staff made voluntary changes to the hours that they work, generally working longer and more enthusiastically than before the programme. It has to be acknowledged, though, that practitioners within early years' education tend to be dedicated and the teachers and other practitioners involved in *Creativity Matters* were no exception. Interestingly though, staff have made voluntary changes to their own lifelong learning, especially increasing their visits to cultural sites (such as galleries and museums); explorations of the local area and culture; and, their personal creativity and art-making. For example, the staff undertook visits to significant cultural sites that they had not previously done:

I wouldn't have gone to the Tate Modern if it wasn't for being at Maples [children's centre]. I actually enjoyed it and it opened up my eyes to so much more. It's about taking the time thinking, and now realizing I should have brought my son to things like this when he was much younger.

Importantly, the staff continue to report higher levels of enjoyment in their work. They also have changed in terms of their responses to the children and to their own creativity, as indicated in the following:

I always thought of creativity as painting and drawing. At school I thought I couldn't do art. I am thinking a bit more creatively as well, thinking freer. I am a 'boxes – one way' thinker, now I am trying to link more things together and changing the way I am with the children. I am changing in the way I think I am talking and verbalizing things with the children, for example, I am no longer saying 'and what is that', it's more flowing and I might say, 'and what could you do with that?' My tone has changed with the children, it is a softer tone of giving and awe and wonder. When I use my voice I am more at their level and get down to their level more with eye contact. I am listening more and giving them time. I don't want children to be in the position I was in and have that fear factor. You can make someone feel good or that it is not worth it.

From the outset, it was the expectation of the practitioners that the presence of the artist within the settings would 'bring' greater creativity to the centre. The learning between the artists and practitioners was reciprocal. For example, practitioners had an expectation of how the artist would relate to the children, while the artists approached learning and collaborations with children in a different way. The practitioners valued the days in between the artists' visits as an opportunity to sustain and extend children's experiences. This allowed some of the more tentative practitioners to explore and develop their own creative practice in relation to the work of the artists, often adapting, extending or continuing the artist-initiated activities.

Across all centres there was a unanimous perspective that the project was not 'more work' but a more interesting way of work that they would like to sustain. At the same time, there is a genuine fear expressed by the early years' practitioners about the future of the children experiencing creative possibilities of this kind, and how children's approach to learning might be received by teachers in the primary school system. It would be reasonable to say that the practitioners feel confident that young children are getting an integrated creative education in the settings, but feel that this will not be the case in the future where the children will be stifled by the formal school processes.

Impact on Artists

A number of educational programmes around the world have looked at the impact of the involvement of artists in a range of educational settings. Such studies tend to focus on the impact the artists have on education. While that was a significant part of *Creativity Matters*, it was equally important that we could develop a model of artistic practice embedded within a larger notions of the artist as proactive social agent actively generated (or perhaps re-generating) a society's or community's cultural capital. An emerging view of practice as a social act is apparent in this comment from one of the artists:

> Over the last ten years I have instigated and developed a series of projects that might loosely be classified as works of 'visual sociology'. These are generally collaborative and involve working closely with communities, often at a liminal point in their socio-historical evolution. My role as an artist has been to re-present aspects of the individual and of the group experience, thus bringing the dialogue into engagement with a wider audience. I have explored issues of group and individual identity and the different ways in which they become manifest.

The artists within *Creativity Matters* all saw working in context and collaboration as part of their artistic practices, as is suggested in this observation by an artist:

> Some of our ideas, methods and materials seemed to open up areas for new specific ways of working in the future, just as we were informed and enlightened by their specific knowledge in the ways of engaging with pre-school children.

Despite this background, the artists were still very surprised by the extent of influence that the project had on their artwork, in a positive sense. The artists developed new models of

collaborative practice and through engagement with the children, the artists began to question notions of materiality and performativity in their art-making practices. There appeared to be a strong sense of reciprocity between the artists, the children and the practitioners, as evident in this comment:

> The children have made good relationships with Liz (artist), talking to her, watching her work, asking if they can use her tools. She interacts with them really well and she will stop and help them to get involved and find ways for them to get involved. She takes time explaining about her tools and what does what.

The artists responded positively to prolonged engagement with the early years' settings and have continued to collaborate with the centres after the formal ending of the pilot period. The artists have developed greater levels of reflective practice and expanded their research and documentation skills.

Impact on Parents and the Community

Parental involvement at three of the four pilot centres was less than practitioners had anticipated. At the outset of *Creativity Matters* it had been a desire of all people involved to make the boundaries between early years learning within the setting and the family and community context more permeable. This is proving to be a slower and more complex process than anticipated and certainly ways to move from informing to involving parents continue to be explored. The settings expressed a level of frustration at trying to encourage parental involvement:

> I have had some frustrations about the lack of parental involvement. I think that when they see the sculpture up they'll 'get it'. It amazes me that they haven't so far. We put information about it in the newsletter and we talk about it at the door inviting them to go through and see what Liz the artist is doing today.

Future programmes will involve the children more directly as conduits for encouraging their parents to become more closely involved with the arts learning. Several parents made suggestions about how parental involvement could be enhanced:

> Running talks might be useful for increasing parental involvement, and doing some workshops to get them seeing and doing together. It would also be good to get the artists to work with the parents, to get them involved in a casual way, hands on and able to chat while doing. I would have liked to have worked with her [artist] full stop, to be her sidekick.

In what would be described as 'working-class' or marginalized geographic areas, interviews with parents revealed that interest in arts and cultural development is not a middle-class phenomenon. Parents link art experiences to 'creativity' and consider creativity to be a vital survival skill that is important for their children's future. The parents felt that the arts might provide their children with the ability to deal with the life's challenges in the context of high-crime communities.

Challenges

A considerable amount of arts education research is tantamount to pure advocacy as there is often a connection that is far too direct between the funding body and the processes of evaluation and reflection. Similarly, research in the arts is often characterized as being overly descriptive with only limited critical analysis. Such research does little to enlighten practitioners as the lack of open sharing limits the capacity for collective learning within the arts education community. In a climate of collegial sharing and as an acknowledgement of the importance of research an activity that goes beyond uncritical 'answering of questions', this section discusses some of the areas that emerged as challenges and contested areas within the project.

An interesting conundrum within *Creativity Matters* (and it could be argued many other arts and education reform programmes) is what happens to students if their experiences of such programmes are intermittent throughout their education? Specifically, once a child has experienced arts-rich education, how readily could they cope with less rich education? As one parent noted, 'Is it worth taking them out of the box [when they are just going to go back into the box once they start school]?' This question was also voiced by both practitioners and artists. We need to consider the impact of this programme at different stages of a child's development. It is also important to assess the value of continuation of the programme into school education. It has often been said that a child's early years are wonderful and that the process of going through school effectively serves to reduce a child's creative potential.

The reverse side of the debate is a view that perhaps in the early years, children should not be extended as then later experiences of formal education may be boring and not stimulating. Consider these two examples suggesting that children should be (albeit by default) in the box. The first comment is made by a practitioner and the second by a department manager:

> We don't teach all that ICT in the Nursery years because otherwise they will know it all when they reach reception and year one and they will be bored.

> We don't want everyone to succeed, or else who in life will do the mindless and menial types of roles like cleaning etc.

Clearly such comments raise issues about the supposed limitations within both our education systems and more broadly within society. This is the context in which arts education is occurring and it is incumbent upon the proponents of reform to consider such factors.

A further challenge, as alluded to earlier, was to promote a culture of reflection and research within the practitioners. The declaration of 'reflective practice' was apparent at all four centres but not visible. Certainly, reflections were taking place for all staff at all levels, but the extraction, articulation and sharing of these did not occur at the level that may have been expected.

The life of most teachers, educators and artists tends to be dominated by the time needed to make or deliver. This rarely leaves time or space in the day to reflect on actions. If these reflections do occur, the reflective thinking remains relatively private and is not revealed in a

format that would allow for sharing with – or valuing by – others. The structure of *Creativity Matters* asked the practitioners and artists to make formalized reflections (though a range of creative media such as photographs, video, journals and so on).

For many of the professionals participating in the project this was the first time they had stopped to reflect deliberately on their own thinking. Unfortunately, though, these reflections were often only reported to the research team and were not shared with their peers as a resource for developing shared thinking, and also not shared with managers who could have picked up on opportunities to scaffold new thinking arising within practitioners. In future programmes it is important to consider what it means to be reflective. Greater provisions need to be made for training reflective practitioners and for forums for sharing learning. To address this issue it may be possible to create a workforce of researchers who research themselves, their peers and their neighbours within their context. As art education has traditionally lacked evaluative discourse, such training would be of immediate benefit to the discipline as a whole.

The walls of a classroom have no mirrors, other than the mirrors in children's eyes. These mirrors are tiny and so often wonderful practices are neither revealed nor communicated. Communication is different from information, yet despite extensive information strategies, parents from three of the four settings were generally not 'aware' of the project. Arts-rich programmes need to be highly visible, so an ability to be able to articulate the core elements of a programme and to be able to communicate experiences across diverse audiences is a vital element underpinning success.

At the outset of *Creativity Matters* there was a philosophical foundation that states that all participants in the project will be artists, learners, researchers and participants. How these roles develop appears to be largely dependent on the level of ownership the individual takes within the project. The entering disposition might also impact on whether an individual sees his or her self as existing at different times within all the various roles. Some of the practitioners think that things and events are happening 'to' them and others see themselves as learners and contributors within contexts. The active contributors view themselves as learners and providers of the project. Generally it was more likely that the artist would adopt the various roles (learner, research and so on), while the teachers seem to remain quite fixed within their role as teacher or practitioner.

Above and beyond all the challenges mentioned to date, the impact of leadership appears to be paramount. Leadership capacity, at all levels has a direct influence on the effectiveness of an arts-based programme. Leadership, especially within the early years' setting largely determines communication, project progress and profile. Concurrently, participation in *Creativity Matters* seems to develop leadership capacity within practitioners. This burgeoning capacity may provide a sustainable forum to articulate knowledge of practice and enhance future leaders in arts education.

Conclusions and continuance

Creativity Matters provides new models for community-based, arts partnership programmes for young children. It appears to be a highly effective way to improve children's learning and social

skills in the early years. Furthermore, the project has had generally successful outcomes for early years' practitioners and artists and improved links to other educational providers, especially the links between secondary school, higher education and early years' centres. The project encourages greater use of cultural and community facilities and made some improvements to models of family learning and community sustainability. Future directions should highlight greater community involvement, recognition (and accreditation) of practitioner learning and opportunities for sharing of practice, especially for artists and practitioners.

Creativity Matters provides a unique opportunity to document the impact for families, schools and communities of children's creative engagements in early years' child-centred arts activities. Creative strategies and partnerships in arts and early years' education can foster, develop and sustain dynamic learning environments. Aligned to the project, a programme of practitioner research continues to provide ongoing longitudinal data and develop research potential within the early childhood workers and community.

Creativity Matters continues throughout London. It is hoped that once all three of the project evaluative phases are complete it may be able to be expanded to cover even more early years' settings. In this way, perhaps all children's yesterdays will be as good as their tomorrows.

Acknowledgements

This paper is a direct collaboration with the team at The Engine Room with special thanks to Sally Dennis for her high-quality research and inspiration. *Creativity Matters* is a partnership project that could not have occurred without the commitment and expertise of all the artists, teachers, early years' professionals, parents, community and children.

Notes

1. Arts Council of England (2004). *Exciting Minds*. London: Creative Partnerships.
2. Bamford, A. (2006). The Wow Factor: Global research compendium on the impact of the arts in education (Berlin, Waxmann Verlag).
3. *Ibid.*
4. UNESCO (2004). Education for all: The quality imperative (Paris, The EFA Global Monitoring Report Team).
5. *Ibid.*
6. *Ibid.*
7. Robinson, K. (1999). *Out of our minds: learning to be creative*. London: Capstone.
8. National Advisory Committee on Creativity (1999). *All our futures: Creativity, culture and education*. London: DES.
9. Arts Council of England (2004). *Op. cit.*
10. *Ibid.*
11. National Advisory Committee on Creativity (1999). *Ibid.*
12. See http://www.qca.org.uk.
13. See www.unicef.org, www.ozco.org.au and www.culturalpolicy.org.

Additional Resources

Access Art www.accessart.org.uk

Arts Council England www.artscouncil.org.uk

Creative Learning Agency www.creativelearningagency.org.uk

Creative Partnerships www.creative-partnerships.com

Centres for Curiosity and Imagination www.curiosityandimagination.org.uk

National Grid for Learning www.ngfl.gov.uk

QCA National Curriculum in Action www.ncaction.org.uk/creativity

6

Daily Life: A Pre-service Art-teacher Educator and her Work

Lynn Beudert

The pre-service college or university-level classroom is an important teaching and learning environment; yet few researchers study this classroom setting.[1] How do art education faculty, especially those who are involved in preparing future art teachers, go about their jobs? What are the intellectual, emotional, and physical undercurrents of this work and how might these qualities be reflected within the daily context of the pre-service university or college-level classroom environment?

This paper is an exploration of part of daily life of a faculty art-teacher educator. I was fortunate to spend a sabbatical year in the art education programme at the University of British Columbia, Canada. It was not only an exciting year during which I had a marvellous opportunity to interact with excellent colleagues, but I was also presented with a once-in-a-lifetime opportunity when one of these colleagues allowed me to become both a student and participant observer in her secondary art education methods course.

The art educator in question is Dr Kit Grauer, a professor in the Faculty of Education at the University of British Columbia. An award-winning university level teacher (also with vast kindergarten to twelfth-grade school-teaching experiences), Dr Grauer has been honoured for her teaching and her research both within and outside her university. She is also a successful researcher[2] and has been a leader within the field of art education for 30 years. It should be noted that this paper is not necessarily about Dr Grauer's successes (or disappointments), rather it is a portrait, a description of selected aspects of her working life.

The format of the paper is as follows: first, the background to this study is discussed. Second, I describe how the research was conducted and analysed. Third, I present examples and

narratives of Dr Grauer's teaching. Finally, I discuss the meaning of this form of enquiry for future research within art-teacher education.

Context: The Pre-service Methods Course

Admittance to the one-year post-baccalaureate art-teacher education programme at the University of British Columbia is selective. All of the pre-service student teachers enter the programme after completing undergraduate degrees, mostly in fine arts or art and design from various Canadian institutions. At the time of this study, art education student-teachers were required to take an intensive eighteen-unit secondary art education methods course which was taught by Kit (Dr Grauer) during the thirteen-week autumn term. After completing the course, they participated in a thirteen-week student teaching practicum during the following spring term and a post-practicum art theory and research course in the summer term.

The art education methods course was composed of 26 student-teachers. The student-teachers met as a group for twelve-contact hours each week. One of the major goals of the course was to integrate art content (including making art, art history and art criticism) and art education pedagogy. With this concept of integration in mind, the student-teachers were asked to learn about the teaching of art, create visual metaphors, keep written and visual journals, analyse written case studies and videotapes related to teaching art, teach their peers during in-class micro-teaching assignments and undertake a two-week practicum experience in local schools.

Research Methodology

Virginia Richardson[3] encourages all educators to inquire into the nature of their teaching, and that of others. Such personal research allows educators to frame ways in which they can explore, understand and improve their own teaching within art classrooms. Thus, using Richardson's concept of practical enquiry coupled with my interest in exploring classroom life, my goals were to develop an understanding of Kit's teaching as a faculty art-teacher educator.

Some of these goals were as follows:

- To make sense of what Eisner[4] refers to as the nuances of the classroom. For example, I wished to study the conversations, the teaching episodes, the classroom ecology,[5] the 'dailyness' of classroom life[6] and the nitty-gritty[7] that are implicit within the pre-service classroom as a faculty member and student-teachers study art and teaching together.
- To examine how Kit managed the classroom environment and, also, how she taught within it. For example, I wished to study how she allocated time to class assignments and activities, how she paced her lessons, how she monitored the classroom and called on student-teachers to answer questions, as well as how she alleviated student teachers' anxieties in matter-of-fact and nurturing ways. I wanted to listen to how Kit projected her voice or laughed at her own sense of humour. I wanted to monitor how she dealt with controversial issues or negotiated with student-teachers which, in turn, might allow me to ask questions about why she chose and modelled particular teaching strategies – teaching methods which seemed to be successful both as a means of communicating art education content to student-teachers and as possible models for teaching secondary school student-teachers.

- To observe how Kit communicated what she cared about to student-teachers. What were the intellectual, moral and emotional dimensions of her faculty work? Were there elements of passion, joy and disappointment involved in this work? How did Kit see her role as an art-teacher educator?
- To be attentive to other emerging themes that might develop during the course of the academic term, given that classrooms are complex, dynamic and changing settings.

I attended all of Kit's class sessions during the thirteen-week autumn term. In essence, I took on the dual roles of participant observer and *temporary* student within the classroom. Kit graciously allowed me to sit amongst the student teachers (all of whom had consented to participating in my project). A high-quality tape recorder and microphone were placed in full view on a table in the front of the room, so that I could record the various spoken interactions – formal lectures, informal conversations, student teacher chatter, one-on-one utterances and so forth – that would take place during each class session. After each class session, I would listen to the audio tapes carefully before sending them off to be transcribed by an expert. As I listened to the tapes, I would 're-live' the experiences that I had just encountered, as well as make notes about the daily happenings. As this was a qualitative research study, I wanted to make sure that I identified any emerging themes and patterns which, in turn, may re-surface in the subsequent classroom sessions.

In order to triangulate the data and to supplement the tape recordings, I took copious hand-written field notes as I participated in the methods course. I would write down details of what I was observing in A4 notebooks, leaving a large margin on one side of each page for additional notes, comments and observations (for example, included in these margins were reminders to check with Kit about a conversation with a student, or large bold comments reinforcing an earlier point or continuing theme). I also examined all of the course materials and books, which were complemented by the assorted handouts that Kit gave out on a daily basis. The methods course also focused on helping students understand and negotiate the various provincial curricular materials and standards required for teaching art in elementary and secondary schools in British Columbia.

The data collection was enhanced further by formal interviews and ongoing conversations with the student-teachers, as well as with Kit herself. A number of the student-teachers agreed to be interviewed over the course of the term. (Kit, as the instructor, gave me permission to conduct interviews with her students, but she agreed that all of the student teacher interviewees should remain anonymous.) I met each of the interviewees individually and asked each one to talk about his or her perceptions of the class, the various assignments and the reasons why he or she was pursuing art-teacher certification. The student-teachers spoke candidly and all their comments remained anonymous. These interviews were not tape-recorded, rather I took notes and asked clarifying questions, when needed. My interviews and conversations with Kit were both structured and informal. When her busy schedule permitted, I scheduled formal interview times with her. However, I usually conferred with Kit on a continuing basis, even if it was just for a few minutes. These brief conversations allowed me to make sure that I had understood what her goals and intentions had been during her lessons.

Once the audio tapes were transcribed and the text placed on the computer, the written transcripts and field notes were analysed for patterns and themes. Additionally, I looked for key themes that emerged from the interview data and diligently sorted through the other data – photographs taken of and within the classroom (including images of students' work and portfolios), notes taken when the whole group of student-teachers visited schools, observations of student teachers during their two-week practicum experiences and analyses of Kit's course materials.

A number of themes emerged from the data collection and analysis. Three overarching themes, each with individual sub themes, are presented in this paper. They are as follows: (i) pedagogical components, (ii) building a classroom community and (iii) balancing life: work and home.

Pedagogical Components

Integrated pedagogy: making connections
In this course, Kit was expected to integrate art content from the disciplines of art – art-making, art criticism, art history and aesthetics – art education pedagogy and general education methods. The student-teachers received no discipline-specific art courses (e.g. studio or art history) at this time in their programme. For example, they learned about teaching art subject (or discipline) content within this one integrated methods class. Categories that reflect the student-teachers' evolving beliefs included subject matter knowledge, pedagogical content knowledge, personal competence and personal conceptions of teaching.[8]

In class pedagogy: teacher educator modelling
From the very beginning of the course, Kit asked the student-teachers to 'observe what she was doing' and then to 'think about' what she was doing (field notes, September). For example, she would teach (model) a lesson and then ask the student-teachers to deconstruct it, analyse it and put it back together. The student-teachers would then discuss the strengths of Kit's teaching and the teaching method and their appropriateness for secondary school students. This concern for describing, analysing and especially interpreting teaching was a thread that ran throughout the methods course. Additionally, there was the expectation that the student-teachers' own practices would develop as they observed and emulated these pedagogical examples. Kit believed that university educators could help someone learn to teach, in that aspects of successful teaching can be taught, and that there are aspects of learning to teach that can be learned. On a typical day, I wrote the following in my notes:

> Kit walks around the room and monitors the group work. The groups were formed, by pulling names out of dish. As the names were called, the groups were formed. Kit was actively observing what the groups were doing and keeping them on task. All the student teachers were involved. She alerted them to the fact that they had one more minute to work. The pace was fast moving. Kit then said, 'Can you wrap up that thought and come back to the group?'

In class pedagogy: thinking out loud in the classroom
Kit was not one to hide the processes of her thinking:

You get to think about teaching all of the time. It weaves in and out of your life. On the way home on Monday, I was thinking about planning. For me, it's as close to art-making as is teaching. You've got this stuff. It pushes your juices. It's the creative process at best.

The student-teachers 'heard' Kit's mind actively at work. As she taught and interacted with the student-teachers, she would continually 'talk about teaching'. At times, this thinking was not perfect, in that Kit showed the imperfect processes of her thinking. She did not necessarily have all the answers (although she did have answers); however, she was able to talk teaching issues through with the student-teachers and help them resolve teaching problems. She was also able to help allay their fears about teaching, in that she was empathetic towards and was supportive of their concerns. She always provided opportunities for quiet thinking time within her class, so that everyone in the class had time to think. Essentially, Kit trusted her own and the student-teachers' thinking and encouraged her own self and the student-teachers to expand on such thinking.

In-class pedagogy: micro-teaching experiences as an example
All of the student-teachers were responsible for teaching two micro-teaching lessons. Micro-teaching involved 'getting your feet wet', as Kit would call it. This first micro-teaching assignment was scheduled three weeks into the term and after the student-teachers had been introduced to unit and lesson planning. The student-teachers worked in peer teams of five, taking it in turns to teach and to videotape one another. They were also responsible for fetching the video equipment, setting it up and taking it down. Given the number of student-teachers in the course, the micro-teaching took place over three class sessions. After an individual student had taught, the rest of the group would evaluate the teacher. This was done both verbally, immediately after the student had finished teaching, and as written comments on printed evaluation forms. The student-teachers would then take the video home and evaluate themselves. Kit did not ask to see the videotapes.

During these sessions, a strong emphasis was placed on teamwork. Many of the team members were visibly nervous at first, but after the first student-teacher had taught, the whole team became more relaxed. The team members responded to the 'teacher' as though they were students were in the grade level that was being taught. Micro-teaching is a familiar component of learning to teach. However, there is little research to suggest that skills learned in micro-teaching transfer to the real world of the classroom [9]. Nonetheless, the micro-teaching sessions provided a context for exploring teaching issues and for fostering mutual support. Some team members would ask their peer evaluators to look for certain things in their teaching, for example, whether they had good eye contact or, as in one case, the fundamental concern: 'How many times do I say "um"?'.

When the student-teachers next met together as a whole class, Kit requested that they reflect on their own personal micro-teaching experience. She would ask questions such as: 'What did you learn from the experience? What did you learn from each other?' Often she would reiterate her two main objectives for the course, which were:

Construct; Deconstruct. I want you to be comfortable constructing lessons and pulling them apart. I want us to study teachers' thinking and think about how we can analyse this thinking. Why is the teacher doing it this way? How does the teacher seamlessly construct a lesson?

Teaching is a vulnerable activity in that one is constantly at the forefront. Kit purposely put her student-teachers on view.

Field-based pedagogy: school observations
Recognizing that teacher education must be closely aligned with school-based pedagogy and experiences, all of the student teachers visited exemplary school sites for one-day visits as a whole class and completed a two-week practicum in the school in which they would student-teach the next term. Field-based pedagogies are part of the long tradition of learning how to teach and aim to ground prospective teachers in practice. In the first class meeting back at the university, immediately after the two-week practicum, Kit asked the following of the student-teachers:

Think of three things that you learned on the practicum. These three things should be (a) personal, (b) teaching tips that the whole class can learn from and (c) one other thing that we can talk about in this course. Spend five minutes writing these down, and then we'll debrief.

As they wrote down their reflections, one student talked to Kit and told her that there were many issues from the practicum. In response, she immediately went around the room calling on all of the student-teachers to tell her about the issues they faced. As they did so, she responded back to them:

Chris, you don't have to introduce everything to the students at the beginning of the class. And, yes, you have to think about stopping and starting and making the flow of the lesson work. Pamela, wait and don't talk when they are talking. Sandra, be clear; spell things out blatantly, step-by-step, and give examples. Mark, use assertive language; don't undermine yourself. Kim, you need to know the students' names.

Reflective pedagogy: the use of cases, visual metaphors and narratives
Kit used a series of reflective assignments, in the form of analyses of case studies and reflective essays in order to allow the student-teachers to become prime partners in the teaching and learning experience, to monitor their pedagogical growth and to become partners in their own professional development.[10] The student-teachers also participated in an inter-institutional dialogue with other student-teachers over the Internet.

Kit was a firm believer in the use of case studies or anecdotes to discuss teaching events. For instance, she would use them as a means of discussing teaching events with the student-teachers, or as a means of introducing the topic of a lesson, or a vehicle in which to get her ideas across. Some of the case studies were written by Kit's former student teachers and were based on their

personal teaching experiences during the student-teaching practicum. This recycling of experiences was an extremely important component in Kit's teaching. Goodson and others[11] suggest that stories and narratives of teaching can provide rich case studies of classroom life. Van Manen[12] has written about the use of anecdotes and their place within a teaching pedagogy. Kit used them often in her teaching. For example, Kit spoke about her family and, in particular, about the teaching stories recounted by her husband, an experienced secondary school art teacher teaching in Vancouver.

Building a Classroom Community
A designated art education classroom
Kit's art education methods classroom was not only the location in which the student teachers met together as class group, but it was also a place where they were able to socialize and get to know one another. A designated art education classroom, complete with a coffeemaker, fridge and microwave, soon became a meeting place both within and outside class time. This time together seemed to bring about a communal venturing forth along with a community of collegiality and friendship and so helping the student-teachers establish social and affable relationships that moved beyond those considered to be merely collegial and within the pre-service university classroom walls.

Developing pedagogical relationships
Audio-tape transcripts show how the student teachers early in the term were anxious about their coursework. Some student-teachers, in particular, were quite busy figuring out what was expected, were worried when assignments were due and were even trying to anticipate what might be on the final course exam. As the term progressed, they appeared to be less concerned with judging themselves and their ability to teach based on course marks and assignments that they had yet to complete. I observed how the student-teachers began to slowly interact with one another, trust one another and so take care of one another in pedagogical and positive ways.

These interactions undoubtedly fostered a sense of community in this classroom. Yet these relationships did not suddenly happen overnight. It was Kit's careful orchestration and facilitation of the classroom environment that nurtured them. She provided the student-teachers with opportunities for brainstorming, piggybacking off one another's ideas, sharing and working in teams or with partners, together with the general bashing around of ideas. Rudduck[13] writes about the qualities that students respect in teachers. She identifies them as fairness, autonomy, intellectual challenge, social support and security. Kit's classroom became a supportive, safe place where the student-teachers were slowly encouraged to reflect upon and, at times, to let go of old conceptions about and images of teaching, familiar pedagogical practices and comfortable routines.

Balancing Life: Work and Person
The sharing of one's self with others
There were, of course, moments when Kit would collapse in her office after class and reflect upon and question what had transpired that day, as well as query her own self. She would ask

if the student-teachers were overwhelmed because of the large amount of information to cover. There is no doubt that academic life often becomes busier for art-teacher educators as a term progresses. In Kit's case, administrative tasks piled up and the impact of various department-wide pressures started to affect her daily life. This project took place during a hectic fall term for Kit and her colleagues, and at a time when administrative changes were taking place within her institution. Kit's workday was usually extremely long and often began at 6.00 am with an hour-long commute in order to miss the commuter traffic into Vancouver.

Additionally and importantly, I watched Kit strive to balance professional and personal concerns. Kit is a wife, a mother, a daughter, sister, friend, as well as a professional colleague to many. The faculty member and student-teacher relationship was not the only way Kit shared herself with others.

Discussion

Briefly, I would like to discuss a few selected ideas that have been generated from the study and anchor them in the broader art-teacher education literature, as well as furnish some suggestions for future research. First, in Kit's classroom there was a layering of pedagogical practices. As she taught about teaching strategies for primary and secondary school art-teaching, she would constantly demonstrate how to use these approaches. Often teacher educators are criticized for not 'walking the talk'[14] and for merely telling student-teachers how to teach, instead of actually modelling and soliciting feedback on a variety of teaching methodologies. This did not happen in Kit's classroom, for she believed that 'beginning art teachers should be constantly aware of the variety of instructional methodologies and strategies that are currently part of the field of education'.[15]

Such talk about teaching art is, to some extent, a form of research and enquiry.[16] For example, teacher educators might ask how a particular strategy worked. Or they might ask if they had missed something or left something out. Thus, in this vein, Kit would ask the student-teachers if a particular teaching strategy was successful, either as a way of communicating content to her student-teachers or as an appropriate model for teaching art in the secondary school. Additionally, Kit's overall instructional approach provided ways for student-teachers to analyse classroom teaching in small segments in order that they might get a better handle on the basic elements and nitty-gritty of teaching. All too often, art-teacher educators tend to focus on the larger picture of the classroom. Yet teaching art is far more subtle and complex.[17]

Second, my observations allowed me to determine that Kit encountered and confronted curricular and pedagogical issues that are not unlike those of art teachers in primary and secondary schools. Kit's success as a teacher relied on sound management and planning skills in terms of her methods course curriculum and her presentation of lesson plans. From time to time, she had to deal with absentee class members or a group of student-teachers worried about the nature and frequency of course assignments. And on several occasions, she had to cope with a difficult and troublesome student-teacher who, unfortunately, became unwilling to take constructive criticism or advice. Thus, as implied earlier, establishing, facilitating and maintaining a working and successful pedagogical community required effort, faith and stamina on Kit's part, not just pedagogical and curricular expertise and know-how.

Third, it was evident that Kit had some autonomy in what she chose to teach within the methods course. She did pay strict attention to the Canadian Provincial visual arts guidelines and the standards developed for schools in British Columbia, but essentially she was able to choose the curricular and instructional strategies employed within her course. Evidence of this curricular freedom was not surprising, given that many faculty art-teacher educators within North America have some leeway as they develop and implement teacher education courses and curricula.[18]

Last, on one level, Kit's working life resembled that of other art-teacher educators involved in preparing art teachers. There are certain job requirements, such as developing and teaching courses, working on administrative tasks and conducting research in the field that seem to be part and parcel of a good many faculty members' responsibilities. Not unlike many art-teacher educators, balancing and getting a handle on these tasks as a term progresses took their physical and emotional toll on Kit. Trying to complete all of these components, required long working days, long commutes to work, as well as weekends and evenings at home spent on lesson preparation and institutional assignments.

Yet, on another level, Kit's daily working life was (and still is) one of a kind given her unique character and personal traits, and, of course, the professional contexts of the institution and country in which she works. Moreover, Kit's daily life is further shaped by her passion for teaching and art education, her wealth of experience and expertise, the care that she demonstrates towards student-teachers, her willingness to take risks and her openness and sincerity.

Conclusion

This research has allowed me to gain insight into the complexity of Kit's professional life and how she journeyed through her working life, day by day, and over an academic term. Yet Kit is not alone in this pedagogical endeavour. Art-teacher education is an international responsibility. All faculty art-teacher educators, whether they work in preparation programmes within North America, Europe or elsewhere within the world, almost certainly undertake comparable journeys as they construct and negotiate the complexity of the pedagogical interactions and contextual meanings that give shape to the pre-service educational settings in which they *live* and work. This lifework is becoming increasingly multifaceted, therefore, it is important to understand and view its complexity through the perspectives and lenses of art-teacher educators. Such research inquiries, analyses and narratives provide a means of authenticating and representing diverse educators' voices by way of documenting the intellectual, emotional and moral elements of preparing art teachers. They also provide possible contexts for self-reflexive enquiry and action research, in addition to opportunities to talk with others about our own teaching within higher education.

In Kit's case, it is clear that her pedagogical voice and beliefs are informed by both theory and practice. Analyses and interpretations of her teaching, her 'mind workings'[19] and her own words call attention to Kit's conviction that successful pre-service classroom pedagogy is achieved by helping and encouraging student-teachers to make critical and informed connections not only

to learners' lives and art worlds, but also to their own. Student-teachers are recognized as active participants in the construction of their own learning and teaching community, and to this end, Kit combines elements of teacher modelling, reflection and field experiences that acknowledge pre-service students' pedagogical growth and collegiality. Moreover, Kit constantly interweaves aspects of her own professional (and personal) life in and out of this community as balances her roles as teacher educator, researcher and colleague (and mother and wife).

In my own case, as a researcher and higher education faculty member, I was able to help Kit *and* myself gain a better understanding of what it means to negotiate the complexities of academic life. During the research project, Kit overtly acknowledged how my presence in her classroom allowed her to clarify her own values and beliefs about teaching. For example, merely knowing that her teaching was being observed and documented meant that she paid even more attention to crafting her teaching. I do not believe that Kit changed or modified her teaching specifically because I was always in her classroom, rather she saw the research project as a means of completing an informal action research study on her own teaching. She regularly asked me to comment on her lessons and give her advice on how she could improve her instruction in the future. Kit had taught this integrated methods course over a number of years; therefore, she recognized that she (and her student-teachers) would benefit from a personal investigation into her own fairly well-established ways of teaching and being in the classroom.

Research on the daily lives of faculty art-teacher educators has barely made a dent in the research literature.[20] It seems that the intellectual scholarship and daily work of art-teacher educators remain on the fringes of our field, because they have not been researched and do not fit within the constraints of conventional art education research and enquiry. However, enquiries of this kind have the potential to understand more fully how faculty members' lives are linked and to know that, within higher education, we can learn not just from Kit, but also from one another.

Postscript

As a postscript, I would like to share a brief story. Last year, Kit attended a research conference at Stanford University, California. A female faculty member attending the conference, who teaches in Minnesota, USA, came up to her and said, 'You are Kit Grauer'. Kit looked perplexed and said to the faculty member, 'Do I know you?' The faculty member replied, 'No, but I know you. You have transformed my teaching!' Kit was startled yet again, but then began to smile as the faculty member went on to say that she had read the original version of this paper published in the *International Journal of Art and Design Education*.[21]

Acknowledgement

The author wishes to thank Dr Kit Grauer of the University of British Columbia for graciously allowing her to learn from her. It takes a great deal of courage and grace to allow someone into your classroom to study 'you' and your teaching. The author is also indebted to the National Art Education Association for a research grant that funded several aspects of this project. Thank you.

Notes

1. Studies of classroom settings include the following: Day, M. D. (1997). Preparing Teachers of Art for the Year 2000 and beyond. In M. D. Day (ed.) *Preparing Teachers of Art*. National Art Education Association, 3–26. Galbraith, L. (1995) The Pre-service Art Education Classroom: A Look Through the Window. In Galbraith, L. (ed) *Pre-service Art Education: Issues and Practice*. The National Art Education Association, 1–30. Hutchens, J. (1997) Accomplishing Change in the University: Strategies for Improving Art Teacher Preparation. In Day, M. D. (ed.) *Preparing Teachers of Art*, National Art Education Association, pp. 139–54. Zimmerman, E. (1994) Current Research and Practice about Pre-Service Art Specialist Teacher Education, *Studies in Art Education*, 35(2): 79–90.
2. Grauer, K. (1998). 'Beliefs of pre-service Teachers Toward Art Education'. *Studies in Art Education*, 39, (4), 350–70.
3. Richardson, V. (1994). 'Conducting Research on Practice', *Educational Researcher*, 23(5): 5–10.
4. Eisner, E. W. (1998). *The Enlightened Eye: Qualitative Inquiry and the Enhancement of Educational Practice*. New York: Macmillan.
5. Doyle, W. (1990). Themes in Teacher Education. In W. R. Houston (ed.) *Handbook of Research on Teacher Education*. New York: Macmillan 3–24.
6. Diamond, P. (1991). *Teacher Education as Transformation: A Psychological Perspective*. Milton Keynes: Open University Press.
7. *Ibid.*
8. *Ibid.*
9. Carter, K. and Anders D. (1996). Program Pedagogy. In Murray F. (ed.) *The Teacher Educator's Handbook: Building a Knowledge Base for the Preparation of Teachers*. San Francisco: Jossey Bass, 557–92.
10. Schiller, M., Shumard, S. & Homan, H. (1994). 'Dialogue Journals with Pre-service Art Teachers: A Study by Three University Student Teacher Supervisors. Arts and Learning', 1(1): 41–56. Wasserman, S. (1993). *Getting Down to Cases*. New York: Teachers College Press.
11. Goodson, I. F. (1992). *Studying Teachers' Lives*, New York: Teachers College Press; also Huberman, M. (1993) *The Lives of Teachers*. New York: Teachers College Press.
12. Van Manen, M. (1991). *The Tact of Teaching: The Meaning of Pedagogical Thoughtfulness*. New York: State University of New York Press.
13. Rudduck, J. (1991). *Innovation and Change: Developing Involvement and Understanding*. Milton Keynes: Open University Press.
14. Grauer, K. (1997). 'Walking the Talk: The Challenge of Pedagogical Content in Art Education'. In Irwin, R. L. & Grauer, K. (eds.) *Readings in Canadian Art Teacher Education*. Alymer Express Ltd., Ontario: Canadian Society for Education through Art, 73–82.
15. *Ibid.* p. 78.
16. *Ibid.*
17. *Ibid.*
18. Galbraith, L. (2001). 'Teachers of Teachers: Faculty Working Lives and Art Teacher Education in the United States'. *Studies in Art Education*, 42(2): 163–81.
19. Galbraith, L. (1996). 'Videodisc and Hypermedia Case Studies in Preservice Education'. *Studies in Art Education*, 37(2): 91–100.
20. Beudert, L. (2006). *Work, Pedagogy and Change: Foundations for the Art Teacher Educator*. Reston, Virginia: National Art Education Association.
21. Galbraith, L. (2004). 'Daily Life: A Pre-service Art Teacher Educator and Her Work'. *International Journal of Art & Design Education*, 23(2): 118–126.

7

A Dual Inheritance: The Politics of Educational Reform and PhDs in Art and Design

Fiona Candlin

Introduction

Over the last 40 years the relationship of art practice to academia in the United Kingdom has been quietly but fundamentally changing. Within the post-1960 art school, art practice was often conceived of as divorced from any notion of academic or theoretical work, as John Stezaker recalls, 'the image of the artist as the kind of impassioned and emotional anti-intellectual is something we all know about in art schools from this period'[1] By the 1990s, however, the ground had shifted to such a degree that it was possible to pursue doctoral study in art practice. This emergence of practice-based PhDs can be considered as part of a larger shift in art education and its acceptance of theory.

This chapter attempts to trace the pedagogical, institutional and political history of the practice-based PhDs in art and design in the United Kingdom. On the one hand, the emergence of this form of doctoral study can be located within a certain intellectual, ideological and practical set of approaches and be considered as the product of, among other things, social art history, conceptual art, feminist theory and post-structuralism. Although by no means homogeneous these approaches and debates were broadly critical of modernism and of the notion that art was autonomous in regard to social, historical, political, and theoretical issues. In this context the practice-based PhD could be interpreted as the logical consequence of critical, politically aware practices.

On the other hand, the founding of the practice-based PhD can also be connected to a series of educational reforms which are, in turn, related to the political climate of the mid to late

twentieth century. I argue that the very possibility of these critical practices being taught in art schools, colleges and later universities, is linked to a series of educational reforms, in particular to the 1960 Coldstream Report and to the 1991 White Paper on Higher Education. In other words, the practice-based PhD, which emerged from a predominantly left-wing tradition, may also be closely linked with conservative education policies. This institutional and legislative history is important because it raises difficult questions concerning the critical potential of theory and practice that might otherwise remain hidden.

The paper begins with a discussion of post 1960s art schools, the introduction of theory and its eventual canonization within art education. I then explore more recent educational reforms, considering the effect of university management on both the constitution of research and the consequences for a critical art practice.

The Introduction and Orthodoxy of Theory

Prior to 1960 art education in England considered design, sculpture and painting to be based on good drawing skills and a firm knowledge of anatomy, composition and perspective. Yet after the recommendations made by The National Advisory Council on Art Education (1960), better known as *The Coldstream Report*, this emphasis on professional craft-based training was to shift towards a liberal education in art. It was a change that had massive implications for art education, in particular for the relationship of studio practice to art history and theory.

The Coldstream Report aimed at bringing art education closer into line with undergraduate degrees and did so partly by including a compulsory academic element into the new Diploma in Art and Design (DipAD). Coldstream intended the history of art to form a 'complementary and helpful counterpoint to the main object'[2] and recommended that it 'be studied throughout the course and [...] be examined for the diploma'.[3] What was to be taught under the rubric of complementary studies and art history was, however, vague and the definition of 'helpful' was left to the individual discretion of the tutor or the institution.

The range of subjects that could be potentially included under complementary studies is illustrated by an anecdote told by Stuart Morgan. Morgan conjures up an image of the art schools of this period as havens of creativity and fun. He recalls Mrs Brady, the Head of Complementary Studies at an unspecified art college, who on his first day told him to forget his university education and to remember that 'these are artists, Mr Morgan, their brains are in their fingers'.[4] Classes on poetry, Egyptian culture, Italian language and extrasensory perception went on alongside Scandinavian studies and Japanese, all as Mrs Brady thought fit.

While the DipAD legitimated art education by introducing an element of academic work, the concomitant lack of formulation that Morgan celebrates ensured that complementary studies remained marginal in relation to art practice. Although *The Coldstream Report* can be credited with introducing complementary studies into art, it certainly did not guarantee that any critical or rigorous art theory or art history was in fact taught. Indeed, four years later a follow-up report, *The Summerson Report*, criticized both the 'lack of emphasis given to the study of original works' and the absence of 'serious interest in the social relationships of the arts, either in the

past or in our own time'.[5] Moreover, in some ways *The Coldstream Report* actually exacerbated the divide between theory and practice. *The Summerson Report* registers:

> ...a certain resistance to the whole idea, as if History of Art were some tiresome extraneous discipline which was being imposed on the natural body of art studies.[6]

Complementary studies and art history were supposed to have a strongly supporting role in the newly formulated DipAD, but in removing history and theory to the safe distance of the classroom and by restricting it to twenty per cent of course time, *The Coldstream Report* actually programmed a gulf between art theory and art practice into higher education:

> The priority, autonomy and prestige conferred on studio work guaranteed a generally irreconcilable breach between studio and lecture room, practice and theory and history, 'doing' and 'talking'.[7]

Nevertheless, *The Coldstream Report* did enable the introduction of theoretical material into art education, and, paradoxically, the lack of structured and rigorous education in art history (or in studio practice) gave room to more marginal groups and critical stances. Griselda Pollock has commented on this situation:

> In practice art schools deliver very little education [...] The absence, however, of systematic induction into an (ortho)doxy leaves open unexpected possibilities for counter-courses, women's workshops etc.[8]

Both the introduction of complementary studies and the shift away from craft based training meant that by default *The Coldstream Report* opened up possibilities for theory and, as Pollock points out, for feminist theory to be taught and practised within art schools.

While the emergence of feminism generally and in art schools specifically does not mean that the integration of theory and practice met with wholesale acceptance, feminism is obviously informed by a recognition of the roles and representations of women within society. Precisely by engaging with feminism the art practitioner also engages with theoretical, historical and cultural issues. How that engagement was, and is, articulated differs widely. Nonetheless, it did mean that feminism formed one of the main intersections between theory and practice in art schools.

Conceptual art similarly brought the relationship between theory and practice clearly into question. As with feminist art practice, conceptual art pitted itself against the concepts of artwork as a purely visual process which were prevalent at the time. Artists such as Art & Language produced work, which was an explicit critique of Fried's advancement of an art 'accessible to eyesight alone' and of Greenberg's construction of art as being autonomous.[9] Not only was conceptual art work often produced in tandem with theoretical discussion, but theoretical discussion was integral to the artwork. For instance, Art & Language's 'Indexes' (1972) consisted of eight filing cabinets filled with texts that could be read in situ and, along similar

lines, Joseph Kosuth's 'Information Room' presented 'Art as Idea as Idea'[10] by displaying two large tables covered with books on linguistic philosophy. Conceptual art, rather than being concerned with a reduction or eradication of external issues attempted to be a critical investigation of them, specifically those considerations concerned with the discursive constitution of art. In this way many conceptual artists not only sought to eliminate the theorist/writer divide, but explicitly worked against the exclusion of theory from the studio.

Feminist and conceptual art practice formed one of the routes through which a separation of theory and practice was questioned and bridged, but this was not the only means through which it happened. In their introduction to The Block Reader in1996, the editors retrospectively outline the areas of enquiry and thought which were a response to the secondary role of art history in art colleges prevalent during the mid- to late 1970s.[11] These responses contributed to a critique of 'the tired formulas of sensibility-plus-dates' and aimed at an understanding of art as a social, material and expressive practice determined by specific forms of production and reception. By the late 70s social history, institutional critique, the cultural analysis of Raymond Williams and Pierre Bourdieu, varieties of reception theory were all current, as was the work of Althusser, Foucault and Lacan.[12] These differing approaches were by no means mutually exclusive and together they constituted different ways of re-thinking the boundaries of art and art history.

Arguably, work that integrates theory and practice is now commonplace. The intellectual ground that was fought for in the 1970s and 1980s has become relatively accepted, with 'the new art history' finding 'a place in commentaries, curricula and publishing catalogues'.[13] By 1992 feminist commentators could talk about 'the orthodoxy of scripto-visual work'[14] while theoretical and social historical approaches became sufficiently usual within art institutions to prompt Christopher Frayling to write that 'the new art history has recently become the new orthodoxy art as a carrier of social values'.[15] Likewise 'radical' art practices have become increasingly mainstream. In 1997 John Stezaker commented that

> I would never have believed I'd still be talking about conceptualism. Yet it has become almost the dominant mode. You only have to go round art galleries to see that you're exceptional if you're not working in one way or another in a conceptual mode.[16]

Art is increasingly taught and made in relation to wider intellectual, social and gendered concerns. At the same time art education is by no means homogeneous and enough teaching remains sufficiently rooted in notions of art's autonomy from historical and theoretical issues for Michael Ginsborg, from Wimbledon School of Art, to write in 1993:

> One could posit two very broad, interdependent tendencies in current art practice. They should certainly not be taken as exclusive [...] In the first critical discourse is not only admitted into the arena of practice, it is seen as constituting it [...] In the second tendency the values at work are very different. Intuition, discovery and spontaneity are the priorities... Verbal articulation and criticism are secondary in the face of the visual practice itself unless, that is, they deal with form, technique, or process.[17]

Like other institutions, individual universities and art schools are not homogeneous, and competing beliefs and practices can be voiced in the same studio or classroom. Similarly, there are differences between institutions; the university or art college 'system' is not univocal. Despite this there is an identifiable tradition of critical theory and practice within art education.

In many ways the practice-based PhDs in art are the logical consequence of the theoretically informed art practices that have emerged over the past three decades. Although previously marginal these practices are now firmly located within art education; a clear institutional acceptance of theory and practice to which there are several possible responses. On the one hand, it could be read as marking the importance of critical discourses such as feminism and social histories. In this context, the inauguration of practice-based PhDs would demonstrate the validity of ways of working that were problematic within the parameters of modernist art education and practice.

On the other hand, while there may be individual practitioners, or even departments wherein the integration of theory and practice retains its critical agenda and is used to deconstruct the silent ideologies of modernism, theory and practice could be understood as having become another orthodoxy. Pessimistically, the practice-based PhD could be conceived of as the formulaic version of its forebears; it maintains the form of theory and practice but has lost its original impetus. Rather than challenging the status quo it now upholds it. Theory/practice may still retain some adversarial potential against 'the staunch defenders of the purity of art against social histories of art or theoretically informed (who) dread the contamination of the visual by the verbal'[18] but it might already be just another higher qualification.

Alternatively, there could be a less polarized interpretation of the practice-based PhD The institutionalization of debates does not necessarily imply a simple assimilation and therefore eradication of all critical potential. Any process of assimilation or incorporation changes that which assimilates and here the practice-based PhDs do have an effect upon the politics of knowledge within the institution. The inauguration of the practice-based PhD assumes that artwork counts as knowledge, as legitimate academic research. By crossing traditional academic boundaries, such as those between theory and practice, words and images, fact and fiction, the PhD becomes an active agent in changing the literal and conceptual construction of academic work. Ways of working and types of knowledge that have been excluded from the academic or artistic sphere are legitimated with the introduction of the practice-based PhD. As the heir of these feminist, conceptual and poststructuralist debates on theory and practice, the practice-based PhD starts to re-figure the boundaries of what knowledge is considered to be in the university. The major difference is that this happens from within the institution and not from an adversarial, apparently non co-opted position.

Yet some caution is necessary. The practice-based PhD can be conceived of as critically re-formulating the constitution of academia but this does not address the question of what is at stake for the institution itself. After all, it is unlikely that the universities who have now officially recognized art as a research activity did so purely on the grounds of inclusion or out of a desire to embrace the multiplicity of knowledge. In the next section I shall discuss the institutional

investment in practice-based PhDs and consider how more recent educational reforms have re-situated theory and practice within the academy.

Practice-based PhDs and Market-oriented Reform

The Coldstream policy decisions concerning art education were not external to art practice but had a significant impact on what it is possible to teach, learn and produce within art schools. Likewise, the reasons for instituting practice-based PhDs are not solely intellectual or pedagogical, but, arguably, are inextricably connected to educational reform. I shall now look briefly at the changes in art education since 1991 and their eventual effect on the institution of practice-based PhDs. To what degree have recent and current university reforms affected the kind of work that might be carried out therein?

By 1992 a large number of undergraduate degrees in art were being taught within the university system. This was mainly due to two changes in art education, namely the institution of undergraduate courses in art, and the impact of the 1991 Government policy White Paper on Higher Education across the board. The DipAD, which *The Coldstream Report* introduced, had initially been conceived of as 'corresponding to a first degree' [19] and in 1974 when the National Council for Diplomas in Art and Design (NCDAD) merged with the Council for National Academic Awards (CNAA), the DipAD was converted into an undergraduate degree. Following the merger and the change from DipAD to Bachelor of Arts it was stated that 'in future art and design will be regarded and treated as an integral part of higher education rather than an isolated subject area with its own institutions, procedures and validation body'.[20]

Although a clear integration of qualifications in art and higher education was intended, some ambiguities did remain. The lack of formulation evident in art schools continued into polytechnic course design, something that Terry Atkinson and Michael Baldwin took issue with:

> In the NCDAD report there is a bald statement asserting 'the central problem is one of fostering a satisfactory relationship between art and design and the rest of the educational system while protecting the unique features which are essential to the character and quality of art and design education.' The interpretation of this statement will be particularly crucial in context of the recent inclusion of many fine-art departments in the new Polytechnics. Now the NCDAD give no clue as to what, in their view, might constitute a 'satisfactory relationship' (and also their notions of 'unique features' and the 'character and quality of fine-art education' are, in the final analysis, vacuous and foggy).[21]

Despite calls for integration, art and design was perceived by the NCDAD report as being somehow different from mainstream education. Nevertheless, art courses now took the form of undergraduate degrees and in many instances were being taught within the auspices of polytechnics rather than art schools.[22]

Whether or not art schools remained independent or whether they became part of polytechnics, in 1991 it became possible for both polytechnics and to a lesser extent colleges, to take on university status. The Government White Paper, *Higher Education: A New Framework,*

recommended that the 'binary line' between polytechnic and university education be abolished. This line, or rather the lack of it, was identified as the key to related changes, among which were:

A single funding structure [...] greater cost efficiency through more competition and better use of resources; degree awarding powers to all major institutions; the right to use the title of university; a United Kingdom-wide quality unit developed by institutions; funding related quality assessment by the funding councils.[23]

Under the 1992 Further and Higher Education Act, the majority of polytechnics did rename themselves universities, enabling them to award their own taught and research degrees. Likewise some art colleges which had never integrated with polytechnics merged with universities.

The funding structure introduced by the Further and Higher Education Act was to have major consequences for universities generally and art teaching specifically as it became tied to (largely full-time) student numbers and to the results of the Research Assessment Exercise (RAE). RAEs had predated the 1992 Further and Higher Education Act but this explicitly linked them to funding. Although RAE money is distributed by universities in different ways – and often it is only a percentage which goes directly to the department – the combination of large students numbers with strong RAE results can benefit a department in many ways, including more staff, teaching assistants, bursaries, better library resources or funded conference trips.

The role of postgraduates in art and any other discipline, is an ambivalent one in relation to the RAE. What material the postgraduates work on, or the quality of their output, has no explicit bearing on the outcome of the exercise, but in broader terms they are seen to add to the general profile of a department. As in other years the 2001 RAE History of Art, Architecture and Design Panel noted: 'Research students and research studentships form an important source of the research ethos of institutions'.[24]

Similarly, the Art & Design panel commented: 'All such postgraduate activity, including research registrations and completions will be considered as indicators of the vitality of the research culture'.[25]

Quantity counts in that a postgraduate presence is seen to be indicative of a department's research culture that is, in turn, made credible if postgraduate and departmental areas of research correspond. Hence, postgraduates have an indirect effect on the RAE and subsequent funding.[26]

Postgraduates have a more direct influence in terms of the fees that they bring into their university and, to a lesser extent, the department. This is no doubt reflected in the fact that nationally, in the United Kingdom, the numbers of creative arts postgraduates more than doubled in seven years.[27] Thus, it is in the interests of the university and can be in the interests of departments to have postgraduates for financial and cultural reasons, although developing a good research culture is itself potentially financial reason.

Due to the institutional separation of art practice and academic research there has been no history of doctoral study in practical art or indeed of art history within art colleges while only a minority of institutions have offered M.A. courses. Within the terms of the RAE, which the new universities are now subject to, art departments answered to the same requirements and assessment procedures as other disciplines. One of the criteria for RAEs is, as I have commented, a postgraduate presence and it is notable that doctoral programmes in practical art have, on the whole, only been in evidence since postgraduate work became an important issue in the relationship between research activity, status and funding. The rising numbers of postgraduates generally and the inception of practice-based PhDs can be considered as part and parcel of the departmental need to self account both financially and academically. As such, I would suggest that these moves constitute a strategy for departmental survival and that the very possibility of conducting research using practical art is, in part, a product of conservative educational policy and market-oriented educational reform. In this context it is perhaps difficult to see how an integrated theory and practice PhD could possibly be perceived as critical in relation to current cultural, institutional or party politics.

Management's Self-critique?

The Summerson Report noted in 1964 that practitioners perceived theory to be the optional extra on top of practice, and indeed theorists and practitioners alike have often seen managerial decisions as an irritant, something to be dealt with before the proper business of producing art begins. Yet, as *The Coldstream Report* demonstrates, administration is not something that simply gets in the way and ultimately remains discrete from the art and research. The regulation, funding and structure of art courses does not form a backdrop against which this thing called art is played out, but rather, academic management forms a leading role in constituting what art is understood to be in educational terms. So while theory and practice may have had an effect on the politics of knowledge within the university, university politics have a significant effect on the form art practice and theory can take within higher education.

The practice-based PhDs can trace their lineage through certain pedagogical concerns but are also the product of conservative educational reform. The rising numbers of art and design PhDs are symptomatic of a market-led university culture in which departments are assessed on the basis of their research culture. In this context practice-based research does represent a re-thinking of academic boundaries, not one that takes place for ethical or critical reasons but in response to educational reforms that force departments to prioritize financial survival above intellectual inquiry.

The way in which a predominantly socialist commitment to integrated theory and practice meets with 'Thatcherite' educational reforms over the ground of these PhDs is uncomfortable. It is not, however, a cause for complete despair. Educational reforms are of great consequence to making art, but this does not then imply that managerial recommendations determine the sort of art or theory that is produced, indeed at council level there is rarely any consideration given to the specific art objects made.

Moreover, in the case of the Coldstream changes, the new structuring of art colleges opened up the potential for critical discourses, such as social history and feminism, to be taught within

the walls. These managerial changes effectively helped in the production and development of feminism and social art history. Along with its recommendations, *The Coldstream Report*, therefore, in effect, allowed for the possibility of its own critique. More recently, conservative educational reform may have prompted the inauguration of practice-based PhDs, but paradoxically may have created a site for the critical re-thinking of academic practice. In this sense restructuring can never be watertight or closed to what it did not intend and while managerial decisions can be said to have a constitutive relation to the work made, they are not simply deterministic.

Notes

1. Stezaker, J. in Roberts, J. (ed.) (1997). *The Impossible Document: Photography and Conceptual Art in Britain 1966-1976*. London: Camerawords, p. 145.
2. *Ibid.* emphasis in text.
3. Ashwin, C. (1975). *Art Education; Documents and Policies 1768-1975*. London: Society for Research into Higher Education, p. 98.
4. Morgan, S. (1993). 'The Pleasure Principle', *The Curriculum for Fine Art in Higher Education. The Essential Elements of Fine Art Courses in the 90s.* (Transcript of a one day conference held at The Tate Gallery, Millbank, London) p. 52.
5. Ashwin, C. (1975). *Op.cit.*, p. 112.
6. *Ibid.*, p. 114.
7. Orton, F. (1985). 'Postmodernism', 'Modernism' and Art Education (English) Modernised, *Circa Education Series*, p. 63.
8. Pollock, G. 'Art, Art School, Culture: Individualism After the Death of the Artist', *Block 11*, Winter 1985/6, p. 11.
9. Fried, M. 'The Achievement of Morris Louis', *Artforum*, February 1967, quoted in C. Harrison (1991). *Essays on Art and Language*, Oxford: Basil Blackwell, p. 32.
10. See, for example, Clement Greenberg, 'Towards a Newer Laocoon', in F. Frascina (ed.) (1985). *Pollock and After: The Critical Debate*. London: Harper and Row.
11. Meyer, U. (1972). *Conceptual Art*. New York: Dutton E. P., p. xi.
12. Bird, J., Curtis, B., Mash, M., Putnam, T., Robertson, G. & Tickner, L. (eds.) (1996). *The Block Reader in Visual Culture*, Routledge, London and New York, p. 3.
13. *Ibid.*, p. xiii.
14. *Ibid.*
15. Pollock, G. in Barrett, M. & Phillips, A. (eds.) (1992). *Destabilizing Theory: Contemporary Feminist Debates*, Cambridge: Polity Press, p. 63. In 'Painting, Feminism, History' Pollock takes on the critics of the orthodoxy of scripto-visual work and defends the importance of a theory of representation in art practice.
16. Frayling, C. in Hetherington, P. (ed.) (1994). Issues in Art and Education: *Artists in the 1990s, Their Education and Values*. Millbank, London: Tate publishing, p. 9.
17. Roberts, J. (ed.), *op. cit.*, p. 161.
18. Ginsborg, M. in Hetherington, P. (ed.) (1994). *Op. cit.*, 79-80.
19. Pollock, G. 'Trouble in the Archives', *Women's Art Magazine*, Sept./Oct. 1993, p. 10.
20. Ashwin, C. *op. cit.*, p. 130.

21. *Ibid.*, p. 149.
22. Atkinson, T. and Baldwin, M. 'Art Teaching', *Art Language*, 1(4): November 1971, p. 43.
23. Following the Robbins Report of 1961 the Department of Education and Science presented *A Plan for Polytechnics and Other Colleges* to the Government. This paper proposed 30 new institutions, catering to students of all levels and oriented towards applied subject matter and technical education. Degrees would be awarded by the newly established Council for National Academic Awards (CNAA). In addition, *A Plan for Polytechnics and Other Colleges* aimed at reducing the number of colleges engaged in full-time education. To achieve this end many such colleges were merged to form the basis of the new polytechnics. This, of course, included the previously independent art colleges and resulted in most art degrees being offered within the Polytechnic sector. By 1970 all but four of the proposed 30 polytechnics were in place. See Morrish, I. (1970) *Education Since 1800*. London: George Allen and Union Ltd, 108–111.
24. Brookman, J. & Utley, A. 'More Students for Less, Major Promises', *The Times Higher Education Supplement*, 24 May 1991, p. 2.
25. 'RAE History of Art, Architecture and Design', 1996, p. 137.
26. *Ibid.*, p. 137.
27. *University Statistics Students and Staff*, Universities Statistical Record, Volume One, 1988–1989, Table 13, pp. 46–49 and Volume 1, 1993–94, 44–47.

8

PRACTICE-BASED RESEARCH DEGREE STUDENTS IN ART AND DESIGN: IDENTITY AND ADAPTATION

John Hockey

Introduction

Research into the field of United Kingdom doctoral education developed considerably during the 1990s, with bodies of evidence on the student experience now available in the natural[1] and social sciences[2] as well as humanities.[3] This same period, particularly its latter half, saw the growth of research degrees in art and design, specifically in terms of practice-based research (as distinct from art history). It is now possible to study for a practice-based doctorate in over forty departments.[4] There is presently a small literature on this particular form of study, some of which is concerned with developing research protocols, regulations, and training programmes.[5] Attention has also been paid to supervision[6] and the provision of resources to aid students.[7] Empirical research on students' actual experience of doing art and design practice-based research is sparse to say the least.[8] Given that research on the student experience of studying for this kind of practice-based doctorate was (and still is) underdeveloped, a research project was initiated with the aim of producing some empirical literature on the topic.

The Research

During 1995 and 1997 research was carried out involving qualitative interviewing of 50 research students, who were located at 25 United Kingdom higher education institutions. Interviews were in-depth, semi-structured and tape-recorded, lasting between 60 and 90 minutes. Subsequently they were transcribed. Students interviewed covered the whole spectrum of art and design disciplines, and included: painting, ceramics, installation, photography, printmaking, sculpture, glass-making and design. Those interviewed also embraced a continuum

ranging from individuals in their first year of study, to those who were about to submit their work a number of years hence. In addition twenty of these students were studying part-time, and amongst these there was a considerable experience of earning salaries via their creative endeavour. The purpose of these interviews was to gain an understanding of student experience and the interview agenda covered such topics as: relationships with supervisors, relationships between practice (making) and theory, between practice and peers, between practice and the self, conceptions of identity and between practice and writing. Given the paucity of the information available on these students, the aim of the project was not statistical in terms of producing generalizations. Rather, the focus was upon uncovering something of the complexity of students' academic lives as they toiled toward doctoral status. In common with much qualitative research, extrapolation from the data relies on the validity of the analysis rather than the representativeness of the events.[9] Data analysis was carried out via the constant comparative method[10] Data collection and data analysis were sequential, hence as data was collected, it was also analysed through an ongoing process of coding. Subsequently, the detailed coding allowed the generation of key thematic categories and subcategories of the students' lived experience. This process of analysis continued until no new categories, in terms of social processes, practices and conceptions, were emerging from the data.[11] What follows is based on data emanating from the aforementioned interviews, and focuses upon a central dimension of student experience, namely the impact this kind of degree study has upon their identity, and how that impact is managed.

Creative Identity

When interviewed, students predominantly expressed a particular way of describing themselves, which was central to their individual and collective biography, and which heavily influenced their experience of doing graduate research. All of them had been initially socialized via their undergraduate degree[12] into the world of creative practice. As a result, without exception, they individually described themselves as a creative person or individual, often also depicting themselves as a sculptor, painter, designer, photographer and so on.

As Jenkins[13] notes, the concepts of 'self' and 'identity' can be argued to be coterminous and that self is 'each individual's reflexive sense of her or his own particular identity, constituted vis-à-vis others in terms of similarity and difference', This internal understanding of a fully reflexive self is simultaneously then a product of social interaction, out of which it emerges.[14] The data thus revealed that a creative identity was paramount to those interviewed. Central to this conception was the activity of creative practice, without which their conception of identity seemed to be problematic. They constantly stressed the importance of the process of 'making' for the ongoing validation of the creative self. Students repeatedly articulated the meaning of using their hands creatively in many ways, and there was much emphasis upon the hands-eyes relationship and the importance of being skilled in visual language. Seeing and then doing with the hands (in a multiplicity of forms) constituted the core of their creative identity. Whilst there was also involvement in subsidiary activities such as teaching, selling their work or curatorial activity, which also helped substantiate this identity, it was evident that self-validation hinged upon the 'making'. Overwhelmingly all their experience of academia was permeated by a concern with the visual both in terms of making and of language. In effect, they saw the world

in a very particular way, viewing it via a particular disciplinary lens.[15] In the United Kingdom, undergraduate degrees in art and design have paid less attention to the development of writing skills, than in other disciplines. Indeed at Masters level, practice-only degrees are also widespread, so it is possible for students to complete two degrees with only a minimal written component. With two exceptions (whose background was primarily in art history), the students interviewed could not be considered skilled in academic writing.

In a sense the interviewees constituted a 'naïve' population in relation to the rigours of completing a research degree. Whilst a certain naivety is characteristic of graduate research students in general, the specific problem for the art and design students was to develop new skills in creating text and to combine these with their familiar creative practice. Whilst practice was undoubtedly central to their research, so also was the analytical portrayal and contextualization of that practice. This constituted the demonstrable evidence required of a research degree. In this context, writing and analysis are combined in a single process. This was encountered as a new demand upon students to engage with a different kind of practice, full of unknown and little understood elements. Developing the craft of academic writing is a difficult enough task for students whose disciplines demand a high facility in writing at undergraduate level, but for art and design students it constitutes a particularly daunting task, which produces a reality 'shock'[16] to their artistic identity. This 'shock' was composed of a number of elements, some of which will be examined.

The Elements of 'Shock'

At its most general level, this shock can be attributed to the fact that students suddenly find themselves in a situation of unfamiliarity; the processes of art and/or design are known territory to them, and they are skilled in negotiating the pathways to successful making. Whilst there might on occasion be considerable struggle with the making, there is also an intimacy with it, and a confidence in their creative ability; an understanding of the boundaries they need to extend; a knowledge of the possibilities and limitations of the materials with which they work. In contrast, when encountering 'research' where they must defend their work to an academic audience in a particular analytical fashion, students were suddenly faced with an unfamiliar situation in which they were in the main largely inexperienced to say the least.

This new status had a considerable impact upon most of the students interviewed, many of whom had, in one way or another, made their living as practising artists and designers. However, in relation to research methodology, conceptual and theoretical resources, and the central craft of analytical writing, they were novices. An unfamiliar intellectual terrain stretched before them which they needed to chart and to combine with their traditional making, in order to gain a research degree. Whilst some of these problems could, and would be remedied by the institution, for example by the provision of general research methods courses (which, however, were often not well orientated towards art and design students), the craft of analysis and writing remained a daunting challenge. Individual and collective confidence was suddenly under threat. The contrast with students' 'artistic' status, experience and feelings prior to commencing the research degree was particularly marked. The following interview extract illustrates this realization:

It may sound a bit big-headed but I know I'm known in the artistic world. I've had a lot of shows of my work and I know that it's well regarded [...] The problem with doing this (research degree) is you are suddenly nothing! [...] What it means is that I am a novice at doing research, it's a bit disconcerting. The contrast is a bit difficult because I am struggling with it and of course I feel inept.

In conjunction with this kind of anxiety another fear haunted students throughout their period of study. Despite their involvement with academic research, none of the group interviewed had altered their conception of identity, as above all, being a creative person remained paramount to them. As a result, the evaluation of the wider artistic community of peers remained an important concern. The interviews revealed a continuing anxiety that prolonged involvement in research work might eventually be to the detriment of their practice, so that the wider community would judge negatively the creative component of the research degree. Students feared that they would also fail against their own criteria. The sheer amount of time and energy necessary for the practice of research is initially and continually a shock to students; time and energy which, from their perspective, could be devoted solely to propelling the creative practice.

A further shock to students was the regulatory framework of a research degree, the most constraining element of which is usually a formal registration document, which outlines in some detail the proposed project. This document imposes certain kinds of boundaries to the research at its onset, and from the students' viewpoint this immediately constrains their creative expression, which hitherto has been largely unfettered. Moreover, in some instances students claimed that the nature of the regulatory framework, and the predominance of non art and design staff upon the scrutinising committees, pressured them into devising research projects which were more conservative than they would have wished:

I didn't have the freedom I had before just to make things as I felt [...] Well I had to justify everything and timetable it and all that. I sort of felt a slave to it, and to some extent still do, you know, caged in. The whole business of getting it [the project] through committees and conforming to regulations is constraining.

Disquiet at the constraints imposed by such institutional frameworks is perhaps inevitable, for, as Bourdieu[17] has noted of people in the creative arts:

The pure intention of the artist is that of a producer who aims to be autonomous, that is entirely the master of his [sic] own products, who tends to reject not only the programmes imposed a priori by scholars and scribes, but also [...] the interpretations superimposed a posteriori on his [sic] work.

Regardless of the type of project they were undertaking, eventually all the students encountered the problem of analytic documentation and recording of demonstrable evidence in some form or another. Whilst artists and designers have traditionally kept notepads and sketchbooks, the systematic reflexivity of practice required by formal research enquiry was a surprise to all the

interviewees. When asked about progress in the process of their making they articulated its nature with words such as, 'momentum', 'on a run', 'on a roll', and 'seamless', conditions which approximate to Csikszentmihalyi's[18] concept of flow. In such circumstances, when the act of making reaches its zenith, students become at one with it, lost in it, fused with it, and creative output is achieved.

For those interviewed, systematic analytic documentation posed a large problem as it required breaking the flow, disturbing the momentum of making and tearing oneself away from an activity central to artistic identity. Whilst some of the projects were more amenable to systematic documentation (for example, the design of functional objects or the testing of particular materials), others which fell towards the fine art end of the spectrum, were much less so. Moreover, regardless of the kind of project pursued, the breaking of momentum in order to undertake analysis was initially disturbing and always difficult. This was particularly so when the making was going well, headway was being achieved, and the creative boundaries were being extended, for then analytical documentation constituted a distraction, a step backwards from being engaged with materials, objects and processes. The quality of such making generates fulfilment for the maker, so there was inevitably considerable reluctance to break the creative momentum.

Such movement from what might be termed the subjective to more objective dimensions entailed other problems. Having to shift one's thinking towards explanation and evidence generated fears that, by coming to understand analytically and in considerable detail how their making was constructed and how it was situated within wider intellectual contexts, the essence of students' creative powers would be diminished. There were fears that creativity would be frozen by objectivity. This fear was intimately connected to the level of self-disclosure, in terms of ideas and emotions, and their relationship to making. The levels of self-disclosure with which individuals were comfortable varied with the kind of projects undertaken. For students whose main focus was the actual process of making per se (e.g. ceramics development), such anxiety was at a relatively low level. In contrast, for those concerned primarily with the impact of what they created upon an audience (e.g. fine art), the anxiety was more intense:

> I'm used to nudes but this is like being nude in a different way [...] I find it all a bit difficult, recording all this stuff about my motives, influences, about my choices, you know colour and shape and what not. And I'm also scared about what all this is doing to the work [...] You have to have some mystery you know, what's art without a little mystery? And that's not just for people who are going to come and look at it. I need some mystery for me, I need to keep some of it, and because it's from here that the spark comes!

In sum, students encounter a number of problems which collectively generate a shock and challenge to their artistic identity, for they have to engage with unfamiliar research processes and procedures, which have a disturbing impact upon that identity in the ways illustrated. How students engaged with and resolved the encounter with the previously unexplored dimension of research will now be depicted.

Forms of Adaptation

Analysis of the interviews revealed three principal ways in which students engaged with undertaking research, ways in which their creative identity came to terms with this new activity. First, there was a small minority of full-time students within whose vocabulary of motives[19] the possession of a research degree was a low priority. Their primary reason for working at an educational institution was not to pursue research, nor to acquire an advanced qualification, but rather the pursuit of their creative practice. This was their central motive and other motives were either assigned a low priority or were absent entirely. These students had been attracted to the prospect of three years of funding, enabling the further development of their creative practice. This was an attractive proposition, particularly in a context of the financial difficulties that normally face most artists and designers in the United Kingdom. In addition, the level of resourcing, in terms of materials and studio space allocated to them as part of their bursary, was also a considerable incentive.

To these individuals, pursuing a research degree was to some extent incidental. In a sense they did not take seriously their formal involvement, what one might term their institutional contract. Their objective was to push the boundaries of their creative practice as far as possible in the time in which they received funding and resources. They either held this stance initially, viewing their studentship as too good an opportunity to miss, regardless of the concomitant expectations, or in contrast, they developed this position as the realities of doing research started to impinge upon their creative work and identities, as previously depicted. In both cases the costs of research in terms of time, energy, creative freedom, and methodological exposure, were viewed as too high to bear. As a result, such individuals were essentially 'passing'[20] as graduate students. They harboured no serious intent to pursue their declared research project; their concern was to enhance their practice. However, paradoxically, where they were seriously engaged was in relation to the work required to continue passing, and thus to continue to receive institutional support. Their capacity to 'pass' was helped by operating in a context where there were few experienced supervisors and little development in research methodology specific to practice-based art and design. So, delay, deception, and minimal research activity were tactics deployed within the general strategy[21] of passing, as one student explained:

> The truth is I'm not here to get a PhD, I'm here to do my work, and I've never thought otherwise. Getting any money to do art is very difficult and I saw this studentship advertised so I just went for it. I have to do just enough to satisfy [my supervisor] and that way, I'll keep on getting my grant. Sometimes I feel a bit guilty about it because he's a nice person, but not enough for me to give up this chance to progress with my work. It didn't take me very long to understand that these kind of practice-driven degrees are new here and because of that staff are working in the dark a lot.

Amongst those interviewed were students who had accomplished such 'passing' for two years, and were hopeful of a third. However, another student interviewed subsequently had his bursary withdrawn on the grounds of 'insufficient progress'. In this case his ability to 'pass' had reached its limit. As a group, these students had made a decision not to let the research process impinge upon their work and upon their sense of self, their creative identity.

One of the reasons for taking on these kinds of students may be a certain lack of quality control at the admission stage. Practice-based degrees and their supervision are still at a relatively early stage of their development in the United Kingdom, a state of affairs endured at one time or another by other disciplines.[22] It is therefore perhaps not surprising that there should be some evidence of uncertain quality control in the selection of research students at this stage of development. After all, the social sciences, with over fifty years of experience of research degree work, were found wanting in terms of the performance of doctoral students and have been complying with quality control measures enforced by the ESRC since 1985.[23]

A second kind of adaptation to the demands of research was evident from the interviews, where students were prepared to grapple with both the objective and subjective dimensions of combining systematic analysis with creative expression. After a process of struggle, they had come to terms with this necessary synthesis, and had developed a method particular to their own projects. As a result they were making headway in their study, chapters were being written, artefacts created, and processes understood. From their point of view some competence had been achieved in mastering previously unfamiliar research skills, via much hard work and considerable soul-searching.

This achievement had, however, involved costs in relation to their creative work. They viewed their creative work as being either in stasis or propelled in directions they would not have wanted, due to the demands of the research. There was evidence in the interviews of considerable ambivalence towards the acquisition of research skills and the progress of their research degree. Whilst there was some satisfaction at having achieved new competencies, at the same time students experienced uneasiness at the costs of that achievement. These students displayed considerable pragmatism and instrumentalism[24] in pursuing research degrees. Once the shock of new demands had been encountered, they adapted by conforming and meeting the criteria necessary for success, many motivated by the perception that a research degree would aid in acquiring an academic position. The long-term prospect of pursuing their creative practice, with institutional support, was indeed an attractive proposition to many, even if it required shorter-term sacrifices. This is a similar perspective to some of the jazz musicians studied by Becker,[25] who, out of economic necessity played more conservative music than they would have chosen. Like those musicians, the students had to handle their feelings about such compromises, whether in relation to their making, or the way they had devised a research methodology for their project that restricted or diverted the direction of their work, for example:

> Well that more or less coincided with living in a house with a bunch of postgrad scientists, and finding out from them about the ways they go about testing things, you know materials, conditions, all those sort of procedural things. I saw that I could apply that way of doing things to my research, if I changed its emphasis. In a way it's copping-out because the actual making has gone nowhere [...] I took the easy way out and I am not happy about that, it's as if I have become timid.

In coming to terms with these kinds of feelings about themselves and their work, students used a general device, as became apparent from interview analysis. In a sense, students perceived

the period of their research degree as a suspension of their true creative activity, and of their true creative selves. Phrases such as, 'this is not really my art' and 'this is not really me' were commonly used to describe a state of separation, a divorce of what was happening, from what should be happening. The future was presented as the site of a resurrection, beyond the constraints of the research degree process, when the real creative self would once again flower, unfettered, unrestrained by the bureaucratic, the analytic and the pragmatic.

These responses constitute a 'technique of neutralisation',[26] or in Goffman's[27] terms methods of role distance used to justify to the self and to an external audience the choices which have been made. Such neutralization serves to ease the sense of loss, the sadness and even the guilt that often accompanies enforced pragmatic behaviour. There is a distancing of the earlier, relatively spontaneous, uninhibited self from the constrained, pragmatic self and its more instrumental making. By this means the truly creative self is not lost but rather suspended in limbo until the research degree process is completed. For whilst there is a neutralization, there is also an optimism present, for what one was before, one will eventually return to in the future. Interestingly, research as a process was seen by these students, as a 'one time' ad hoc endeavour, because from their perspective the creative costs of involvement in it were judged to be too high, and unlikely ever to be repeated.

A third kind of adaptation to the new research status involved students undergoing a series of struggles and tribulations in trying to marry research with creative endeavour, and successfully to incorporate the two aspects in intellectual and practical terms. For these students there was also an additional change in their subjectivity. They began to connect in an emotional way with being both a researcher and a creative person. Rather than viewing the costs of involvement in research as too much to bear, the struggle with research and its linkage to their making came to be viewed as essentially productive. This gain was made not just in pragmatic terms (furthering the research degree) but also in creative headway. Rather than distancing themselves from the research component, these students positively embraced it. Thus students not only learned how to do research in practical terms, but also began to identify with being researchers. This identification was fostered by a number of factors. Gradually, as this group of students struggled with new skills and procedures and began to understand the nature of research, they learned to see its creative possibilities by using these new research elements more fully to understand and give momentum to their making. They begin to trace affinities between the actual making and the research process itself:

There's colours, shapes, forms and textures. You have to weave them all, so the difficult thing is in making the choices and then putting it all together, working out how they are all going to fit with each other. It took me some time and then I realized that's what doing research is like, it's like a collage, you fit things together, you look at the bits and you move them around, and then you try again until you are satisfied. I was much happier when I made that connection.

Once this realization was reached, students began to conceptualize research itself as a creative process, not just a mechanical or technical one, and similarities between their making and this

new endeavour gradually became evident. This affinity helped foster increased empathy towards the research. Interestingly, the term which was widely used by students once they had reached this position, was that of likening research to a craft; a point long ago made by Mills.[28]

Analytical writing subsequently became perceived as a central practice by which their making was understood and communicated; a practice which is creative per se, and which enhances both visual and practical creativity. As a result, the students concerned felt empowered by their involvement in research. The capacity to understand their work via formal analysis permitted them to propel their work in directions they had not previously envisaged. Moreover, this deeper understanding of their work helped build increased confidence: in situating the work within its wider context or history, in describing its precise amalgamation of elements and in the choices made in its construction.

This analytic confidence resulted in a more developed capacity to articulate and justify their making, both to themselves and within the public domain. The result of this new understanding and empowerment was that students began to see themselves as individuals possessing an analytic as well as a creative capacity. In this sense they begin to identify with being researchers and to incorporate that identification within their traditional identity of being a printmaker, photographer, designer, sculptor and so on. For this group of students, the gains had been greater than the costs of doing a research degree and they held essentially optimistic views about undertaking further research in the future.

Conclusion

When individuals enter a new domain requiring new skills and processes, there are often gains to be made, and on occasion negative consequences to be avoided or tolerated. Studying for a practice-based research degree in art and design harboured both of these possibilities. For all the students studied, engagement in academic research involved some degree of risk, either in terms of failure to pass and consequent denouement, or in terms of the negative impact of critical analysis upon their creative capacity. As Kickbusch[29] has noted, taking certain risks may be essential to constructing particular social identities, and for some of the students interviewed, out of the process of risk and struggle was forged the basis for identification not only with the role of creative person, but also with that of researcher. Studying for this kind of research degree consequently constitutes an opportunity for a partial transformation of the self.[30] In essence it is possible to view the three forms of student adaptation to engaging with this particular form of research degree study, as the ways in which the individuals interviewed sought to achieve authenticity, of being true to self in that particular context.[31] In terms of identity salience[32] the act of making was articulated as foremost by all students interviewed, and thus of fundamental importance to their creative identity. As perhaps should be expected, the lack of a really prolonged exposure to the new craft of research, meant that even in the case of students who eventually began to identify with that craft, the composite self which emerged was one which always depicted itself as maker/researcher rather than researcher/maker.

Acknowledgements

Many thanks to Jacquelyn Allen Collinson, the other member of the research team, for her helpful comments, and to Barbara Muldarney for sterling transcription.

Notes

1. Pole, C. (1998). Technicians and Scholars in Pursuit of the PhD: Some Reflections on Doctoral Study, *Research Papers in Education: Policy and Practice*, 15(1): 95–111.
2. Hockey, J. (1994). New Territory: problems of adjusting to the first year of a social science PhD, *Studies in Higher Education*, 19(2): 177–190.
3. Graves, N. & Varma, V. (eds.) (1997). *Working for a Doctorate. A Guide for the Humanities and Social Sciences*. London: Routledge.
4. Candlin, F. (2000). Practice-based Doctorates and Questions of Academic Legitimacy, *International Journal of Art and Design Education*, 19(1): 96–101.
5. United Kingdom Council for Graduate Education (UKCGE) (2001). *Research Training in the Creative & Performing Arts & Design*. Dudley: UKCGE.
6. Hockey, J. & Allen-Collinson, J. (2000). The Supervision of Practice-based Research Degrees in Art and Design, *International Journal of Art and Design Education,* 19(3): 345–355.
7. Newbury, D. (1996). *The Research Training Initiative: Six Research Guides*. Birmingham: Birmingham Institute of Art and Design.
8. Macleod, K. (1998). Research in Fine Art: theory, judgment and discourse, *Drawing Fire*, 2(2): 33–37.
9. Mitchell, J. C. (1983). Case and Situation Analysis, *Sociological Review*, 31(2): 190.
10. Glaser, B. (1993). *Basics of Grounded Theory Analysis*. Mill Valley, CA: Sociology Press.
11. Creswell, J. W. (1998). *Qualitative Inquiry and Research Design*. London: Sage.
12. Wayte, G. R. (1989). *Becoming An Artist: the professional socialisation of art students*. Unpublished PhD thesis. University of Bristol.
13. Jenkins, R. (1996). *Social Identity*. London: Routledge, p. 29.
14. Mead, G. H. (1934). *Mind, Self, and Society*. Chicago: Chicago University Press.
15. Zolberg, V. L. (1990). *Constructing a Sociology of the Arts*. Cambridge: Cambridge University Press.
16. Dornbusch, S. M. (1955). 'The Military Academy as an Assimilating Institution', *Social Forces*, 33(4): 316–321.
17. Bourdieu, P. (1984). *Distinction: A Social Critique of the Judgement of Taste*. Cambridge: Harvard University Press, p. 3.
18. Csikszentmihalyi , M. (1975). *Beyond Boredom and Anxiety*. San Francisco: Jossey-Bass.
19. Mills, C. W. (1940). 'Situated actions and vocabularies of motive', *American Sociological Review*, 5, (December), 904–913.
20. Goffman, E. (1973). *Stigma: Notes on the Management of Spoiled Identity*. Harmondsworth: Penguin, p. 92.
21. Crow, G. (1989). 'The use of the concept strategy in recent sociological literature'. *Sociology*, 23(1): 1–24.
22. Simpson, R. (1983). *How the PhD Came to Britain*. Guildford: Society for Research in Higher Education.

23. Collinson, J. & Hockey, J. (1995). 'Sanctions and Savings: some reflections on ESRC doctoral policy', *Higher Education Review*, 27(3): 56–63.

24. Hill, S. (1981). *Competition and Control at Work*. London: Heinemann.

25. Becker, H. S. (1963). *Outsiders: Studies in the Sociology of Deviance*. New York: The Free Press, 79–100.

26. Sykes, G. & Matza, D. (1957). 'Techniques of neutralization: a theory of delinquency'. *American Sociological Review*, 22, (December), 664–670.

27. Goffman, E. (1961). *Encounters*. Indianapolis: Bobbs-Merril.

28. Mills, C. W. (1975). *The Sociological Imagination*. Harmondsworth: Penguin.

29. Kickbusch, I. (1988). 'New perspectives for research in health behaviour, in R. Anderson (ed.). *Health Behaviour Research and Health Promotion*. Oxford: Oxford University Press, 237–243.

30. Fox, N. (1998). 'Risks, Hazards and Life Choices: Reflections on Health at Work', *Sociology* 32(4): 665–687.

31. Howard, J. A. (2000). 'Social Psychology of Identities'. *Annual Review of Sociology*, 26: 367–393.

32. Stryker, S. (1980). *Symbolic Interactionism: A Social Structural Version*. Menlo Park, CA: Benjamin-Cummings.

9

SCHOOL ART: WHAT'S IN IT?

Dick Downing

Introduction

During 2003 and 2004 the National Foundation for Educational Research (NFER) undertook a year-long study designed to ascertain the content of the English art curriculum at key stage 3 and 4 (ages 11 to 16 years) with particular reference to the inclusion of contemporary art practice. It was commissioned by the Arts Council for England (ACE) and the Tate Galleries, both of whom have an interest in promoting the role of contemporary art in education in England. Their motivation in commissioning the research from NFER was to more fully understand the content of the school art curriculum in order to inform their future strategies, and to test a perception that an orthodoxy pervades 'school art'.

The research had three main objectives:

- To portray the salient contents and foci of 'school art' at key stage 3 and 4 (KS3 and 4), including a depiction of any programmes involving contemporary art practice
- To identify factors and strategies that inhibit and facilitate the inclusion of contemporary art practice in the school curriculum
- To explore the potential of contemporary art practice to make a distinctive contribution to the art curriculum and pupils' learning.

Methodology

The project began with a review of the relevant existing literature on research carried out in England since the introduction of the national curriculum in 1989. The review focused on studies of the content of the school art curriculum, especially that covered at KS 3 and 4. The review was based on literature identified by a systematic search of research databases in education and the social sciences, carried out by the NFER library at Slough.

This produced a limited selection of research concerned specifically with the curriculum content of secondary school art. The literature was generally more concerned with the aims and effects of the curriculum. Very little documentation addressed the main foci and content of 'school art' beyond the Qualifications and Curriculum Authority (QCA) guidelines and suggested schemes of work. Censorship, the sensitivity of issues in contemporary art and the culture of individual schools were all cited as potential barriers to the inclusion of contemporary art in the curriculum, rather than any inherent restrictions in the curriculum as it is specified at a national level.

The second phase of the research was based entirely on qualitative methods. The sample comprised art departments in ten randomly selected schools and in eight schools, identified by the sponsors and their nominees, known to incorporate contemporary art practice in their curriculum (referred to throughout as the CAP identified schools). This judgement was not based on a pre-agreed definition of what constitutes contemporary art practice.

In each of the sample schools, interviews were carried out with the head of the art department and with a number of their colleagues, depending on the size of the department. In total, fifty-four art teaching staff were interviewed. Interviewees were questioned about curriculum design and content, and their perceptions of the factors affecting curriculum choice. They were also asked to itemize the outcomes of the art curriculum in their schools. Part of each interview involved a detailed description of one specific art module for one year group. On average, each year group was covered in twelve interviews through this method, with an average of three year groups covered in each department. Most of the art teachers were also asked to respond to a sample of six images, depicting artworks from a range of artists, as a way of further understanding their thought processes in selecting curriculum content. Teachers in the CAP identified schools were questioned further about the inclusion of contemporary art practice in their curricula.

Some parts of the data lent themselves to rudimentary quantitative analysis, while for others a qualitative analysis of interviewees' accounts was more appropriate. Where possible, both approaches have been combined in the full report to give an understanding of the numbers of responses of particular types and a sense of the specific views being expressed. It is readily acknowledged that the sample size for this research was not large. With limited resources it was necessary to choose between a survey approach or more in-depth data collection with fewer schools. However, the data is rich and in many respects detailed, and while not presuming to be representative, it is presented in a way that is intended to be both indicative and illustrative.

The Content of the Curriculum

The main findings of the report were based on the detailed description of sixty-two art modules, spread fairly evenly over the five year groups in KS 3 and 4. Analysis of the data collected revealed the following characteristics in the art curriculum as taught in the randomly identified schools:

- The prevalent use of painting and drawing as the medium in which pupils work.
- The prevalent use of artistic references from the early twentieth century.

- Limited use of artistic references from pre 1800 and from the latter twentieth and early twenty-first century.
- The prevalent use of male, European artists, predominantly painters.
- The importance placed on development of art form skills, including the use of art materials, the development of specific techniques and observational drawing skills.
- The teaching of the formal elements of art.
- The creation of opportunities for pupils to think in an analytical and evaluative way, whilst employing thinking processes associated with creating and making art.
- The use of the Internet, more than books and other resources, for researching artists and art history.
- Limited use of galleries, museums or professional artists and artists in residence.
- Limited opportunities for using art to explore issues (though more opportunities emerged at key stage 4).
- Limited cross curricular working and interdepartmental planning.
- Limited opportunities of pupils to produce art work using ICT.
- Limited requirement of pupils to engage in creative thinking processes.

The following characteristics were more likely to be reported in the CAP identified cohort of schools:

- Pupils produced work using ICT and other, less traditional media.
- Teachers used artistic reference from the latter twentieth and early twenty-first century to support the curriculum.
- Non-western artists and female artists were included in the artistic references used to support the curriculum.
- Teachers included a wide range of art forms in the references used to support the curriculum.
- Expression of meaning through art was taught as a distinct skill.
- Teachers encouraged pupils to use and develop creative thinking processes.
- The curriculum included visits to galleries and museums and included the use of external artists.

The distinction between the two cohorts was more marked in numerical terms for some features. For example, teachers in CAP schools cited twice as many artistic references overall than their colleagues in the randomly identified schools. Their artistic references were spread over a wider historical period. They were three times more likely to cite the expression of meaning as a taught skill.

The nature of these characteristics reflects the broad and balanced approach to the curriculum prevalent in the underlying principles of curriculum design in the CAP identified schools. However, it is worth noting that these characteristics may not be specifically associated with contemporary art practice. For example, the use of a wider range of artistic references and a wide range of media and materials may simply be more indicative of a broad and balanced art curriculum. The exploration of art as a visual communication tool may be more indicative of a curriculum that is not solely concerned with artistic technique and skill.

Strong evidence of contemporary art practice did not feature in many of the schools in the sample; furthermore, in schools where it did feature, in no case did it displace conventional art teaching approaches. Where introduced, CAP appeared alongside more traditional practices.

Two distinct underlying design principles determining the content of the art curriculum emerged from the analysis of module content. The more prevalent approach to art-teaching emerged as an initially directed approach in which the emphasis was on the development of art skills. This progressed to the introduction of more exploratory and experimental processes, frequently associated with more independent learning, at key stage 4. The second approach, more prevalent in the CAP identified schools, was characterized by a broader based curriculum, which was both pupil and teacher centred, which built on the premise of skills but integrated more creative and conceptual thinking, exploratory work, the exploration of issues in art and awareness of art as a visual communication tool.

Factors Influencing the Choice of Curriculum Content

It might be claimed that, given the massive potential range of artists and art images available for inclusion in the curriculum for school art, and the breadth of purposes for which one might choose to teach art, the actual choices made are somewhat limited. This research indicated evidence of a number of factors that influence the choices made.

National or School-level Contextual Issues

Neither the national curriculum nor the QCA guidelines were experienced as restrictive by the considerable majority of interviewees. However, there were those expressing concern that the GCSE syllabi might limit the opportunity to excel, especially for more able pupils. The primacy of skills in the assessment process was apparent, but not regarded by most teachers as restrictive. It might be argued that teachers are so used to the context and requirements within which they operate that they take them as given and therefore do not perceive them to be restrictive, any more than a fish perceives water to be restrictive of its movement.

The ethos of individual schools was not seen to limit curriculum choices, but several interviewees did refer to the cultural poverty of their pupils and how this limited what pupils could assimilate. Decisions and guidelines by school art departments were generally seen as enabling, to the extent that heads of department were generally very supportive of teachers choosing curriculum content to suit their own interests and skills. However, few departments furnished policy documents setting out the philosophy of art learning and teaching, restricting themselves usually to the more prosaic aspects of planning and curriculum foci. Those that did address philosophical and conceptual issues in describing their curricular approaches were more likely to be amongst the CAP cohort.

Both department documentation and interviewee discourse revealed a very prevalent orthodoxy that the teaching of art skills at key stage 3 should precede a move towards more exploratory and independent learning at key stage 4. There was a discernible tendency amongst heads of department in CAP identified schools to focus more on pupil experience, the importance of

ideas, current events and external stimuli (such as gallery exhibitions). However, less than a third of interviewees were of the definite opinion that their curriculum adequately reflected current developments in the art world, some questioning whether it could or even should. It might be argued that several of the features identified above suggest that only a minority of art teachers seek to challenge what has emerged as a prevailing orthodoxy in art teaching.

Resource Issues

A number of specific resource factors were perceived to inhibit curriculum content choices, namely space; the availability of materials, art images or computers; access to galleries and/ or artist studios; and time. Of these, space was the most widely cited inhibitor, affecting teachers in CAP and randomly identified schools equally. However, teachers in randomly identified schools were more than twice as likely to cite resource shortages and shortage of time as inhibitors. One might question whether this is the result of actual difference in the time or resources available, or a difference in attitude between the two cohorts of teachers.

Teacher-specific Issues

Differences in the training backgrounds of the two cohorts were also evident, with teachers in CAP identified schools being somewhat more likely to have a fine art degree. References were made in interviews to the need for teachers to share their expertise and knowledge, and the only individuals specifically identified by other teachers as sources of artistic references were those with fine art degrees.

Staff in CAP identified schools were more likely to have worked as professional artists before entering teaching, and thus may be able to share a more informed understanding of the art production process with their pupils. There appeared to be a scarcity of courses in art or art teaching for practicing teachers. Courses related to GCSE examinations, especially concerning assessment, comprised the majority of CPD opportunities for both teachers and heads of departments.

These issues may be seen as particularly important factors in determining curriculum content given the apparent freedom that art teachers (as compared to teachers in other subject areas) have in choosing curriculum content.

Issues Relating to Keeping Abreast of Art Developments

References were made in interviews to the need for teachers to share their knowledge of artists, genres and examples, either through teacher networks or within department teams. Courses run by galleries were more likely to be referred to by heads of departments than by art teachers. Visits to galleries were easily the most frequently cited means of keeping up with developments in the art world, but a significant number of interviewees referred to the shortage of time to visit galleries themselves, while the opportunities to take pupils to visit galleries were frequently perceived as restricted by either time, money or bureaucratic obstacles. Other means cited for keeping up with the changing art world were publications, followed by personal contacts or networks.

Issues Relating to Teacher Attitudes to Art Images

When asked directly what influenced their choice of images for inclusion as curriculum content, personal preference was easily the most frequently cited factor. The accessibility of images to pupils was also frequently cited, features including attractiveness and the need to be understandable and not too conceptual. Others referred to the desire to challenge pupils or to 'get them thinking'.

When responding to a set of six specific images, it became clear that the capacity of an image to support the learning of art form skills was a very important factor. Images less relevant to skill learning, even if they elicited more comments concerning their value in terms of content and meaning, were less likely to be included in the curriculum.

An image raising potentially embarrassing or personally challenging issues (such as Billingham's photograph of his parents kissing) was less likely to be included than an image thought to offer opportunities for skills teaching, even though the latter might be regarded by some as boring or over-exposed, as in the case of Van Gogh's Bedroom or Warhol's images of Marilyn Monroe.

Perhaps curiously, teachers from randomly identified schools were more likely to refer to the meaning and issues in the images than were their colleagues in CAP identified schools. The reason for this is unclear. One hypothesis is that teachers in randomly identified schools felt a greater need to justify an image that they might otherwise have to reject on the basis of what they saw as limited artistic value.

Finally, there appeared to be evidence of a slow-changing orthodoxy in the choice of curriculum content, with some teachers continuing to include certain images (Van Gogh, Warhol) even though they saw them as boring or over-exposed.

The Perceived Value of the Art Curriculum and the Particular Contribution that Contemporary Art Practice Might Make to It

Teachers in the full sample of schools identified a range of effects associated with the study of art that largely reflected the typology of effects associated with the study of the arts in general, proposed in Harland et al.[2]

The most commonly cited category of effects was art form knowledge and skills. This included the development of skills and techniques as well as increased awareness of artist and genres and art appreciation.

Other frequently referred to categories of effects included knowledge in the social and cultural domain; personal and social development and extrinsic transfer effects. The overall perceptions of the teachers in both cohorts of schools were similar, and, for the most part, the limited data collected through pupil interviewees supported the teacher's perspectives.

Teachers in the CAP identified schools were asked why they chose to incorporate contemporary art practice to their curriculum. The main reasons given for the inclusion of contemporary art were:

- To provide a curriculum that is more interesting, relevant and accessible to the pupils.
- To increase pupils' understanding of the wider art world and challenge the notion of 'what is art?'.
- To allow individual teacher preference for contemporary genres to be reflected in the curriculum they taught.

None of the schools in the CAP identified sample displaced the more 'typical' overall curriculum design, based in a skills-led progression, with contemporary art practice. Instead, they enhanced and broadened their curriculum content, apparently with the intention of making it more inclusive in terms of pupil interest, teacher interest and the breadth of art studied. They also appeared to be incorporating a greater attention to the exploration of meaning in art and, indeed, the meaning of art. It is notable that the reasons cited above for including contemporary art practice in the curriculum were diametrically opposed to the views of some other teachers, who saw contemporary art as inaccessible for their pupils, either emotionally and intellectually.

Interviewees in the CAP identified schools suggested that the inclusion of contemporary art practice enhanced the more general effects of art education in the following ways:

- Art form knowledge and skills, particularly a wider understanding of what is art/what art can be, through the study of contemporary artworks.
- Intrinsic and immediate effects, focussing on the heightened awareness of the relevance of art to pupils' own lives and the subsequent effect this has on their motivation and enthusiasm for studying and creating artwork.
- Creativity and thinking skills, particularly the development of pupils' lateral thinking skills.
- Knowledge in the social and cultural domain, primarily the increased understanding of social, environmental and citizenship issues through the study of issue-based art images.
- Communication and expressive skills, primarily increased visual communication skills through the study of art for meaning.

This research does not suggest that these outcomes are not produced through curricula that do not include contemporary art practice, only that these are the particular claims made by those espousing contemporary art practice.

Implications for Policy and Practice in Visual Art Teaching
The findings of the research suggested a number of questions that might be worthy of addressing. It is assumed that most, if not all of them, are questions that already exercise the minds of those concerned with art teaching in secondary schools. It is not our intention to suggest that there are two bodies of teachers that have opposing views on each of the questions posed below, rather that the findings from this research revealed no overall consensus on each of the questions identified.

- Is a wider range of artistic genres or references appropriate for a more effective art education? Or should teachers focus on those genres with which they are familiar and confident, even if they are drawn from a narrow historical range?

- Is it appropriate to maintain the current balance between attention to art skills and attention to meaning in art? Would a greater focus on meaning and content alienate some pupils, or would it elevate the status of art as a subject in the curriculum?
- Is contemporary art practice an appropriate component of the school art curriculum? Is it accessible and meaningful for pupils, or beyond their comprehension? Would it engage them and support their learning, or is it too intellectually or emotionally difficult?
- Can contemporary art practice be accessed effectively for inclusion in the school art curriculum? Do the very forms of contemporary art make it problematic for inclusion in classroom practice?
- Can contemporary art practice support the apparently prevalent purpose of teaching art skills? Would it be a distraction from what many teachers (and probably pupils) see as the fundamental purpose of art teaching?
- Are teachers equipped with the knowledge and understanding to incorporate contemporary art practice in their teaching? Are there sufficient opportunities for continuing professional development relating to contemporary art practice?
- Is the freedom of choice of teachers to define art curriculum content an appropriate method of selecting the cultural and artistic references to be included? Is the correct balance between teachers' personal interest and a breadth of reference for pupils currently being achieved?

Curriculum development in statutory education is sometimes seen as the responsibility of policymakers, at either academic or governmental level. In the case of art, that responsibility seems to rest to a considerable degree with teachers. It has become apparent that efforts are already being made to both encourage and enable art teachers to embrace contemporary art practice in their teaching. Several interviewees referred to the value of such efforts, but also to the scarcity of opportunities. There were also calls for more support in this field, for example in the form of information concerning exhibitions, courses, publications and websites.

Rather than focusing on whether a school does or does not address contemporary art practice as part of its art curriculum would seem to be less significant than whether it does, or indeed should, offer an eclectic approach to curriculum content and aims. It may be appropriate for any future debate and dialogue to focus more on these distinctions than specifically on the issues of contemporary art practice.

Why we include art in the school curriculum, and what sort of content could best support our purposes, are still fundamental questions. In a changing world those questions may need constant attention.

Notes
1. The full report upon which this article is based in published as a book: Downing, D. & Watson, R. (2004). *School Art: What's in it? Exploring visual arts in secondary schools*. Slough: NFER.
2. Harland, J., Kinder, K., Lord, P., Scott, A., Schagen, I. and Haynes, J. with Cusworth, L., White, R. and Paola, R. (2000) *Arts Education in Secondary Schools: Effects and Effectiveness*. Slough: NFER.

10

A Preliminary Survey of Drawing Manuals in Britain c. 1825–1875

Rafael C. Denis

Among the many sources available for looking at nineteenth-century art and design education, drawing manuals stand out for their exceptional ability to uncover the many nameless procedures and discourses which only rarely filtered through to more formal expressions of theory and policy. Sifting through the great mass of 'useful knowledge' contained in the many hundreds of manuals published throughout the period, they can be found to contain a wealth of contemporary ideas not only on drawing instruction itself but also on art and education as broader social issues, often revealing hidden attitudes or barely articulated ones which, nonetheless, underpinned the nature of instruction at the time. Drawing manuals possess the further advantage of reflecting a wide and eclectic range of practices, often blurring or cutting across otherwise rigid barriers within nineteenth-century education demarcating divisions of age, gender, class or nationality. Despite their potential usefulness, however, surprisingly little has been published on the subject[1] The aim of the present article is to provide an initial survey of the historical development of drawing manuals during the critical fifty-year period spanning the middle part of the nineteenth century, in the hope that this will encourage more extensive research in the field.

Until the 1830s, most treatises on drawing were directed almost exclusively towards well-to-do amateurs interested in sketching landscape and/or figure drawing, in pen and ink, sepia and watercolours. Like all illustrated books of the time, these tended to be fairly expensive items, a fact which necessarily limited their circulation. A series of technological developments throughout the first three decades of the century – including the coming of the steam printing press and the increased use of wood pulp as a raw material for paper-making – greatly reduced publishing costs, contributing significantly to the expansion of a new reading public among the middle and working classes.[2] These segments of the editorial market were subsequently

targeted with a barrage of elementary drawing manuals, a new cheaper range of manuals on landscape and, increasingly after 1850, manuals on technical subjects such as geometrical drawing, mechanical drawing and drawing for specific trades like carpentry or bricklaying. Manuals were often published in conjunction with the manufacture of artistic materials by companies such as Ackermann & Co., Reeves and Sons, Winsor and Newton or George Rowney and Co., the latter two coming to dominate the largely amateur market for manuals during the late nineteenth century. Publishing houses like John Weale's, Chambers' and Cassell's were responsible for many of the technically oriented manuals, especially the cheaper ones, which found a ready market among the upper reaches of the working-class public. Prices for manuals during the Victorian period began at one penny or sixpence for very simple 'drawing-copies' and ranged as high as several pounds, with most resting in the one shilling to two and sixpence range. Drawing books published in parts proved to be extremely popular, especially in the segment of elementary and technical manuals geared to artisans and mechanics, who might not be able to afford a single large outlay but were willing to invest smaller amounts over an extended period of time. A successful manual easily achieved four or five editions in as many years, and the most popular ones sometimes reached upwards of ten editions in a career spanning as many as thirty years or more in print. By the late 1840s and early 1850s, the supply of drawing manuals was already so great that one especially prolific author, Nathaniel Whittock, felt moved 'to apologise for adding to the number'.[3] Most of his fellow authors, however, saw the overwhelming demand for new editions as justification enough for writing even more manuals.

The impact of cheap engraving and printing was so immediate that the engineer and writer of manuals Robert Scott Burn described this contemporary revolution in mass communication as 'more powerful than the press for printing words'.[4] Independently of purely technological considerations, though, the expansion of the market for manuals cannot be dissociated from the broader drive to popularize instruction in art and design which served as a backdrop for the growth of educational and cultural institutions like those of South Kensington. The Department of Science and Art was itself a powerful agency for the dissemination of manuals sold, issued and distributed under its authority by the publishers Chapman and Hall. Manuals often came recommended with the sanction of the Department, the Society of Arts, the Committee of Council on Education and other educational or charitable entities. Within a few decades, drawing ceased to be perceived as simply an 'elegant art' contributing to 'a genteel education' – as Whittock described it in 1830 – to become a necessary part of general education, for children of both sexes and all classes, as well as many working-class adults.[5] An 1853 circular from the Committee of Council on Education reinforced this point, stating firmly that drawing 'ought to no longer be regarded as an accomplishment only. . .but as an essential part of education', and, by 1864, the Schools Inquiry Commission reported that 95 percent of grammar and other publicly supported schools were teaching drawing to children, while 92 per cent of private schools were doing so.[6] The speed and efficiency with which the new educational establishment succeeded in transforming drawing instruction into a standard commodity must be attributed, in no small degree, to the exceptional power of printed manuals and examples as tools for spreading visual knowledge.

With the initial expansion of the market between about 1825 and 1830, the comparative uniformity of manuals in terms of format and price gave way to more variegated and sophisticated publishing strategies. Whereas an older style of treatise like Dougall's The Cabinet of the Arts (published circa 1815) tried to encompass as many aspects of artistic practice as possible – claiming not only to teach drawing but also etching, engraving, perspective and even surveying – the newer manuals began to address particular media, topics of interest and stages of proficiency in a rather more specific manner. Some of the earliest books emphasizing the possibility of learning elementary drawing without the aid of a master were published around this time, such as Thomas Smith's The Art of Drawing in Its Various Branches or Whittock's The Oxford Drawing Book, both dating from 1825.

Although both these books still bore a strong stylistic resemblance to the widely prevalent manuals of amateur sketching authored by noted landscape painters like David Cox, Samuel Prout or John Varley, they made an effort to adapt the tone and content of their lessons to a new audience which might possess neither previous experience of drawing nor ready access to private instruction. The latter book appealed quite unashamedly to the pretensions towards gentility of its eager middle-class public, couching the simplicity of its method in artfully Romantic assertions of the elegance of drawing as a pastime.

The 1820s also witnessed the initial publication of one of the earliest truly rudimentary drawing manuals for a mass public. Taking advantage of a format popular at that time for learning all sorts of subjects, Pinnock's Catechism of Drawing first appeared around 1821, running into at least two subsequent editions in the 1830s, and followed by Robert Mudie's A Catechism of Perspective in 1831. Although the question and answer structure of the catechism left little room for anything substantial in the way of visual instruction, the fact that drawing was considered to be a form of knowledge worthy of inclusion in a popular educational series even at this early date is significant. One final manual worth mentioning in the context of the 1820s is Louis Benjamin Francœur's Lineal Drawing, and Introduction to Geometry, as Taught in the Lancastrian Schools of France (1824), the first of two English-language translations of Le Dessin Linéaire (1819). Francœur was the author of treatises on mathematics and mechanics, and this simple manual was intended for elementary instruction using the monitorial system.

Nonetheless, the book broke new ground in two ways: first, it was specifically directed towards the 'middling and lower classes of society' and, second, it attempted to address geometrical drawing as a subject in its own right, apart from the artistic aspects of the study.[7] The tendency thus inaugurated of directing working-class practitioners to a particular kind of low-level, technical drawing is certainly of grave import, but it is a subject too large and complex for the scope of the present discussion.[8]

Despite these early examples, both the number and variety of drawing manuals published in the 1820s and 1830s were still comparatively small. A few truly technical manuals appeared occasionally during the 1830s, like Thomas Sopwith's A Treatise on Isometrical Drawing (1834) or Blunt's Civil Engineer and Practical Machinist by Charles John Blunt, but these tended to be expensive volumes, directed to very restricted professional groupings like geologists and civil

engineers. Growing public and political agitation over education during the 1830s contributed to changing all that, however. The formation of the Committee of Council on Education provided an important incentive by creating an authority interested in bringing out standard classroom texts, particularly in terms of drawing instruction, which had not heretofore been perceived to be an integral part of education by any of the sectarian publishing societies. One of the first drawing manuals published under the sanction of the Committee of Council was C. E. Butler Williams' *A Manual for Teaching Model Drawing from Solid Forms* (1843). Butler Williams was a key figure in the history of popular drawing instruction, being among the first to teach drawing on a large-scale basis in his classes at Exeter Hall. His system of teaching drawing from three-dimensional models was based on that of Dupuis, in France, and constituted something of a landmark in the struggle against the widely prevalent practice of copying from the flat, which he dismissed as mere rote-work.[9]

The book was a great success and contributed to the popularity of methods that employed simple models made of wood or wire in learning to draw basic geometrical shapes. Benjamin Waterhouse Hawkins's *The Science of Drawing Simplified* was published that very same year, sold complete with a set of models and a portable cabinet box for a rather pricey two pounds and two shillings. Other systems of model drawing continued to be very popular throughout the remainder of the nineteenth century.

Probably the greatest editorial success among drawing manuals of the 1840s was J. D. Harding's *Lessons on Art* (1849). Although the first edition was priced well above the reach of even some middle-class learners, at 21 shillings, the book proved to be enormously popular and went into ten editions over the following three decades. Harding, of course, is better known as a landscape painter; yet his influence as a drawing master was enormous by any standard. *Lessons on Art* typifies the 'progressive method' which became almost standard in the elementary manuals of the latter half of the nineteenth century. The first lessons begin with the free-hand drawing of straight lines, angles and rectilinear shapes, moving from there to curves and solid geometrical shapes. The second section of the book involves applying these abstract shapes to simple objects and buildings: drawing a fence from intersecting parallel lines or a bridge from an arc. The third section then moves back to circumscribing solid objects with abstract geometrical shapes, as a simplified means of introducing perspective drawing. More complex objects, larger-scale buildings and whole landscape scenes follow in subsequent sections. The system relies on creating a dynamic tension between abstract shapes and real objects, thus establishing an easy and logical transition from representing two-dimensional surfaces to three-dimensional space. Harding's methods were widely copied by other elementary manuals of the period, but rarely with the same success.

The fact that many elementary manuals employed very similar approaches to drawing is no coincidence, since they were often directed to a fairly homogeneous segment of the public: namely, children and youths of the middle classes, as well as the drawing masters who taught them. Of course, there were those who could not afford drawing masters, and, accordingly, self-instruction became an important aspect of the compilation of manuals, many of which emphasized their effectiveness in learning without a master or even as aids for schoolteachers

who did not themselves know how to draw. As opposed to supervised work, however, self-instruction posed the risk of students deviating from approved methods and examples. In order to minimize this danger, most manuals stressed the importance of close adherence to the prescribed instructions. In fact, the preoccupation with surveillance was so strong that some authors took the trouble to detail the finer points of how students should sit, hold their chalk, clean their slates or sharpen their pencils. Butler Williams' manual was an extreme example of this disciplinarian attitude, including fourteen pages of minutely itemized directions regarding nearly every aspect of classroom practice[10]

Another exceptional manual produced in the 1840s was William Dyce's *The Drawing Book of the Government School of Design; or, Elementary Outlines of Ornament*, which was initially printed for the use of students at Somerset House in 1842 and 43 but was not made generally available until 1854. Dyce's manual offered a radical departure from previous methods of drawing instruction, not only in the way its exercises were organized but also in the complex theoretical discussion of the nature of design and ornament which constitutes much of its introduction. The pedagogical dimension of the book is, however, by no means overshadowed by its theoretical importance. The first section deals with 'geometrical design' and consists of 45 exercises based on combinations of flat geometrical figures and their application to abstract patterns and schematic botanical forms. The first ten of these exercises are clearly derived from Francœur's *Lineal Drawing*, taking students from drawing simple lines to circumscribing polygons in circles. The increase in difficulty from one exercise to the next is, however, much greater than in Francœur's book, as suits a manual intended for use by adults or young adults, rather than children. The remaining exercises on geometrical design take the student from copying diaper patterns composed of straight lines and polygons to arranging curved lines tangentially around an axis, suggesting abstract representations of leaves, trees and other elementary plant forms. These schematic 'tracings' (as they have sometimes been called) were widely appropriated by later drawing manuals.

Dyce's second section, on 'freehand design', constitutes the real novelty in terms of drawing for ornamental purposes. Unlike Francœur, he does not proceed from flat geometrical figures to solid ones but opts instead for 'a progression...from the conventional form to [the] natural types', sticking mainly to unshaded linear drawing.[11] Beginning with conventionally treated (i.e., flattened out and symmetrically displayed) plant forms, the exercises in this section take learners through patterns, mouldings and complex ornaments, incorporating natural elements into the schematic design. What was innovative in Dyce's system was his insistence on flat outline as the only correct form of representation in ornamental drawing, rejecting naturalistic representation as incompatible with the purposes of applied design. Contrary to the prevailing attitude of regarding ornamental drawing as a less developed form of imitative drawing, Dyce based his method on the declared assumption that the two procedures are fundamentally opposed in their very conditions of existence. His ideas on the 'abstractive' and 'reproductive' nature of ornamental art, as opposed to the 'imitative' nature of fine art, are at the root of many similar principles later expounded by Richard Redgrave, Owen Jones and Christopher Dresser, thereby constituting what may be one of the first attempts to place design on a separate but equal footing to fine art.[12]

Although Dyce's reflections are fascinating in terms of the subsequent development of artistic theory and practice, they did not manage to achieve much of an immediate impact. On the contrary, even though the plates and exercises of his book were widely circulated and reproduced throughout the mid-Victorian period, they were often sold separately from the text, and the deeper influence of his thinking on the nature of art and design must be traced indirectly through the work of subsequent writers.

The other great theoretically inclined manual of the middle part of the century, John Ruskin's *The Elements of Drawing, in Three Letters to Beginners* (1857), managed to achieve a good deal more in the way of shaking up cherished beliefs regarding the nature of artistic instruction. Originally published in response to demands that he make generally available the system of teaching he had been employing at the Working Men's College since 1854, Ruskin's book can be taken as a calculated blow to the practice of copying by rote which Butler Williams and Harding (who taught Ruskin) had already condemned in their manuals of the 1840s. Indeed, it was intended as such, directing a good deal of rather inflamed invective against South Kensington's methods and purposes: '[t]ry first to manufacture a Raphael;' Ruskin famously wrote, 'then let Raphael direct your manufacture'.[13] The actual exercises certainly retain a bit of the radical flavour of the politically motivated part of the text, though they fall somewhat short of the boldest experimental methods employed in the Working Men's College. Perspective is, nonetheless, repudiated as useless to elementary drawing, inaugurating a new tradition of presenting it not as a fundamental study but as a rather unnecessary constraint, outline drawing is castigated as unnatural, a position Ruskin would reverse in his later writings; disciplined work is regretted as a monotonous but indispensable formality, and colouring is presented more freely than in previous texts geared to a popular audience. Such instructions were written off in some quarters as 'amusing absurdities', as *Blackwood's* qualified them, but their influence in art and design education has been enduring.[14]

Steering away from the usual straight lines, Ruskin's manual begins with an exercise on shading, essentially geared towards mastering the manipulation of pen and ink. In order to vary the type of work, the learner then proceeds to an entirely different type of exercise, copying outline and flowers from the flat, using tracings to compare the copy to the original. The third exercise moves back to shading, this time concentrating on producing a perfectly gradated band of shades ranging from white to black. The fourth and fifth exercises introduce the use of the pencil and apply that knowledge to shading in letters of the alphabet and then outlining them, a common type of exercise in the 1850s. The next exercise brings a more original departure, prompting students to look at the bough of a tree against a grey sky and to draw its outline not by examining the branches themselves but by looking at 'the white interstices between them', stressing the appearance of forms and how they are perceived over the actual shape of objects. The following exercises introduce the use of watercolours, repeating the process of moving from abstract shading exercises to leaves and trees. A total of ten exercises constitutes the first of the 'three letters to beginners' and represent the organized core of Ruskin's method of teaching elementary drawing. The second letter, on 'sketching from nature', provides more of a discussion of representing landscape and less of a structured system of instruction. The third letter, on 'colour and composition', offers suggestions on mixing and harmonising colours and arranging

composition. Ruskin is at pains to point out that 'so far as it is a system', the aim of his system is 'to get rid of systematic rules altogether, and [teach] people to draw as country lads learn to ride, without saddle or stirrups'.[15] Although it would be disingenuous to take this statement at face value, the most remarkable aspect of *The Elements of Drawing* does reside in its willingness to ignore prevailing pedagogical orthodoxies and to challenge hierarchical notions about what constituted 'elementary' and 'advanced' aspects of artistic instruction.

Neither Dyce's nor Ruskin's manuals were typical, however, of those dominating the British market at mid-century. The 1850s gave rise to a new force in the realm of art and design education in the shape of the Department of Science and Art; and, appropriately, those manuals corresponding to the system of instruction at South Kensington came into their own at around this time. Depressingly representative of these are two books covering 'Rudimentary Art Instruction for Artisans and Others, and for Schools', prepared by the sculptor John Bell at the request of the Society of Arts, of which he was a prominent member. Bell's, *Outline from Outline, or from the Flat* and *Outline from Objects, or from the Round* appeared in 1852 and 1854, respectively, focusing on what were described as the 'less ambitious but generally more useful requirements of the artisan and art-workman', purportedly at the expense of 'the highest representative art'.[16] Despite claiming applicability to the purposes of work, the method espoused in these books was fairly rudimentary and the exercises quite shoddy, consisting largely of mere copying with occasional tips on the use of guiding lines and other simple time-saving techniques. They were, however, relatively affordable at three to four shillings and were only slightly worse than most of the other manuals being published at around the same time. Hannah Bolton's *Drawing from Objects* (1850), prepared for the Home and Colonial Training Schools, attempted to provide a little more in the way of theory and repudiated copying from the flat, opting for the Dupuis models instead; but it still offered a fairly dull and repressive system of learning drawing, despite the higher price of seven shillings. Another widely employed manual of the time was *Drawing for Elementary Schools* (1857), authored by Ellis A Davidson, headmaster of the Chester School of Art, who went on to achieve great editorial success through the 1860s and 1870s writing cheaper manuals geared to a working-class audience for the firm of Cassell, Fetter and Galpin. His 1857 manual provided a typically composite method of elementary drawing, moving from lines, angles and curves on to Dyce's 'tracings', on through the use of guiding lines and culminating in a process of copying outlines of tools and implements of domestic, agricultural and industrial labour. Like many authors of the time, both Davidson and Bolton believed wholeheartedly in the virtues of teaching working-class children to study and admire the articles of their future trades.

The number of drawing manuals published after 1850 rose so steeply that the output of any single decade of the latter half of the nineteenth century would probably surpass the entire production of the first fifty years. Authors like Richard Burchett, Horace Grant, Walter Smith, Charles H. Weigall, P. H. Delamotte, F. Edward Hulme and others already mentioned, like Whittock, Harding and Davidson, managed to stay in print almost continually for periods of up to four decades; and, as the market expanded, manuals grew cheaper and more accessible.

The publishing firm of William and Robert Chambers, of Edinburgh, was among the first to forge ahead with the publication of a complete course of Drawing and Perspective in a Series of Progressive Lessons, published between 1851 and 55 in a series of 26 booklets costing from one shilling and sixpence to two shillings each. Each book covered a different subject, beginning with elementary lessons in book one and moving on to figures, animals, landscape and perspective as well as mechanical and architectural drawing in the most advanced books. By the late 1860s, Vere Foster's Drawing-Copy Books were published at the even lower price of threepence each; and, in 1871, Cassell's Penny Drawing-Copy Books brought prices down as low as they would go. The quality of such materials was, of course, negligible, consisting of cheap examples to be copied from the flat; but many higher priced manuals were often only marginally better. This great growth in the supply and availability of manuals brought not only an increase in quantity but also in variety. Manuals geared to technical drawing and engineering became very prevalent after the 1850s, for instance, whereas they had been conspicuously scarce earlier in the century.

Perhaps the most influential of these technical manuals was not British at all, but French. Armengaud, Armengaud and Amouroux's *Nouveau cours raisoneé de dessin industriel* (1848) was first published in English in 1853 as *The Practical Draughtsman's Book of Industrial Design* and later re-published in part as *The Engineer and Machinist's Drawing Book* (1855). These books were the progenitors of a whole range of manuals on geometrical drawing engineering drawing, orthographic projection mechanical and machine drawing which proved to be highly successful throughout the latter half of the nineteenth century. Their special appeal resided in the scale drawings of working machines and machine parts which were thus made available to a much wider audience than ever before. Two of the most popular authors of such manuals were William S Binns who was employed as master of mechanical drawing at Marlborough House and the Government School of Mines, and the engineer Robert Scott Burn, whose numerous works include *The Illustrated London Drawing-Book* and *Mechanics and Mechanism*, both of which managed to stay in print for about forty years after their initial appearance in 1853. The increased demand for technical manuals reflects a fundamental shift in the way instruction in drawing was already moving away from being strictly the preserve of artists, towards a wider role in scientific and vocational education as well.

The rise of technical manuals did not imply a corresponding decline in the supply of drawing books geared to landscape. With increasing leisure for a larger segment of the middle classes a new market for amateur sketching blossomed after the 1830s, and the number of landscape manuals tended to grow continuously. Significantly though, the amateur manuals of the 1850s and 1860s were no longer the expensive, elegant tomes of the early part of the century but often no more than cheap paperback editions costing as little as one shilling, Thomas Rowbotham's *The Art of Sketching from Nature*, published by Winsor & Newton in 1850, went through eighteen editions in just five years, making it one of the most unqualified editorial successes of that or any other time. Landscape sketching seems to have survived the demise of the traditional eighteenth-century 'amateur' precisely by recasting the class-specific appeal of that identity along more popular lines, thereby transposing the ideal of gentility to an ascending middle-class public. This sort of social crossover in terms of the specificity of particular educational

practices became increasingly common as the century wore on. By the 1870s, the market had become so fragmented and complex that drawing manuals of every type were available in every price range: in other words, it was no longer possible to assume that landscape was upmarket or that elementary self-instruction was strictly for those who could not afford lessons. Even technical manuals, which had traditionally been associated with a working-class public, began to appear in luxury editions by the late 1860s and 1870s, as wealthy and successful mechanical engineers formed their libraries.

Despite this increasing fragmentation of the market during the period under investigation, nineteenth-century manuals possess a striking homogeneity in their terms of discourse; and certain recurring themes can be singled out as underpinning the conceptual framework within which drawing instruction tended to operate. Even though a proper discussion of the significance of these discourses is beyond the scope of the present article, it may be useful to point out their existence as a means of concluding this brief historical introduction. Five propositions seem to recur with extraordinary regularity: first, that drawing is important as a source of useful knowledge and moral edification, especially for the lower classes of society; second, that the exercise of drawing is particularly suited to training eye and hand, thereby perfecting their mutual operation; third, that drawing and writing are fundamentally related as forms of visual and manual expression, making it advantageous to learn them in tandem; fourth, that drawing is a universal language, comprehensible to people of all races and nationalities, and therefore of great utility in commerce and industry; and, last, that drawing provides a means of intellectual and moral refinement, exercising an elevating influence capable of raising the mind above sensual or material pursuits. The bearing of these pedagogical assumptions upon even larger issues involving the associations between work and leisure, mind and body, individual and society, science and art, is indeed portentous and deserves to be explored in a much deeper and more systematic manner than has heretofore been the case. A heightened attention to the significance of manuals as constituent elements in the construction of nineteenth-century educational agendas will make the task of unravelling the complex meanings of such intriguing discourses a more fruitful one.

Notes

1. The Fitzwilliam Museum's exhibition catalogue *Gilpin to Ruskin: Drawing Masters and Their Manuals, 1800–1860* (1988) provides a good introduction to the early part of the century, focusing mainly on books geared to amateur sketching. David Jeremiah has done useful research on the Society of Art's role in publishing manuals; see 'The Society of Arts and the National Drawing Education Campaign', *Journal of the Royal Society of Art*, 117 (1968–9), esp. 440–442. Some further writings are available on drawing manuals in the USA; see Marzio, P C (1976) *The Art Crusade: an Analysis of American Drawing Manuals, 1820–1860*; and Korzenik, D. 'How to Draw' Books as Sources for Understanding Art Education of the Nineteenth Century', *Journal of Art & Design Education*, 4 (1985), 169–77. The development of engineering drawing has been usefully surveyed in Baynes, K. & Pugh, F. (1981) *The Art of the Engineer*. For an insightful discussion of late-C19 drawing instruction in the context of its influence on Modernism, see Nesbitt, M. (1986) 'Ready-Made Originals: the Duchamp Model', *October*, 37, 53–64. The same subject is taken up in greater detail by Molly Nesbitt in 'The Language of Industry' in Thierry de Duve, (ed.) (1991) *The Definitively*

Unfinished Marcel Duchamp 351–84. Finally, the National Art Library (Victoria & Albert Museum, London) has a compilation of C19 drawing manuals.

2. For more on the technological aspects, see Clair, C. (1976). *A History of European Printing*, esp. 355–83. On the expansion of the editorial market and the fragmentation of the reading public, see Goldman, P. (1994) *Victorian Illustrated Books 1850–1870*, 33–76; Richard G. Landon, (ed.) (1978), *Book Selling and Book Buying: Aspects of the Nineteenth-century British and North American Book Trade*, esp. 45–50; and Altick, R. (1957) *The English Common Reader*, passim.

3. Nathaniel Whittock, *A New Manual of Perspective* (1849), p. 5.

4. Burn, Robert Scott (1853a), *The Illustrated London Drawing-Book*, 129, and 144–5.

5. Whittock, Nathaniel (1830), *The Oxford Drawing Book*, iii. Among the numerous affirmations of the importance of drawing in general education, see Dark, John (1937) *Elements of Drawing and Perspective*, i; Burn, R. S. (1853a), *op. cit.* i-ii; Davidson, Ellis A *Drawing for* (1857), *Elementary Schools* p. v; Ryan, Charles (1868) *Systematic Drawing and Shading*, p. 9.

6. CCE circular cited in *Art Journal*, 1853, p. 98; Schools Inquiry Commission report cited in Hulme, F. Edward (1882). *Art Instruction in England*, p. 71.

7. Francœur, L. B. (1824). *Lineal Drawing, and Introduction to Geometry* pages 7, 69, and 82. An even earlier example of a book geared to technical drawing is Charles Blunt's *An Essay on Mechanical Drawing* (1811), which appears to have been much the standard reference on the subject during the early part of the century. It was, however, quite expensive at three pounds and sixteen shillings and certainly never reached a popular audience

8. For a full analysis of this subject and other aspects of mid-Victorian drawing instruction, see Denis, R. C. (1995). 'The Educated Eye and the Industrial Hand: Art and Design Instruction for the Working Classes in Mid-Victorian Britain' (unpublished PhD dissertation) Courtauld Institute of Art/University of London, Ch. 1.

9. Acland, T. D. (1858). *Some Account of the Origins and Objects of the New Oxford Examinations for the Title of Associate in Arts and Certificates*, p. 7n. Butler Williams was also professor of geodesy in the College for Civil Engineers; for more on his teaching, see Macdonald, S. (1970) *The History and Philosophy of Art Education*, p. 34.

10. Butler Williams, C. E. (1843). *A Manual for Teaching Model-Drawing from Solid Forms, the Models Founded on Those of M Dupuis*, 237–51.

11. Dyce, W. (1842–3) *Drawing Book of the Government School of Design*, section II, preceding Exercise 46.

12. *Ibid.*, p. i.

13. Cook, E. T. & Wedderburn, A. (eds.), *The Works of John Ruskin* (1903–12), v. 15, p. 12.

14. *Blackwood's Edinburgh Magazine*, v. 57(1860), p. 32; for more on the influence of Ruskin's ideas, see Richard Carline, R. (1968) *Draw They Must*, ch. 8–12; Haslam, R. (1988) 'Looking, Drawing and Learning with John Ruskin at the Working Men's College', *Journal of Art & Design Education*, 7, p. 69; and Efland, A. (1990) *A History of Art Education* 133–139.

15. Cook & Wedderburn, *op. cit.*, v. 15, 15–6.

16. Bell, J. (1852). *Outline from Outline*, iii–iv.

11

Early Obsessive Drawings and Personal Development

Sheila Paine

Drawing activity may not be inherently therapeutic, but evidence of the effect of (traumatic) experience in drawings, is especially apparent in the work of some exceptionally creative persons and of children who draw obsessively. The notion of drawing as potentially therapeutic rather than merely responsive, assumes that the activity and the imagery are interactive in some way with the personality and development of those who draw. This assumption is supported by a childhood-to-maturity case study, which focuses on the drawing and development of one individual with exceptional drawing skills, who has gradually emerged from acute learning, emotional and social difficulties. The evidence from his drawings over a twenty-year period is extended by his own memories (and by observations of him at the time) of their early motivation and significance. Some of his greatest difficulties were also the spur to his creative energy and the activity of drawing and the drawings themselves were instrumental in his maturation. I need to begin by stressing a view that creative activity in general cannot be explained *solely* or even predominantly in terms of response to instability of any kind in the personality or circumstances of the creators. First and foremost it seems to me that drawing (which is by definition creative), is a completely natural human activity and, as art, arguably the one which justifies all the other human activities; in the end, everything else is transient and mundane while art transcends and endures. To draw, and beyond that to be an artist, does not essentially require some psychological impediment, illness, social or practical disadvantage. Although the study of the personalities and lives of artists reveals many examples of those conditions, these are phenomena which are manifested to much the same extent across the human population as a whole.

Nevertheless, it would be unreasonable to deny the role of personality and circumstance in determining the nature (subject-matter, style and meaning) of any artist's productions or, more specifically, not to attempt to explain the astonishing obsession with drawing which emerges

so early in the lives of many children. Many artists have seen the impetus for their work as having emerged from the social or psychological circumstances of their lives rather than from some innate disposition as such. The English painter, Stanley Spencer (1891–1959) is alleged to have explained that his desire to paint is caused by being 'unable or incapable of fulfilling my desires in life itself'. That is, of course a hindsight explanation. Many of those starting out on the study of the practice of art or recalling their first reasons for doing so, will say that they simply (and passionately) wanted to draw and can rarely add that they had any particular projected purpose for the skill of drawing; it was felt to be a rewarding, not to say heady and demanding experience, in its own right and without the need for or possibility of explanation. The obsession with that apparently simple preoccupation may have been the only outward evidence at the time of a tendency to be artistic. There is, initially at least, little apparent difference between the childhood drawing activities of individuals who later become artists and those who do not, which is why it is sometimes worthwhile to look at the early drawings of the former in order to illuminate the processes of drawing in general.

It is rare for children, at the time, to analyse the causes of their own drawing behaviour. But in the recorded lives of mature artists, there are many examples which highlight the strongly affective relationship between personality, experience and (visual) expression. Some of the most interesting, describe the powerful mid-life changes effected in the nature of artistic activity, in particular, individuals who were already artists. Goya (1746–1828) suffered a highly traumatic physical and mental illness in mid-career, possibly with social as well as physical causes. Harold Osborne records that, although 'his artistic activity remained unaffected...signs of emotional change became apparent'.[1] This is something of an understatement, since the cloying compliance of the hired painter which characterizes much of his work prior to the illness, is replaced after it by a potent and frightening energy, expressive of a very different personality. The paintings and etchings he subsequently produced are often darkly menacing, brutally explicit, critically realistic or savagely satirical.

Other instances reveal how intensive creative activities were actually generated as well as formed by emotional experience: by domestic and family difficulties, bereavement, the anguish and horror of war, or by loneliness as well as illness. Like the example of Goya, they all point to a consequential relationship between expression, personality and circumstance. In discussing one such artist, the 'primitive' English painter, Alfred Wallis (1855–1942), Sven Berlin argued that it was the poverty, poor education and other early hardships, which eventually gave rise to obsessive artistic expression by forming the person the artist had become; without such hardship, he argued, he would never have become a painter, since...

> ...he would have been a happy, integrated human being...and his natural creative capacities would have flowed into all the avenues and alleyways of daily life.[2]

Berlin adds his belief that

> ...the only difference between child and mature artist is that the latter has as his heritage, the arts of all time and the experience of complex development.[3]

Berlin contends that the circumstances more than the original disposition of the individual bring about that person's urge to draw or to paint (and presumably are responsible too for what is expressed and how). In Goya's case, the trauma of the illness was rapidly effective in changing the nature of his work; in the case cited by Berlin, the trauma was cumulative over years, before it allegedly brought about the impulse in Wallis to make images at all. It is possible of course that from the build-up of emotional pressures in the working and domestic lives of some individuals, the eventual creative activity emerges as a kind of liberating force. It is, however, strange to argue that contented, rounded individuals do not do very much that is creative, although this is of course a notion originated by Freud after studying far too many neurotics.

The question remains as to whether *any* such individual might respond in this way, or whether in such cases the disposition to draw had been always present but insufficiently provoked by the circumstances of the earlier years. Such examples do not in themselves preclude the possibility that certain individuals, whether in childhood or in maturity, possess innate qualities which make the development of drawing skills more likely and more possible, even if they do not actually make it certain.

In the present century, many attempts to analyse the sources of creative energy have focused on the consequences, not so much of external pressures but of internal psychological ones through investigation of individuals who present themselves as neurotic patients. One such study, by the psychologist John Gedo, was of an (anonymous) patient whom he judged to be exceptionally creative to the point of being a genius. This individual had allegedly developed, early in life, 'conflict-free autonomous (creative) capacities'.[4] Gedo describes the likely childhood of the subject in such a way as to suggest a person of ordinary capabilities in most things but with some exceptional abilities 'beyond those of ordinary mortals'. From childhood the patient had felt himself to be both quite ordinary and in some respects also extraordinary, 'like a cuckoo in a nest of sparrows' as Gedo describes him. As he matured, he passed through stages of grandiosity and disillusionment, searching always to replace the fallible with the idealizable in the family, in religion and finally finding it in his own creative work.[5]

Gedo argues that his patient could only avoid 'the threat of a deficit in his self-esteem' by continually and relentlessly regenerating the creative act in himself. Based on this and other examples, Gedo envisages the creative disposition as a consequence of and a defence against emotional instability. One can only remain unsurprised that the study of neurotic patients throws up descriptions of high trauma, with creative action cast in the therapy role as well as trauma-induced. Such explanations seem entirely valid for some individuals, but inadequate as explanations for the entire range of creative impulse and obsession. And no explanation is offered for the early development of creative capacities to which he refers, which must have determined much that is argued as emergent from the psychological circumstances later on; Gedo's patient displayed creative interests before his psychological problems were evident.

It seems reasonable to suppose however, that all experience, the advantageous and the disadvantageous, might be affective, with the latter sometimes acting as a spur rather than a deterrent. It may well be that an element of personal courage is involved too; even in childhood,

the individual may require determination to overcome the feelings of insecurity inherent in the expressive act, however much predisposed to expressive action or provoked to it by circumstance.

Anthony Storr, from psychoanalytic arguments, suggests that two opposing drives operate throughout life: 'the drive for companionship, love, and everything else which brings us close to our fellow-men; and the drive towards being independent, separate, and autonomous'[6] and adds that more creative people seem more tenacious in pursuing the second of these two 'drives'. Storr's description could easily have more general application to the young, for whom as we all know from personal experience, the struggle to grow up is just like that. The general evidence from children's drawings supports such a view.[6] It could also be applied to specific categories of young individuals, those for whom physical illness, psychological limitation or neuroses, make the tension and its resolution that much more difficult.

The possibility that the act of creation, through drawing, can do more than reflect what is happening, can in fact affect the development of the creator, is one that tempts our consideration. While drawing is practical, intellectual, intelligent, conceptual and having its own logic, it is also in certain forms at least (and perhaps in most), deeply resonant with the expressive side of personality and feeling and therefore having the potential for interaction. It is a further question as to whether such interaction gives rise to the notional improvement in personality and behaviour which therapy implies. So the phenomenon of those exhibiting specific learning and emotional difficulties who nevertheless display exceptional drawing skills seems to have particular potential for the researcher. As with other exceptional individuals, their cases highlight the condition of otherwise normal behaviour. Their drawings, if available as evidence, can illuminate the history of their creativity-personality relationship, even though that evidence, because of its ambiguities, must be cautiously interpreted.

One individual however has been able to remove some of that ambiguity by being able to account retrospectively for some of the events which gave rise to his drawings and for the positive role which they directly played in helping him to deal with his life at various stages. David Downes is now a talented and successful artist, but as a child, he exhibited many of the behavioural phenomena which are normally associated with autism. Fortunately for him and unlike some such children, his development has been a success story; with each successive year, the symptoms faded and his abilities flourished, but not without considerable struggle on his part at every stage. He has had to cope with the social and educational problems which an unusual child encounters and to mature in spite of them. It has also been a journey remarkable for the continuity of the drawing impulse, for the way in which it was sustained by him while also apparently sustaining him. Numerous drawings over the years reveal the story of that interdependent relationship and how his personal difficulties were gradually overcome, in spite of so many discouraging experiences.

As a small child he had initial difficulty in learning to speak, in writing and in relating to other people. Only his precocious idiosyncratic drawing skills revealed to those more receptive individuals around him that his several disabilities of that time masked his considerable abilities.

David was born as the fourth of five children and the second of three sons. It is not too easy to say whether his first drawing impulse was prior to or a consequence of his difficulties with speaking. When it became apparent in infancy that he was not learning to talk at any reasonable pace, one of the strategies his parents devised for helping him was to encourage as much drawing as possible. He seemed willing and eager to draw, but his progress in speech continued to be slow; he appeared to have no wish to try, even to the point of seeming to withhold his co-operation. He would often sit in the centre of the lawn clutching a toy but isolated from the rest of the family. Though bad for his social development, his mother feels that this gave him time to look around on his own and so he did not have the need to copy which many other children have. There were nevertheless some occasions when he was not so remote, and before he was four for example, he displayed a surprising ability to tease his father; teasing is of course an essentially interactive skill and as such it must have signified the beginning of a struggle on David's part to emerge from his isolation.

The prognosis for David's development could not at the time have seemed all that encouraging. The family doctor perceived only a child whom he thought retarded and seemed to think help would not be wholly worthwhile. David's own hindsight diagnosis, having seen the problem from within at the time, is that he must have been suffering from a condition rather like a stroke, where some areas of the brain or the mind are functioning or have developed more slowly than others; he has written that

> Your life is then negotiated by the strongest area of the mind, in my case the observational. This can be of an incredible detriment to normal learning...(and this is where) the concept of obsession comes in.

There seems to have been a family decision taken to find a way of compelling David to speak. His parents and the older children devised games, using animal picture cards (such as 'Where is the pig?') and giving 'dolly mixtures' (small sweets) as prizes; he was given a lot of attention in such ways. Without any doubt, the decision and subsequent campaign was crucial, a rescue action from a condition that might otherwise have intensified. Speech came slowly but the initial impediment was overcome, as a gradual release from it. By this stage, drawing had become a regular and enthusiastically approached activity and these earliest drawings were surprisingly and explicitly representational; one such drawing made when David was just five years of age, is easily recognizable as a particular local church and greatly astonished the district nurse who happened to see David create it, on one of her visits. Spontaneous in line (from a 'biro' pen), the drawing effectively remembers the overall structure, solidity and strength as well as the detail of the church tower and nave. It is one of the first of what was to become a constant reportage by David of the nature and character of his own part of the Suffolk landscape. Like many of the numerous other drawings he did at the time, it is small and characterized by a delicate wavering line.

From the intimate nature of many of these works, it looks as though they were generated from some inner desire rather than from the outer encouragement of his anxious family. It remains an impossible question to answer as to whether so much drawing would have taken place if

David had not been so encouraged. From the distance of time as well as from things said by him while still a child, it is clear that he diffused his anxieties in an escapist way as well as analysed what he saw, through the making of these images. 'What consumed me' he wrote later, 'was my overwhelming desire to draw, and to express my emotions. The drawings did not convey isolation, they more communicated a desire to be swallowed up by this imaginary world'.

That world was for him a perplexing and at times alarming one. He was from early days both fascinated by weather conditions as well as particularly frightened by bad weather in all its forms. There was a special unease brought on by the similarity between the forms of some quite harmless objects and their visual meteorological counterparts: a bare-branched tree could be very worrying because it resembled lightning. Cracks in masonry (perhaps for the same reason) had the same effect and would cause him to stare in horror at them, once frightening his younger brother with the intensity of his gaze. He was abnormally afraid of low-flying aircraft; in that part of England, fighter aircraft undertook regular training. David remembers how he found them grotesque and the noise intolerable; he would scream loudly as they passed over. Possibly most alarming of all to him were windmills, of which there were a number of derelict ones in the area. Of these he remembers one in particular on the coast near Southwold:

> The prevailing winds and decades of desertion had sculpted it into a very twisted shape.
> I could not get within yards of it without bursting into hysterical fits of fear.

He also responded to unseen fears; he was terrified when he heard for instance of a man who had met a violent death in a nearby mill, having been trapped in the blades. Thus the drawings which feature trees, storms, lightning, clouds, broken walls, aircraft and windmills were not only stimulated by simply seeing what was around him in the Suffolk countryside but also, and even mainly, by the instinctive desire to defuse their threatening aspects. To achieve this he had to make the drawings look 'scary' and to incorporate in them the shapes and forms which he found (he says) so 'horribly grotesque'.

Not all the things with which he was fascinated were terrifying; some were simply persistently intriguing places which were observed on journeys by car to different towns and villages in the area. One other motivating idea seems related to his fears however, the notion of power. David now remembers that he had always been attracted to things powerful. He feels that this was never because he himself wanted to be powerful, but because he found the idea of it to be very exciting. There was power in the lightning which he also feared, but there was power too, implicit in the towers of churches and in the tall buildings. Especial power could be found in the animate, even when not directly encountered: 'I had these lion books for Christmas. I hadn't seen lions before; they were fierce and powerful'. There was power too in people, perhaps too much to easily accommodate at times: 'Uncle John was very grumpy, so I thought I would personify him as a lion', and he drew him disproportionately large and roaming fiercely across what is recognizably David's own bedroom. He also appears to have courted the destructive power visible in the demolition which he sometimes witnessed; he remembers being alarmed by the 'cranes with balls on the end, smashing buildings up to build skyscrapers that looked

even worse' and although he says he wasn't enjoying the damage, there was perhaps some of the usual boys' enjoyment of drama, danger and violence, along with the less usual anxiety, wilfully engendered by it.

One can argue that David was a child whose obsession was not the act of drawing in itself but the need to come to terms with the demonic phenomena which made him so afraid. Through incessant drawing, he could withdraw from some of his immediate fears about the people around him at school and he could face some of his most frightening experiences of the physical world by pinning them down on his paper and under his hand. The drawings of windmills, cities and wild weather conditions are paradoxically recollected by him as the 'only source of security in an insecure world'.

When, in adolescence, asked to make a portrait of a class-mate, he produced a remarkable profile study in pastel colour, which reveals not only the intensity of his observation and the level of his manipulative skill with the materials, but also his perception of the personality of the sitter. So acute an eye for character and feeling seems to deny the very problem of social interaction which had affected much of his early years as well as the sense of a 'mental wilderness' which he felt himself to be in and from which he was trying so desperately to emerge. Or perhaps it epitomizes his yearning interest in people and the way in which such drawings were created as a move to close the psycho-social gap between him and them. Many of David's adolescent drawings continue the picture of an individual attempting to overcome the problems that still remained. His experiences at secondary school were traumatic; he was rejected and taunted by the less intelligent of his peers and the art tuition which should have nourished his abilities directly, was largely alien to his own ideas and interests. While he did his best to adapt to what was required, he continued the mainstream of his activity at home, drawing, mostly with pen and wash, many fairly diminutive and intense studies of the locality. It was only when he eventually graduated to an art college that he found tutors who valued and knew how to make use of his highly personal drawing style in a wider artistic context.

Throughout his life, from the earliest years, David has never ceased to draw obsessively and with passion. The full record of his development in drawing and in overcoming his many difficulties, reveals the instrumental role of the drawing activity itself with great clarity at every stage. In later life, he has even drawn what may be regarded as a triumphant finalising statement on the windmills and the weather which so terrified him and which as a child, he had to keep portraying to hold the fear at bay. One can hope for further evidence as graphic as this in studies yet to be made, to extend and confirm this remarkable picture of a function of the drawing process. It is of course still only one explanation (or part of an explanation) for the obsession with drawing which some children so fascinatingly display.

Acknowledgement
I am indebted to David Downes and to Dave and Diana Downes for their generous help with this research over a number of years.

Sheila Paine

Notes

1. Osborne, H (1987) *The Oxford Companion to Art*. Oxford: Oxford University Press.
2. Berlin, S (1949) *Alfred Wallis: Primitive*. London: Nicholson and Watson, p. 69.
3. Berlin, S (1949) *ibid* p. 77
4. Gedo, J (1972) On the psychology of genius, in *International Journal of Psychoanalysis*, 53 (April 1972), 199–204.
5. *Ibid*
6. Storr, A (1988). *The School of Genius*. London: Andre Deutsch.

Other material

Downes, David (1994) Disordered Development, unpublished MA dissertation.
Paine, S (1985). The Development of Drawing in the Childhood and Adolescence of Individuals, unpublished PhD thesis, London University.

Editor's Footnote

A more comprehensive, illustrated account of this case study is included in Sheila Paine's book, *Artists Emerging: Sustained Expression Through Drawing*, Aldershot: Lund Humphries (2000).

12

Young People, Photography and Engagement

Nick Stanley

Introduction

It is quite unusual for research in art and education to be sustained for a period over a decade, and even rarer for joint collaboration between researcher and funding body to prosper and grow over such a span of time. The partnership between the Arts Council of England and Birmingham Institute of Art and Design looking into the role of photography in education formally began in 1992 when we jointly appointed Darren Newbury to be a researcher under the aegis of the photography and media education advisory teacher scheme.

But this was not really the start of the story. In 1990 I had been asked to chair the Arts Council of Great Britain's Photography and the National Curriculum Working Party which was dedicated to raising the profile of photography within the English National Curriculum and offering worked out examples of good practice for all of the entire age range of compulsory education. This group of twelve brought together specialisms across the range of photography and media education. Its publication *Creating Vision*[1] tackled not only curriculum planning but created a manifesto for photographic education, which included a conceptual process model. Two pairs of concepts were bracketed together: engagement and representation, and social context and social use. Engagement has proved a particularly fruitful term in subsequent research. The term refers to:

> ...the involvement of the self in the processes of reading and making photographs, the identification of the self in the process of producing photographs and consuming them. It is about what happens when and where the self and the photograph meet. Identification of the self in the process of looking involves understanding how the self is made to look – and how the self is represented.[2]

The second pair, social context and social use, demonstrate ways in which social values are embedded in both the making and reading of photographic imagery. Taken together the terms can inform what I have called 'critical practice'.[3] *Creating Vision* provided an excellent springboard for subsequent research.

Darren Newbury's project 'Styles and Sites of Photographic Education' lasted for three years. He initially tracked the career development of professional photography students in secondary and further education and paid special attention to vocational courses.[4] He employed the concepts developed in *Creating Vision* but stressed additionally the value of visual literacy. Here he had two considerations in mind. First, he coined the term, deconstructive visual literacy, to mean the ability of the student to demonstrate an understanding of visual texts through language. Second, he considered that the ability to communicate visually required the student to acquire and employ a visual grammatical structure.[5] He went on to pursue how this could occur practically in a range of case studies. At the same time he used his work towards a PhD, which he obtained in 1995.[6]

In 1997 the Arts Council of England provided another research opportunity through the teacher development post scheme. Roz Hall was appointed to the project 'Young people, digital technology and democratic cultural engagement' and worked continuously until 2002. She completed her PhD in 2000.[7] She has achieved new perspectives in photographic education through employing a democratic action research approach and in developing the concept of process generated evaluation. I consider these concepts later in this paper.

Throughout the decade a major source of strength has come through active collaborative alliances. Beside the Arts Council, West Midlands Arts has provided us with advisors and members of the board of management. We have also gained from partnership with photography agencies, Building Sites/Photopack in the first project, and joint direction with Jubilee Arts/ CPlex in the second. This has meant that we have been able to agree a mutual agenda addressing the interests of both parties. This has not always been easy. As Darren Newbury candidly records 'my experience of some of the early project meetings was of being spun round unsure of which way I or the project would end up pointing'.[8] As experience accumulates, there is a risk of becoming less adventurous. So Roz Hall had not only the benefit of joint supervision from Darren Newbury and myself, she was also heir to our undoubted preconceptions which she had to deal with both within the management of the project as well as in the supervision of her PhD Longevity is not necessarily always a good thing in the running of a project, but new partners and new personnel from existing collaborators have helped to prevent staleness creeping in.

What are the major accomplishments of this decade of research? There are three that I would like to propose. I deal with them under their respective headings: methodological ingenuity and innovation; engagement, facilitation and empowerment; and issues of quality and evaluation in this kind of research.

Methodological Ingenuity and Innovation

There are a number of quite basic premises that this research has questioned. At the heart of professional photographic education there is often either an obsession with technical control, concentrating on such things as lighting, camera and lens, or identify with a restricted sense of the role of the professional photographer. As Darren Newbury discovered when talking with National Diploma photography students, their approach to work was so technically mediated that they were both resistant to and disorientated when asked to consider issues of social context, to engage in critical practice.[9] This resistance represents a significant limitation on the potential of photography to contribute to democratic education. But there was another technical assumption that this research has sought to undermine. It is frequently argued that digital technologies offer a special opportunity for young people to bring their own experiences of interacting with computers into the classroom. Roz Hall disputes this claim:

> This research has discovered that not all young people have access as would enable them to bring such supposed competencies and knowledges into schools. Furthermore, it identifies such access as 'privileged', as it is not a part of many young people's informal experiences.[10]

Both Roz Hall and Darren Newbury's case studies have dealt with individuals and groups who have neither had formal photographic training nor privileged access to photographic or digital imagery. Sites such as Hereward College of FE, the Maypole Lesbian, Gay and Bisexual Group, the Bull Ring shopping centre in Birmingham, and the Referral Unit in Sandwell all required a fundamental reappraisal of what photography can accomplish. They also tested the nerve and resolve of the researchers, as there were few if any guidelines for practice in such situations.

For the most part the researchers had to evaluate their own performance as they progressed. This meant that some unexpected discoveries took place. But these only occurred, significantly, because the researchers had learnt to live with uncertainty. As I have argued, any critical approach requires us to chart and acknowledge contradictory and disputed perspectives. This means that accounts contain within them the kernel of visual polemics. Photographic reality is too important to leave undisputed amongst ourselves.[11] What both researchers were able to do was combine and integrate a range of methodologies involving observation, interviews, qualitative action research, and self-reflective diaries. Diaries, in particular, provide the means for the researcher to bring together the range of disparate, contradictory and even warring elements into one frame for analysis. Most importantly, for this research, the diary incorporates perspectives not just of the researcher, but also the research priorities and agendas of the young people with whom the researcher is working.[12]

If complex and integrated answers were primary objectives of the research, similar variety was sought in means of disseminating the findings. Both projects had multiple outcomes, which became self-reinforcing. So, journal publications were written for a variety of audiences. JADE (Journal of Art & Design Education) and the Article Press were core venues to engage with art and design educators, but magazines for and by young people, such as Young People Now

were keen to receive contributions from and about young people involved in the research, as was *Disability and Society*. Contributions were also made to books and catalogues.[13] Conferences hosted by the Arts Council, NSEAD, London School of Economics, and 'The next five minutes' in Amsterdam and Rotterdam, provided a regular means of communicating with other work being undertaken in photographic education in informal settings. Exhibitions provided another important outlet and gave a different perspective on the research, demonstrating how young people had interpreted and created their own imagery. The work of Foundation students at Hereward College dealing with issues of their visual identity and their relationship to their wheelchairs were incorporated in the publication *Photography, art and media* and their photographs were exhibited at Ikon Gallery, Birmingham. Photographs made by the young people in the Pupil Referral Unit in Sandwell were displayed on the advertising panels across the sides of local buses. Work created by young people at the Bull Ring were enlarged to poster size and exhibited on hoardings around the new Bull Ring building site at the same time as the originals were shown in St Martin's Church in the Bull Ring. From the 'Young Queer and Safe' project, Haroon Iltaf's 'Khoosra' series was shown both at the Round House and at Watershed Media Centre, Bristol. So the projects set up by Darren Newbury and Roz Hall provided a platform for young people to communicate directly with a larger public. This exposure was also useful for the young people in planning their future education and direction.

Engagement, Facilitation and Empowerment

Ethical considerations have always been at the heart of planning and conducting all stages of research. In terms of engagement the first priority has been to enable young people to represent their own concerns in whatever way they judge most appropriate. There is, as both researchers have recognized, an apparent paradox in any work which risks appearing to 'give freedom of expression' to those less powerful. But providing space is not the same as giving permission. The work that Darren Newbury documented at Hereward College, Coventry provides a good example of how such a paradox can be overcome. Two students used photographs to question and rephrase taken-for-granted perceptions of disability. The first student chose to examine his own body through Polaroid photographs. These images, he explained, showed his body 'not as somehow lacking, (dis)abled but... "a powerful image of my spine and structure" ' [14]. As Darren Newbury notes, such imagery provides the student with a means of coming to terms with the reality of his own body, but at the same time it challenges the usual visual shorthand to be found in charity organizations' advertising. The second student likewise chose to attack the simple presumption that wheelchairs enable the disabled. He turned the tables on our normal expectations by stating:

> A floor is freedom for me, the chair confines me in certain respects because it doesn't allow me to move around without a machine. When you talk about electric wheelchairs, especially in advertising, there's a certain element of 'you can climb a mountain with an electric wheelchair' and the fact is that you know you can't, it doesn't happen like that... this is not the wheelchair, this is me.[15]

These students in and out of wheelchairs make the viewer properly aware of the vital distinction between physical impairment as a medical fact, and disability as a social construct. At the same

time they offer 'evidence of a more complex negotiation between the public and private, positive and negative, meanings of photographic images, and the continual shifting of meaning as the context and audience change'.[16]

In her fieldwork Roz Hall sought to extend the concept of engagement and empowerment through a self-conscious embracing of the principles of democratic and collaborative research. Here the distinction between researcher and researched is abandoned in favour of an approach that treats young people as both subjects and experts in their own right and with an expectation to have a major input into the direction of the research. This has meant rethinking the normal management of the research process. As Roz Hall has noted:

> Opportunities for input were not limited to those who might feel more comfortable in formal settings, such as steering group meetings. Instead, informal meeting spaces, phone calls, e-mails, and mobile phone text messages, have been used to relay observations, ideas and suggestions, and to discuss forthcoming opportunities and dilemmas.[17]

In all three major areas of research, constructing a website with the Maypole young lesbian, gay and bisexual group, work with educationally disadvantaged in the Referral Unit in Sandwell, and with young people in the Bull Ring (and, interestingly, here, involving young people from Maypole as co-researchers), young people have received technical assistance to achieve their desired objectives – often involving aspects of individual identity. Rarely have these young people been much concerned with the technology in itself. Rather, they have treated both photography and digital manipulation as means to an end – producing images that express aspects of themselves in a way they find both pleasing and convincing, and reflective of their engagement with the wider world. They are not just producers and consumers, they are also making arguments about the nature of the world and how they recognize it.

But ethical concerns are not confined to consideration of the interests of young people. The researchers' perspectives have also to be recognized and respected. The research that the sponsors asked for (and collaborative research always means that the demands are several and not always fully consistent) requires the researcher to enter uncharted territory, and often without a map. There are two aspects to this situation. On the one hand supervisors have a responsibility for what happens to those whom they supervise. I was very aware of this with respect to the Bull Ring project in particular where Roz Hall and her co-workers with valuable and highly portable equipment in their hands, had to negotiate with stall holders, market police and a range of young people who would drift in to participate or observe. The only real precaution that was always respected was that no session was ever taken by one individual on their own. But, on the other hand, as Darren Newbury rightly argues, researcher autonomy is crucial.[18] This can sometimes be very tough for the supervisor when it does not look as though the line of research is going well (which really means that it is not unfolding as the supervisors would envisage doing it themselves). Providing a balance between 'holding' the researcher emotionally, socially and institutionally whilst respecting their right to pursue their own agenda is both an ethical and practical issue. In fact, of course, it is normally a matter of constant

negotiation, but under conditions that do not favour the researcher on short-term contract. However, such an understanding, even if it be only provisional, is vital to enable the researcher to have confidence in putting their intellectual, practical and emotional energy into the project. This means often respecting the researcher's decision to enter new sites of research as circumstances permit.

III: Issues of Quality and Evaluation

A key feature of the whole programme has been an insistence upon rigorous standards by which to judge the success of the various projects. Two inter-related concepts have been constantly been used, quality and evaluation. Quality was readily perceived by participants in the projects as being vital, as the following exchange illustrates:

> Emma: 'Do you think it mattered more that the work looked good because it wasn't in school? That the quality of what you produced was important because it wasn't going to be just for school, it was going to be for outside?'

> Ian: 'No one wants to look at a tacky web site that's been made by a six year old with a crayon, do they? You know, you don't want to be too formal but you don't want it to be tacky.'[19]

But quality is not a neutral concept. As both researchers were keenly aware, photographic research in the public domain can be readily seen as a form of community art-work. In this context there is an implied assumption that in concentrating on process, workers in this sector are prepared to sacrifice quality in the resulting product. This further reinforces the dominant hierarchy assumptions. Community arts practitioners become 'complicit in the process of marginalisation'.[20]

In order to head off such a possibility, both researchers developed a set of evaluative concepts and methods. Early on, Darren Newbury perceived that in the photography and media project into representations of HIV/AIDS at Josiah Mason College in Birmingham there developed a tension between the objectives of media educators seeking to 'develop conceptual skills in order to critically understand the media forms that influence their lives',[21] and the technical skills required to make images that were successful for GCE A level examination students. The failure to develop clear evaluative tools threatened the integrity of the project. Similarly, at Hereward College, the researcher was able to consider the students' own concepts of success which were often based on the effective contradiction of dominant values.

'Success' became a hallmark term of value for evaluating schemes. In the spirit of democratic action research, criteria for evaluation were negotiated with the various partners in the creative process based on the criteria that each brought to the venture. The process became formalized in Roz Hall's work with the Maypole group. She generated a term 'process generated evaluation' to emphasize the dynamic quality involved. Terms of evaluation develop during the project, rather than being set at the outset. As Roz Hall explains:

...process generated evaluation is responsive to the shifting priorities of young people, acknowledging the transience of contemporary cultural experiences... [it] is responsive to the increasingly diverse and distinct experiences of young people's lives.[22]

Key to this form of evaluation is the cultural participation of young people and their engagement in the process of establishing criteria. Some of the informal discussions and exchanges between participants are also available for later consideration. Reviewing the activities and conversations between participants which have been captured in a research diary by the researcher, provides further material for the construction of evaluative criteria.[23]

Facilitation and engagement lead to empowerment for the young participants. Establishing criteria for quality negotiated between all parties enables proper forms of evaluation to become feasible. Such evaluation provides a secure basis for success that young people can demonstrate and record in other arenas, including formal education.

The significance of democratic and collaborative creative practice is that it opens up to young people the dynamic possibilities that are inherent in photographic practice and understanding. They can operate and extend what I have termed a forensic vision,[24] establishing themselves as engaged actors in a range of discourses from public media, creative production and educational values in general. What the young people have in common throughout the projects discussed here is not just a sense of engagement and self-discovery through exploring aspects of their own identity and interests, but they have also become participants in the polemics about the nature of the society that they inhabit and help form. They have assumed the role of researchers in their own right rather than remaining the traditional subject of inquiry by professional researchers. Perhaps this is the best commendation one could hope for from the approaches developed throughout the Arts Council/West Midlands Arts/BIAD photographic research over this last decade.

Coda

In retrospect, the achievements of this research have been on a broad front, and have furthered the practice and methodology in democratic research, and with special significance for the advancement of photography. What remains to be addressed now? First, it must be admitted, the resistance to critical practice within technical photographic education has hardly been dented. Much more work needs to be done in this area. Similarly, it is not at all clear how democratic action research can fit into a prescriptive formal curriculum. This has perhaps been the source of the greatest disappointment throughout the decade. Despite a continual effort to intervene in formal educational settings, this research has not solved the apparent contradiction between the formality of the National Curriculum and student-centred learning. This remains a major issue throughout art and design education, and especially in photographic and media education. But there are some positive leads that this research offers. Perhaps the most significant is the role of the self-reflective journal. So far, our research has concentrated on the diary as record and setting for self-reflection largely by the researcher. There are good reasons to believe that the self-reflective diary can perform a significant job in the context of records of achievement in all levels of art and design education. This can provide the means for young

people to become recognized as both subjects and experts in their own right, as well as sophisticated researchers. Engagement may be the key to a more genuinely democratic education in which photography plays a leading role.

Acknowledgements

I would like to thank the following for reading and commenting on this paper: Danya Cleghorn, Deborah Clomp, Haroon Iltaf, Roz Hall, Sue Isherwood, Darren Newbury, Vivienne Reiss. However, they are not responsible for any shortcomings remaining in this text.

Notes

1. Isherwood, S. and Stanley, N. (eds.) (1994) *Creating vision: photography and the National Curriculum*, Arts Council of Great Britain.
2. Isherwood and Stanley (1994). *Ibid.*, p. 33.
3. Stanley, N. (1996). 'Photography and the politics of engagement' *Journal of Art & Design Education*, 15(1): 95.
4. Newbury, D. (1993). *Photography and visual education*. Birmingham: The Article Press, University of Central England.
5. Newbury, D. (1993). *Ibid.* page 8, also in a similar formulation in Newbury, D. (1994) *Photography, art and media: new directions in the teaching of visual culture*, Arts Council of Great Britain/University of Central England/Building Sights, p. 6.
6. Newbury, D. (1995). 'Towards a new practice in photographic education' PhD thesis. University of Central England.
7. Hall, R. (2000). 'Practicing inclusivity with new media: young people, digital technology and democratic cultural participation' PhD thesis. University of Central England.
8. Newbury, D. (1995). 'A journey in research, from research assistant to Doctor of Philosophy' *Journal of Graduate Education*, 2, p. 56.
9. Newbury, D. (1997). 'Talking about practice: photography students, photographic culture and professional identities' *British Journal of Sociology of Education*, 18(3): 431.
10. Hall, R. (2000). 'Inclusion through distinction' *International Journal of Art & Design Education*, 19(3): 314.
11. Stanley, N. (1996). *Op. cit.* p. 96.
12. Hall, R. (2002). 'Unpicking peaches: young people and democratic cultural participation' ESRC Research Seminar Series, Department of Cultural Studies, University of Birmingham, p. 3.
13. For example, Cleghorn, D. *et al.* (February 1999) 'Young, queer and safe?' *Young People Now*; Tomlinson, L.; Newbury, D.; Burston C. and Tomlinson R. (1995) *Class of 95*, Photopack, Birmingham; Brake J. (1996) *Changing images : photography, education and young people*, edited by Newbury D., Viewpoint Photography Gallery, Salford; Newbury, D. (2000) 'Changing practices : art education and popular culture' in Hickman, R. (ed.) *Art Education 11 – 18 : meaning, purpose and direction*, London: Continuum, 69–82; Hall, R. and Newbury, D. ' "What makes you switch on ?": young people, the internet and cultural participation' in Sefton-Green J. (ed.) (1999)*Young people, creativity and new technologies: the challenge for digital arts*, London: Routledge, 101–110; Hall, R.; Herne, S.; Raphael, A. and Sinker, R., 'Whose art is it anyway ? Art education outside the classroom' in Sefton-Green J. and Sinker R. (eds.) (2000) *Evaluating creativity: making and learning by young people*, Routledge, 154–186.

14. Newbury, D. (1994). *Op. cit.*, p. 31.
15. Newbury, D. (1994). *Ibid.*, p. 32.
16. Newbury, D. (1996). 'Reconstructing the self: photography, education and disability' *Disability and Society*, 11 (3), p 352.
17. Hall, R. (2002). *Op. cit.*, p. 2.
18. Newbury, D. (1995). *Op. cit.*, p. 55
19. Hall, R. (2001). 'Developing methods of evaluation' Jubilee Arts Evaluation Working Party, Jubilee Arts, Sandwell, p. 5.
20. Hall, R. (1998). 'Evaluating young people's creative use of digital technology : whose benchmarks and why?' paper given at International Symposium on Electronic Arts: Revolution/Terror conference, Manchester Metropolitan University and Liverpool John Moores University, p. 2.
21. Fuirer, M. and Newbury, D. (February1993) 'Telling stories: photography, drama and HIV/AIDS' *Arts Education*, p. 21.
22. Hall, R. (2001). *Op .cit.*, p. 6
23. Hall, R. (2002). 'Tailor-made practice' *Engage*, 11, p. 46.
24. Stanley, N. (1996). *Op. cit.*, p. 99.

13

Constructing Neonarratives: A Pluralistic Approach to Research

Robyn Stewart

Introduction

Calls for more research linking theory with culture and contemporary classroom practice suggest that research focused on art or art education should explore dichotomies in the many faceted areas of cognition, perception and creativity. This may be because cultural developments and curriculum praxis tend to move at different paces. The cultural approach to research described here proposes to continue a comprehensive analysis of the structure of the field of art and education, attempting to identify more precisely the nature of the field and its relationship to contemporary sociocultural practices and related educational needs.

This qualitative interactive approach is fashioned to recognize the complicated nature of art and education while taking into account the complexity of views within contemporary cultural conditions. While this may be seen as contrary to much extant postmodernist thinking it is necessary to provide more awareness of shared views as well as those which we dispute.

The method known as 'Neonarrative'[1] develops new stories to account for the overarching cultural conditions which mediate contemporary art and education, teaching and learning. It is an interdisciplinary research framework, understood in terms of postmodern and post-colonial contexts which provide the sociocultural dimensions, and its methods reside within a sociocultural frame.

The research sequence develops Neonarratives from a narratological approach combining autobiographical data and interview texts, storied within the contemporary world. Narrative discourse is used as a medium of representation for the structuring of knowledge in the particular setting of the research interview. The narratives form tools for assembling personal

accounts, and it is from these tales that constructed Neonarratives emerge as different stories which represent aspects of contemporary cultural conditions of visual arts and art education.

Using an Interdisciplinary Approach to Research

A critical aspect of research design is the fit between the cultural conditions surrounding the issues being investigated and the methodological process. In a Modernist world where notions of 'one best way' generally prevail, research is usually situated within discrete disciplines thought to provide the investigator with findings which could be interpreted as field-specific. However, contemporary art practices in the western world are shaped by theories of the postmodern and the postcolonial. These complex theories attempt to describe constantly changing contemporary cultural conditions and their effects on people's lives. They present the researcher with a challenge to come to grips with the notion that a monocular view of the world is no longer realistic. Instead, tentativeness, uncertainty and a pluralistic approach to studies of how personal experience reflects meaning may be more appropriate ways to review the contemporary condition.

Thinking within a postmodern culture,[2] proposes a search for a 'new rationality' which promotes an interdisciplinary approach to research and teaching. This search for communicative rationality, visualizes a dialogue between different disciplines '...which, finally, may bring about unpredictable results in the solution of problems raised in the context of the lifeworld'.[3] Chalmers[4] observes that sociology and anthropology are woefully missing from some current art education proposals. This lack of attention contrasts with the broad definition and social contextualization of art education evident in a number of papers,[5] where each is concerned with interdisciplinary critiques and reformulations of art, culture and education.

Precedents for an inter-disciplinary approach to research are numerous,[6] and reinforced by Dissanayake,[7] who in seeking to link 'art' and 'life' developed an ethological way to look at the purposes of art. Berger and Luckman[8] also support inter-disciplinary methods through the use of a dialectical perspective, and similarly, for curriculum planning, Lawton[9] suggests a mix of sociological and philosophical inquiry and psychological research.

The Neonarrative method was developed in response to the need to use a qualitative method appropriate for viewing the processes of framing within a contemporary culture.[10] Its method lies in narrative, considering the subjective and intersubjectively gained knowledge of the life experiences of individual participants[11] including the researcher, whose partially shared experiences in the lifeworld of the subjects cannot be discounted. The research process centres on the gathering of data reflecting perspectives of players in the field and is characterized by processes of reflection, in which interdisciplinary notions of interpretation, description and comparison are engaged.

The study which developed the Neonarrative method was concerned with the relationships among artists, art educators and culture as they impact on the framing and transmission of visual perception.[12] It was oriented towards people's ideas about the world and/or their experiences of it.[13] and it was designed to describe and explore the major themes or tensions in their visuality and the transmission of that visuality to others.

Constructing Neonarratives

Qualitative approaches to research, such as the Neonarrative, comprise a many faceted combination of views which are appropriate within postmodern theoretical constructs and assume pluralistic approaches to cultural analyses. The Neonarrative model features the interactive development and analysis of narratives leading toward Neonarratives, or new stories, and represents a naturalistic approach strongly featuring the personal accounts from the respondents. So, for example, if the argument is that visuality is culturally constructed, so must be the parallel argument that one's broader experiences are also culturally constructed. Thus, a culturally embedded account of these experiences directly from the respondents is appropriate and the subsequent formation of Neonarratives is necessary to give cohesion to the otherwise disparate narratives. What Neonarrative method presents is a process for analysing what actually happened according to the people involved.

In this model, narratives of participants are used as 'tools for constructing knowledge'.[14] The experiences of individual participants are recorded and documented 'for unique and common patterns of experience, outlook and response'.[15] For instance, reference to the 'voices' of artists and teachers may function as a 'legitimization of descriptions of knowledge' of artists and teachers about artistic learning and teaching, as valid knowledge for teaching practice, and may subscribe to the theoretical knowledge base for teaching practice.[16] Such a study focuses on the experience of learning, using the artists' and teachers' own accounts of, and reactions to, learning. Perceptions, values, insider stories, experiences and accounts inform the study. Data are constructed of interviews with artists and art educators and are supported by their autobiographical details. The common theme on which each source is focused is the process being explored.

The Neonarrative approach is guided by narratology, as a qualitative method which offers an interpretive reconstruction of an aspect of a person's life. Narrative may be interpreted as an essential aspect of social life which enables the passing on of knowledge.[17] Narratives, however, are not necessarily concerned with the legitimacy of such knowledge. They are essentially tales of the field.

The Process of Narratology: Autobiography and Interview

Narratology is about the study of stories.[18] Important themes identified within studies can be explored to uncover, interpret and reconstruct significant events which have contributed to the framing of particular aspects of particular activities in people's lives. A study of narrative is mainly epistemological in nature, focusing on stories constructed from knowledge based on everyday lived experiences over time. It gives voice to experience. Narratology is concerned with collaboration between researcher and participant, synthesising and shaping subjective and objective personal practical knowledge. Its focus is on how people know.

In the Neonarrative method the narrative is concerned with developing a plausible account where meaning is constructed from the personal histories of participants embedded within the social history of their world. Its bricolage of approaches is composed of autobiography and interview. The Neonarrative is constructed of the resulting reconceptualization of the processes which form the conditions under investigation.

Biography is used to form a beginning, a foundation, which may be then completed through the use of interviews as a further set of narrative devices to enhance this process. Autobiography is collected because it reflects on meaningful past actions, prompts reflexive thinking, and offers a means of focusing the thoughts of the participants, guiding them through issues of historical, environmental and conceptual development.

The composition of biographical material represents a mix of subjective, fictional and non-fictional accounts of lived experiences over time. Its collection precedes the interview process and recognizes the complexity with which lived experience is represented, where underlying cultural codes and conventions colour the stories. Autobiography provides a foundation and reference to explain why people act the way they do, accepting and relying on the subjective verbal and written expressions of meaning given by the participants, treated as devices, tools, or bricolages for creating texts.[19] Elbaz describes autobiography as personal experience imaginatively organized to rearrange truth.[20]

The Process of Interviewing

Interviewing is said to be a straightforward method of trying to discover what people think.[21] It is essentially a way of collecting subjective data. As a consequence, its use offers a most important technique in the search for meaning. By documenting the way participants talk about their work, the social relationships and social structures which shape the way they live and relate to their work, and the nature of practices they are actually engaged in, interpretive research actually enables experiences of participants, researcher and reader to relate through common experiences.

Well articulated conversations between researcher and participant enable the collection of data in a non-prejudiced and non-prescriptive way. However, a number of factors can interfere with the effectiveness and quality of data collection. These variables include the quality of the environment surrounding the interview, and the self-awareness and articulateness of the participant. The quality of the researcher's preparation, perception, alertness, sensitivity and observation abilities are factors, as are the informant's responsiveness, well being, comfort, communicativeness, confidence, self-awareness, health and emotional state at the time of the interview.

Issues of Validity, Reliability and Generalizability

Connelly and Clandinin[22] question the appropriateness of criteria such as reliability, validity and generalizability for qualitative methods generally. They contend that narrative explanation is holistic and not dependent on cause and effect and present the notion that narratology 'may be read and lived vicariously by others',[23] arguing that plausibility and adequacy are factors determining whether a story rings true. Spence,[24] speaks of 'narrative truth' made up of consistency, conviction, aesthetic finality and closure. Consequently, a sense of 'authenticity'[25] is created through the ability of the reader to recognize and empathize with the events of the narrative. In this sense, stories function as arguments in which something essentially human is learned through understanding, through the story, the actual life or community events. It is clear that a number of factors are used by qualitative researchers as they seek to remodel the research criteria. The problem is to identify criteria which best reflect the purpose and context of each study by enhancing and making meaningful the content and process of the narrative.

Analysing narrative data: a thematic approach

The Neonarrative method presents a thematic approach to the interview content and narrative construct and uses restructured stories and relevant anecdotes organized to highlight the themes of the study. Each theme, or organizer, then becomes the 'hermeneutic tool'[26] used to deconstruct the stories being studied. Themes act as organizers and can categorize data into phenomena, as clusters of information either relating to particular persons or sites, or to particular types or aspect of the social.

In this method, themes identified in the stories of participants verify subjective meaning contained in the text through communicable accounts of common-sense reality. As well, interactions identified among and between themes through these accounts add to notions of the intersubjectivity and wider accessibility of the narrative.

Brief description of the research process

Five phases constitute the methods applied. These are

- the identification of the research method;
- the establishment of the collaborative process;
- the conduct, transcription and review of interviews;
- the follow up procedures;
- the analysis of data and synthesis into neonarratives.

These phases are independent, sequential and based on temporal logic, and access. In the original study, the autobiographies and stories of six professional artists and six art educators, each were carefully selected as credible representatives of the visual arts field.

Ethical protocol is maintained where participants and their interview transcripts are coded and agree to processes of confidentiality. Interviews are conducted, transcribed and sorted into salient themes identified in the literature. The data are then systematically structured into narratives constructing the experiential quality and explanations, within the environmental, cultural and social scenes where the action occurs. To do this, an analytical framework of five sectors is used flowing from the themes and contexts of cultural knowledge. These are made up of the interviews, cultural attitudes and sentiments, forms of knowledge, sources of knowledge and determining qualities.

The data are further analysed to create clusters of thoughts, presented as narratives, to reflect participant responses collected during the interviews. In order to develop these narrative clusters, the raw data, which had been thematically grouped are subjected to close scrutiny. It is also further categorized into groups to reflect the different cultural roles of the participants.

Relevant statements made by the participants in support of each of the themes, are selected to contribute to each narrative, and entered into the data-base. At the completion of the initial selection and data entry process, each narrative is carefully edited to create as coherent a statement as possible. Throughout the whole procedure the researcher should be mindful of the characteristic personal genre which each participant presents as they collaborate in the

research process. The process attempts to create, in their narratives, a style which complements their individual personalities.

Depending on the intended dissemination of the study it could be important to include brief, biographical details at the beginning of the first theme, to introduce each participant. At the completion of each thematic story, a reduction is created of what they said, encapsulating the main threads of the story. These reductions are then used to create the summary narrative at the end of this stage of the analysis. Finally, each participant is asked to complete a final review of their stories, to ensure that the analysis appropriately reflects their thoughts. A final edit follows to accommodate their responses. The neonarratives are then constructed as an amalgam of data and theory to create new stories from those that had gone before.

Conclusions

Changing conditions for art and education in a climate of economic rationalism, national curricula, key competencies and accountability are provoking a culture shaped by demands for relevance. Within this climate artists and educators have long relied on rational arguments about the benefits of art and artistic learning as important cultural tools. Yet it is becoming increasingly clear that claims for importance from other disciplines are making the battle for inclusion increasingly difficult for art.

Importantly, what is needed is strong and persuasive evidence of the value and worth of artistic learning for the educational and overarching cultural needs and growth of this nation [Australia] as we approach the twenty first century. For example, how do we position education in the visual arts as central for the development of visual perception for the human computer interface, and the understanding and development of meaning in multimedia and technology? The most persuasive way to support such claims is to underpin them with clearly articulated quality research outcomes which evidence art and art education as value added essentials of everyone's life long learning.

However, research is not just a matter of gathering data and finding some evidence. It involves a clearly articulated, thorough approach which relies on the precise identification of important questions and is underpinned by a strong theoretical base. The challenge for visual artists and art educators working into related areas such as research, is the imperative that a clear understanding and articulation of valid and robust methods of investigation are applied without losing the characteristic freshness of creativity. The Neonarrative method offers a culturally relevant, sound, rigorous, multifaceted approach to gathering such evidence.

Notes

1. Alexander, D., Muir, D. and Chant, D. (1992). Interrogating Stories: How Teachers Think they Learned to Teach, *Teaching and Teacher Education,* 8(1): 59–68.
2. Barros-Mani, N. (1991). Postmodern Culture, Legitimation Crisis and the Transformation of the University: A Latin American View, *New Education* 13(2): 17–24 (p. 22).
3. *Ibid.,* p. 23.
4. Chalmers, F. G. (1990). Art Education and the Promotion of Intercultural Understanding, *Journal of Social Theory in Art Education,* 10(1): 20–29.

5. See for example: Wasson, R. (1992). 'New Approaches to Teaching Art History and Aesthetics'. Keynote Address, Art and Design in the Real World Conference, Brisbane, 1992; Hamblen, K. (1990). Beyond the Aesthetic of Cash Culture Literacy, *Studies in Art Education*, 31(4): 216–225 and Duncum, P. (1990) Clearing the Decks for Dominant Culture: Some first Principles for a Contemporary Art Education, *Studies in Art Education*, 31 (4), 207–215 and Stuhr, P. D., Petrovich-Mwaniki, L. & Wasson, R. (1992). Curriculum Guidelines for the Multicultural Art Classroom, *Art Education*, 45(1): 16–24.

6. Such as: Zolberg, V. (1990). *Constructing a Sociology of the Arts*. Cambridge: Cambridge University Press; Bauman, Z. (1992). *Intimations of Postmodernity*. New York: Routledge; Jensen, K. (1991). Education Planning through Problem Solving Techniques, *Labour Education*, 83, pp. 32–39; Dissanayake, E. (1990). *What is Art For?* Seattle: University of Washington Press; McTaggert, R. (1991). *Getting Started in Arts Education Research*. Geelong: Arts Education Press.

7. Dissanayake, E. (1990). Op. cit.

8. Berger, P. & Luckman, T. (1981). *The Social Construction of Reality*. London: Allen Lane, p. 29

9. Lawton, D. (1975). *Class, Culture and Curriculum*. London: Routledge and Kegan Paul, p. 69.

10. Stewart, R. (1994). Neonarratives of Visuality: Contemporary Aesthetic Constructs About Artistic Learning. Unpublished PhD Thesis, The University of Queensland.

11. Denzin, N. K. (1984). *On Understanding Emotion*. San Francisco: Josey-Bass, p.133.

12. Stewart, R. (1994). Op. cit.

13. Marton, F. (1981). Phenomenography: Describing conceptions of the world around us, *Instructional Science*, 10, 177–200, p. 178.

14. Nespor, J. & Barylske, J. (1991) Narrative Discourse and Teacher Knowledge, *American Educational Research Journal*, 28(4): 805–823 (see page 819).

15. See Goetz, J D & LeCompte, M D (1984). *Ethnography and Qualitative Design in Educational Research*. Orlando, FL: Academic Press.

16. Carlgren, I. & Lindblad, S. (1991). On Teachers' Practical Reasoning and Professional Knowledge: Considering Conceptions of Context in Teachers' Thinking, *Teacher and Teacher Education*. 7(5/6): 507–516 (see page 515).

17. Alexander, D. et al. (1992). Op. cit., p. 77.

18. Connelly, M. and Clandinin, J. (1987). On Narrative Method, Biography and Narrative Unities in the Study of Teaching, *The Journal of Educational Thought*, 21(3): 130–139.

19. Denzin, N. K. (1989). *Interpretive Biography*. London: Sage Publications, p. 22.

20. Elbaz, R. (1987). *The Changing Nature of the Self: A Critical Study of The Autobiographical Discourse*. University of Iowa Press, p. 1.

21. Alexander, D. (1987). 'From Citizen to Individual'. Unpublished PhD thesis, The University of Queensland, p.141.

22. Connelly, M. & Clandinin, J. (1990). Stories of Experience and Narrative Inquiry, *Educational Researcher*, 19(5): 2–14, p. 7.

23. Connelly, M. & Clandinin, J. (1990). Ibid., p. 8. Crites, S (1986). Storytime: recollecting the past and projecting the future, in Sarbin, T. (ed.), *The Storied Nature of Human Conduct*. New York: Praeger, 152–173.

24. Spence, D. (1982). *Narrative Truth and Historical Method*. New York: Norton & Company.

25. See Rosen, B. (1988). *And None of it was Nonsense*. Portsmouth, NH: Heinemann.

26. Van Maanen, M. (1990). *Researching Lived Experience: Human Science for an Action Sensitive Pedagogy*. Althouse Press, University of Western Ontario, p. 170.

14

THE NARRATIVE APPROACH IN ART EDUCATION: A CASE STUDY

Gabriele Esser-Hall, Jeff Rankin and Dumile Johannes Ndita

Introduction

This case study will illustrate the narrative approach in art education practiced at Border Technikon Art School, East London, South Africa. The fine art curriculum of this institution encourages students to employ visual means to communicate personal experience. Inherent in this teaching method is the willingness to listen and to explore shared narratives.[1] In this paper, Jeff Rankin and Gabriele Esser-Hall, meet the subject of narration, Dumile Johannes Ndita (known as DJ), whose drawings tell his personal story related to his experience as an artist in post-apartheid South Africa. His personal tutor, Jeff, will give an account of the practical aspects of teaching within the local context of the School of Fine Art. He will show that DJ's work is living proof of the immediate, communicative potential of the narrative approach. In this specific case, the artist's personal story has brought uncomfortable truths to light that have impacted on the wider community. Gabriele will reflect on shared and interconnecting institutional narratives, which place DJ's work into the wider context of culture.

We aim to show that the narrative approach to visual art education allows the work to disclose levels of meaning independent of imposed interpretation as 'an open ended play between the text of the subject and the text of the addressee'.[2] It eliminates the omniscient authoritative voice of self-proclaimed experts and enables teacher and students to reflect on shared narratives and engage in mutually beneficial dialogue.

Jeff's Personal Narrative

This is a story, not least because it comes from a centre where a narrative approach to learning and practice has been established as the norm. The centre is the fine art programme of Border Technikon, which has several campuses in and around East London on the coast of South Africa's Eastern Cape Province. To contextualize my relationship with D. J. Ndita, the artist whose work tells the central story, I need to provide a background narrative of my own experience.

I moved from Durban to East London (known as Emonti to the majority Xhosa-speaking community) at the end of 1993, and was asked to help in establishing a new art school as part of the country's youngest and smallest Technikon. Being White, and having previously worked in only segregated apartheid-era institutions, I was both excited and challenged at the thought of starting from scratch in an environment free of such historical complexities, such heavy baggage.

That Border Technikon was actually a child of the apartheid system, having been founded as part of the 'Independent' Ciskei Bantustan, was stored somewhere in my cupboard of skeletons (and still is). For my story and that told by DJ's work, this sinister knowledge becomes instrumental. As a political cartoonist during the 1980s, I commented on the situation in Ciskei, and on the puppet regime of Lennox Sebe. In one cartoon, I depict Sebe relaxing on a Ciskei beach, with a white company executive reaching for a conspiratorial handshake from beyond the homeland borders. Behind Sebe are the realities of his corrupt empire: the shack dwellings of his people beneath a threatening storm. This sets the local stage for DJ's visual theatre.

The relevant parts of my own story continue as a mixture of vision and blunder, as I carried the responsibility of course direction for fine art, from 1994 to the present. Vision is hopefully manifest in the narrative approach we follow. As part of this I must acknowledge the work of my wife Judy, a narrative therapist and head of the Psychological Services Centre in East London, affiliated to Rhodes and Fort Hare Universities. Judy has been a great support in our efforts to apply a narrative framework to the fine art programme.

Perhaps *visual* narrative is a more accurate label, broadly encompassing the fact that we work with 'images that tell'. However, our supporting narrative framework goes much further than this: we respond to the need to re-negotiate a network of relationships distorted by a history of dominance. In this response we recognize that fixed (and stubborn) relational assumptions have to be challenged, representations have to be critically reviewed, and we welcome the social constructionist denial of absolute reality.[3] With visual art as a shared platform, we are discovering the power of the artefact as a narrative medium: a voice, as it were which challenges and reviews and honours the fluidity of truth.

Blunder, on the other hand, has certainly been part of the experience, and sometimes positive. A major instance was my blundering into this venture (the new art school) with expectations of order, trying naively to suppress the reality of other people's lives in the interests of smooth functioning. The vast majority of our students understand a lifestyle conditioned by the denial

of opportunity and a social status which was officially second-class; not to mention the associated material poverty. This is not a neatly-packaged condition which respects personal and professional boundaries; it influences the way we all work and the outcome of our efforts.

My story (and that of other staff) includes a particularly difficult time when we were repeatedly held hostage and physically threatened by students in and around the school building, and while such action may be understandable it will never be acceptable. Nevertheless, through these experiences I've not only become used to disorder and dysfunction as the dominant expectation of the working day, I've also learned that the creative soul can thrive in this environment, and that a creative richness can emerge. This has been an invaluable lesson of survival; indeed, it may be the lesson that Africa has to teach an order-obsessed world.

Dysfunction is not restricted to isolated cases such as our institution. With the dramatic changes South Africa has experienced since the early 1990s, there were bound to be casualties (or surprises). One of these, in my experience, is a frustrating sense of corruption and disservice within the public sector. It may be that foreign systems have been misplaced in Africa,[4] but many in power would argue. Before allowing this to lead us, as it does, into the story of DJ's work, it is useful to briefly discuss the prevalence of 'political correctness' in the local environment.

With the need for a community (that of the Eastern Cape providing the classic example) to move from profound and legislated disadvantage to personal stability and opportunity, positions of power and influence are understandably coveted. In this context the responsibilities and accountability attached to such positions may be neglected, at least during the country's extended transformation period. Questioning such neglect within a socially conservative community can easily be seen as disrespectful and politically incorrect.

The governing African National Congress (ANC) has its traditional power-base in the Eastern Cape. Through such factors I sense a popular pressure to yield to the tide of 'political correctness'. This is particularly true of members of the historically disadvantaged community of the region, who have struggled with the centuries-old demons of social and political repression, demons which have inculcated an uncritical respect for the ruling hierarchy. In many cases I see the struggle solved by submission to this pressure, but the story told by DJ's work is one of reflexive defiance.

The Narrative Approach in Practice: Zanokhanyo 'Bringing to Light'

DJ lives in the informal 'squatter' village of Mzamomhle, near the city of East London. Of course this would not be by choice: in keeping with levels of income and opportunity, informal settlements allow people an affordable shelter within improvised structures of plastic, sheet metal, wood and other scrap. Across South Africa these settlements have become a permanent feature, a material illustration of vastly unequal resources.

DJ enrolled as a fine art student with Border Technikon, completing his degree at the end of 2002. His two major areas of study for the degree were drawing (resulting in a solo exhibition) and a research project, which followed a reflection-on-practice methodology. At the time of entering the degree level, DJ was contacted by the East London office of the Provincial Arts and Culture Department. They asked if he would assist with rehabilitating a building on the edge of Mzamomhle which had previously been used as a craft centre; the intention was to create a community art centre with the Xhosa name 'Zanokhanyo' (literally: to bring light).

At the time of this request DJ asked me, as his study supervisor, if he should use this project as the focus of his research. I agreed, based on the experiential potential of such a project, not to mention its benefit to the community; but from the margins, I was sceptical regarding his negotiations with the provincial department. It seemed to me that DJ was seen as a window of exploitation by others responsible for the project, although without ever having checked this out I have to reserve judgment. Based on this perception, however, I advised DJ to approach the research from a narrative point of view: in other words, that he should tell the story of his accumulative experience at Zanokhanyo, rather than enduring an academic 'how-to' process which failed to reflect his real experience.

As it turned out, this was sound advice: the first indication came with the offer of one hundred South African rands per month (about $10 US) for his services. Despite even this incredulous offer, no payment was ever received for work done (according to DJ) in his efforts to help set up the art centre. It is hardly surprising that DJ developed what I see as a respectful defiance in reaction to such pressure.

The reflection-on-practice method of research has been introduced to focus on the centrality of practice in our work. In effect, after a lengthy period of developing a body of work (primarily drawings in DJ's case), degree students are asked to initiate a three-part interview or 'conversation with their work' shared by fellow students, staff and invited participants. The three parts are as follows:

1) The student displays the work and gives an oral presentation for participants.
2) Student and group exchange questions, answers and general discussion (in work's presence).
3) The student leaves the room, allowing the group further discussion (in work's presence).

Each of the three parts runs for about twenty minutes, with the hour-long session being video-recorded for the student. Part of the students' work is to transcribe the entire session. This written record facilitates what Kvale describes as 'narrative analysis of what was said [leading to] a new story being told, a story developing the themes of the original interview'.[5] In our case, the addition of recorded visual images adds a rich layer to the language of the interview, and to the potential of thematic development. Regarding this method I note that, although DJ has agreed to the writing of this paper, Kvale nevertheless questions the right and power of any outside voice to interpret or 'attribute meaning to the statements of others'.[6]

I share degree supervision with other staff members, and the above process is not necessarily prioritized (depending on supervisor and merits of the projects). In my case, however, I see this reflection-on-practice approach as invaluable in the narrative context. In my own teaching specifically, this is the outcome of a four-year course development in which undergraduate students are asked to see meaning as a constantly negotiated process. This interview method is an advance on that process, allowing the student to negotiate meaning and value through a narrative generated by conversation.[7] In DJ's case the negotiation became an internal and reflexive exchange, as rewarding an outcome as any in my view.

The narrative base of DJ's art education encouraged a remembering of lived experience,[8] as well as the documenting of emerging themes through image and word. The benefit for his audience is a series of rich personal stories, including that of the Zanokhanyo project. The literal translation of this word, 'to bring light,' is ironic in its relevance for this paper. While the name may be inappropriate for this specific community project, DJ's involvement and his recording of it through narrative images are processes which have brought light to the cultural development of this region; a light which, while critical and challenging, should also be seen as a valuable contribution to post-apartheid cultural identity.

In a less ironic sense, by doing this work DJ has helped to make sense of his own life and relationships. He has also discovered for himself, and shown to others, new aspects of the artist's role (and its transformation) in the changing South African context. Beginning with his drawing 'My Taxi Driving', DJ's work takes us through the reality of his experience at Zanokhanyo. Of this piece, an ape-like self-portrait on all fours, one foot bare and the other three wearing roller blades, the artist says:

> During the Zanokhanyo project I did not have any source of income. I decided to drive a taxi to make a living. I portrayed myself as a baboon with roller blades. This represents me getting a taxi to drive.

Issues of survival are emphasized in another drawing, 'Risky Decision', DJ notes of this work:

> During the Zanokhanyo project I sometimes had to decide whether to use the money I borrowed from my neighbours to buy food (and life, both shown as a spoon), or use it to get to art school (and the future, symbolised in the book) ... The corroded nasal part represents diseases that I had at the time.

DJ's vision, his determination, his being crippled by developments around Zanokhanyo, and the taxi driving as means to an end, is encapsulated by the handicapped bird of his work 'Alternative'. He expands on the detail:

> Even if I lose one part of my body, I will never stop working to bring light to the people. I'll always find other means to keep me going. I represented myself as a bird that has no other leg but continues to walk by means of crutches. This is about me finding taxi driving as another way to make a living.

Through such language DJ reveals how his commitment to the community is as sincere and driven as the many others similarly involved in this type of work in South Africa, people whose search for a qualitative role in the country's development is invaluable. This attitude exemplifies the African cosmology of 'Ubuntu' (loosely translated as the positioning of community in self, and self within the community) and its appearance is heartening at a time when so much is heard of corruption and self interest.

His art-work 'The Rich Department', is central to this writing, in that it swims directly against the tide of thoughtless hierarchical respect, and aims a critical eye where such gaze is deserved. In this case, as DJ's caption describes:

> The huge person with a dog's head represents the (Provincial) Arts and Culture Department as a very rich department empowered to support the (community) projects, but some of the people in charge are not good enough for their job.

It is difficult to overestimate the significance of such a statement. Perhaps the best way of illustrating this, backed by the context sketched above, is my first-hand description of the scene at the opening of DJ's degree exhibition: in front of this large ink drawing stand several viewers, some of whom I know are linked, as employees or otherwise, to the department personified in the work (the state is a major employer in the Eastern Cape). The viewers are quiet, taking in both the image and its caption (as above); this becomes an exchange of smiles, giggles and, unmistakably, raised eyebrows. There is no doubt that they have noticed the challenge posed by DJ's words, and the target of his biting visual satire.

Since the early 1990s protest art has given way, particularly within the conservative cultural environment of the Eastern Cape, to the needs of development in 'arts and culture' (a term which has taken on a paradoxically bureaucratic face). This is an environment that does not easily tolerate dissent, despite policies which support freedom of expression: platforms tend to be politically correct. This is why DJ's reactive challenge, his swim against the tide of expected behaviour, could indicate an exciting maturity in his conceptual and creative approaches (of course, it could also be a temporary change of approach, a brief reaction to a specific circumstance). In the 'new South African' context he moved beyond a behavioural boundary, into realms of comment not popularly seen as the artist's reserve. His approach is also a reminder that Ubuntu cannot exist in the absence of integrity.

In this work DJ affirms another principle of the narrative approach: the recognition of power where it is being exercised, challenging it, and making it visible.[9] In South Africa the influence of ancestral, familial and specific cultural upbringing could create confusing differences in our approach to the place of art and its societal mandate. Clearly, this confusion could be active in the relationship between DJ and myself, beginning with the difference of our mother tongues. What helps is the narrative insistence that, while cultural stories are to be respected, they are heard in the context of culture being a dynamic process (not a static reality). In this sense the hearing and re-telling becomes transformative, generating further layers of stories and a new (and evolving) cultural perspective.[10]

Nevertheless, returning to the conceptual maturity seen in DJ's work, there are two pieces to discuss in this context. The first is from a series entitled 'Baby-Man', in which DJ portrays himself (albeit ambiguously) with an infant's diaper-clad body. He explains:

> The community treated me like a baby, asking how an inexperienced young man like me can be given an opportunity to run a project, while they have been there since the beginning of the community but they are not given the opportunity. They wanted to do what I was doing, but without me. I represented myself as a baby with an adult's head. This series starts with the day I realised they were treating me like a child. The first image shows me as a helpless baby who couldn't do anything about what was being said about him. The second one is about me holding a ... workshop, or addressing the community people about my plans, and asking for their participation. The third (and illustrated) image is about me taking my tools and getting to work at the centre. The hammer represents the power of the Baby-Man.

This 'power of the Baby-Man' is a concept rich in irony, which benefits, no doubt, from the evolutionary process of a work in series. But DJ's words indicate his willingness to accept this irony, to see the satirical power of the image while at the same time offering the unexpected in the way the parts are put together.

The title of the final example, 'Enemy,' provides conclusive insight into DJ's experience at Zanokhanyo (and, particularly, his perception of the experience). The work includes a hazardous-looking branch of thorns, typical of the hardy vegetation of the Eastern Cape. Emerging from this branch is a human hand. DJ completes the description:

> It seems as if I signed a deal that was wrong, and this created me some enemies. The hand with the matchstick and a rope represents me with my skills and the intentions of bringing light to the people.

To the end, DJ remains faithful to the mission of community development, which he undoubtedly expected of the Zanokhanyo project. The hand and the matchstick reveal his best intentions in this context.

Shared Narratives in Style: Western/ancestral Art

DJ's style is based on the shared narratives of traditional western visual representation and ancestral African expression. This style might be dismissed as out of date, outside the canon of contemporary art, but according to Shusterman:

> ...aesthetic values can never be permanently fixed by art theory or art criticism but must be continually tested in experience and may be overturned by the tribunal of changing aesthetic perceptions.[11]

The artist's mix of semi-anthropomorphic and full-anthropomorphic representations of self is poignant and evocative, as he shares his, 'emotional episodes that have mobilised [his] true

feelings [and] describe incidents that somehow transform or enhance [his] sense of self.[12'] Even when perceived out of context, DJ's visual language conveys an atmosphere of suffering and tension. Brought into the personal narrative of the condition of an artist in post-apartheid South Africa, their meaning is ultimately defined and from this moment his story, so profoundly steeped in personal experience, interconnects solely with stories and embodied experience of his immediate environment. Yet they also go beyond it, and though the outsider will find it impossible to fully grasp the suffering in its entirety, emphatic response is conceivable, as they are part of the corpus of stories connected to suppression and defiance. They search for an understanding of the human condition through visual interpretation and celebrate the strength of creative endeavour in alien and unsupportive environments.

Shared Narratives

DJ's and Jeff's stories are made up of emphatic voices of embodied 'tellers' and bring to light inherent meanings. They do not need interpretation by an authority claiming to be the advocate of a dominant art critical discourse. Traditional discourse has constructed narratives to perpetuate power structures. As a result of these institutionalized and categorized narratives the notion of the 'Other' has been affirmed, a notion that is still prevalent in so called 'post-colonial' discourse. Shared narratives do not impose as they take their cue from personal experience where each individual teller is aware that 'this "world" when conceived as an experiential creation is subjective, not dialogical or intersubjective'.[13]

This joint weaving of narrative constructions, be they verbal or visual allows the beholder an aesthetic experience based on embodied response, where questions about canonical 'worthiness' of a work of art become irrelevant. While the material manifestation of the work is immutable in its form, it is subjected to a multitude of different stories through the cross-fertilization of shared narratives. As Shusterman[14] points out, the work's meaning and value can change with the changing realities and practices that condition our experience of it. For example, it is conceivable that DJ's drawings will eventually take their place in the history books on the post-apartheid era in South Africa and will thus connect to a wholly different canon of stories.

The drawings are the visual witnesses of DJ's emotional experiences. By creating these haunting images, he has allowed himself to explore his personal experience that is deeply anchored in the multitude of interconnecting institutional narratives of post-apartheid South Africa. In fact, the work would not exist without this detrimental influence. By sharing his experience with others, he has brought them into the realm of what Corradi Fiumari calls reciprocal narratives. In her opinion these 'reciprocal narratives [are] the originary medium and receptacle of all human knowledge'.[15] DJ's exhibition performed this role within his immediate community. By presenting the work to the wider audience of art educators it will resonate in different environments and become part of other narratives.

The narrative approach to art education practised at Border Technikon has encouraged DJ to visualize his memory of past experiences and provided him with the tools to make visible the mental concepts connected to them. His drawings are the living proof that the artist has acknowledged that the here and now:

...is a repetition of the past, and [that] the here-and-now interpretation may serve to retranscribe our memories, and thus shape a different paradigm, or a novel view of one's identity that can be used in the lived present. The so-called present, in turn, is utilised for shaping the future, and for envisioning further reconstruction as retrospective valuations of our past and ever-new reconstructions of future events.[16]

Though DJ's work exists largely in the local domain, as yet excluded from the wider canon of contemporary art, the potential to gain a stronger voice is given, as it has its roots in the future rather than in the past.

Interconnecting Institutional Narratives

Interconnecting institutional narratives lack the embodied 'teller'. They are firmly established in current cultural and political discourses of state and nation and have a stronghold in all shared and personal narratives; indeed define them to a large extent. The personal narratives of DJ and Jeff reflect how they are affected by and respond to demands laid down by institutional narratives.

The structures of these interconnecting institutionalized narratives are largely hidden, never openly defined, as they consist of set institutional paradigms that characterize the political structure of post-apartheid South Africa. DJ's and Jeff's stories have their root in these interconnecting narratives. They frame the shared narratives of student and teacher.

From the stories told above three main strands emerge that exemplify the influence of interconnecting institutional narratives in post-apartheid South African art education and production:

- Order (shared narrative of the ruling class)
- Denial of opportunity (shared narrative of the oppressed under the old regime)
- 'Power over' politics of new institutions (shared narrative of the 'disenfranchised')

Jeff talks about his fixed ideas on the smooth running of an art school when he began work at Border Technikon. These were based on the interconnecting institutional narrative of strict organization and order, a remnant of an imposed value system by the former South Africa that forced an alien ideology onto the colonized.

Though DJ's metaphorical representations of turmoil and instability mock obsolete concepts of order as ideological constructs and deny the received concept of order, they are executed in a highly structured and disciplined way. They essentially exude a sense of order as a result of structured, meticulously planned instruction by his tutor who operates within the framework of a *de facto* unstructured institutional paradigm. This shows the strength of the narrative approach, where order is seen as an essential part of any creative endeavour intrinsic to the artist. DJ's work is the result of his engagement with the Provincial Arts and Culture Department and its public service project: the 'Zanokhanyo' community art centre. As Jeff points out, that institution exploited the artist. That this exploitation was made public is largely due to his education at

Border Technikon. The narrative approach gave him a voice, which allowed him to depart from an assured, yet powerless position of the politically correct and enabled him to critique one area of interconnecting institutional narratives of post-apartheid South Africa. His work reflects on the effect of hidden agendas on the individual and publicizes them to a wider local audience of people immediately connected and affected by policies made by these institutions. A small, yet significant beginning.

Conclusion

In conclusion, the specific narrative approach used at Border Technikon's art school offers new scope. The individual focus on the artist faced by a narrative reflection generates new and shared cultural stories, which impact on the local audience, because fundamental societal transformations challenge the role of the artist in an African context. This paper has shown that the narrative approach is not only effective in accommodating that challenge but absolutely necessary to give artists back their long lost voice. Art educators beyond the realm of South Africa should take heed of this approach.

Notes

Editor's note: the images from the original article have not been used in this version. See *JADE* 23 (2).

1. Corradi Fiumari, G. (1990). *The Other Side of Language*. London: Routledge.
2. Moi, T. (ed.) (1992). *The Kristeva Reader*. Oxford: Blackwells, p. 34.
3. See Bromley, R. (2000). *Narratives for a New Belonging: Diasporic Cultural Fictions*. Edinburgh: Edinburgh University Press; Burr, V (1995) *An Introduction to Social Constructionism*. Routledge; Freedman, J. & Combs, G. (1996) *Narrative Therapy: The Social Construction of Preferred Realities*. W W Norton.
4. Davidson, B. (1991). *African Civilization Revisited*. Africa World Press.
5. Kvale, S. (1996). *InterViews; An Introduction to Qualitative Research Interviewing*. Thousand Oaks: Sage, p. 199.
6. Kvale, S. *Ibid.*, p. 227.
7. Kvale, S. *ibid.*
8. White, M. (1997). *Narratives of Therapists' Lives*. London: Dulwich Centre Publications.
9. *Ibid.*
10. Clifford, J. (1988). *Predicament of Culture: Twentieth Century ethnography, literature and art*, Harvard University Press, p. 37.
11. Shusterman, R. (1992). *Pragmatic Aesthetics. Living Beauty. Rethinking Art*. Oxford: Blackwell, p. 26.
12. Shusterman, R. *op. cit.*, p. 18.
13. Corradi Fiumari, G. (2001). *The Mind's Affective Life. A Psychoanalytic and Philosophical Inquiry*. London: Routledge, p. 113.
14. Shusterman, R. (1992). *Op. cit.*
15. Corradi Fiumari, G. (2001). *Op. cit.*, p.16.
16. Corradi Fiumari, G. (2001). *Ibid.*, p. 114.

15

A Cross-cultural Study of Art-teacher Education in Taiwan and England

Mei-Lan Lo

Introduction

The content of this article is derived from research carried out for my doctorate, which compared art-teacher education in Taiwan and England. It was presented at the 6th InSEA European Regional Congress in 2003 and revised in 2005. This revision was sponsored by a research project of the National Science Council in Taiwan. The main questions posed in this research were (1) What are the similarities and differences of art-teacher education in Taiwan and England? (2) What are their respective strengths and weaknesses? (3) What are the implications of this for reforming art-teacher education in Taiwan? To answer these questions, a cross-cultural study using a multi-method approach was adopted which drew on data collected from a wide variety of sources, including reviews of literature, analysis of national curriculum policy, a questionnaire survey of educators' views of art-teacher education, observations of classroom practice and interviews with art educators, all of which were carried out between October 1998 and July 2001 when I studied in England, and when I reflected on my teaching practice in art-teacher education in Taiwan from September 2001 to July 2005. The main findings of art-teacher education in two systems are reported as follows.

Art-teacher education reform in Taiwan

'Education is the root of a nation, especially teacher education' is a well-known idiom in Chinese society.[1] There is a long Chinese tradition of 'respecting teachers and a body of moral teachings' going back to Confucius (551–479 BC). Confucius is respected both as a sage and teacher, and his birthday on 28 September is celebrated as 'Teachers Day'. Teacher education has always been afforded importance in Taiwan, as Hsieh and Chen note:

National education is the basis of all graded schools; teacher education is an essential issue in all kinds of education. Thus, teacher quality is important. Teacher education should be the first priority to be emphasised.[2]

Teacher education was regarded as 'instrumental to military defence',[3] and was highly controlled by the government through a national system of entrance scholarships and teacher qualifications.[4] However, the 1990s heralded a period of significant change. The Teacher Education Law was amended on 7 February 1994 to open up new channels for education and training.[5] After this, all public and private universities with teacher education centres became eligible to provide teacher education programmes.[6] Teacher education was no longer monopolized by normal universities and teachers' colleges. This finally broke down the traditional system of 'centralized, unified, government scholarship and job distribution'. Reforms of teacher education in the 1990s continued to contribute towards an increasing pluralism of provision and competition.[7] In recent years it is said that there has been continuing improvement in teacher education. According to the Ministry of Education,[8] teacher education in Taiwan traditionally falls into two categories. The first type is the normal college, preparing teachers for primary schools and kindergarten. The second type is the normal university, preparing teachers for middle schools. Both types of institutions accept senior high school graduates for four-year training courses. In recent years, some normal colleges have begun the training of teachers for middle schools, and normal universities have begun the training of teachers for primary schools. In addition, some other universities also offer teacher training programmes to prepare teachers of primary and middle schools, since the 1994 Teacher Education Law was revised. The Teacher Education Law was issued initially in 1979 and was revised in 1994, 1996, 1997, 2001, 2002, 2003, 2004 and 2005 respectively. The present version was revised on 22 June 2005. It prescribed regulations for training kindergarten, primary and secondary school teachers.

Art-teacher education in Taiwan is controlled by the Ministry of Education in the same way as the other subjects. A full programme of teacher education includes common courses, disciplinary courses, education specialization courses, and a half-year of teaching practicum. Those who meet the programme requirements obtain a certificate. They must then also pass the teacher qualification exam held by the Ministry of Education for final teacher qualification.[10] These courses prepare students to teach common subjects in primary and secondary schools, and this kind of training is not subject-specific. This new arrangement fundamentally challenged the specialist model of art-teacher education, because anyone who takes these courses can gain qualified teacher status in general, including teaching art. Although it allows for diversification of teacher education routes, this kind of programme is exclusively vocational and the syllabus concentrates on general education rather than being tailored to 'art education'.[11]

Following global and postmodern trends, the national curriculum for school education went through significant changes at the turn of the century in Taiwan. The Ministry of Education proposed an 'Outline' of a National Curriculum for the twenty-first century to replace the 'Standards' in 2001. A major consideration was to allow teachers to exercise greater professional judgement and more latitude to experiment with curriculum content and modes of delivery.[12] The new National Curriculum was a radical departure from tradition in that the subject

disciplines were grouped into seven learning areas, namely: languages, health and physical education, social studies, arts and humanities, mathematics, science and technology, and an activity period.[13] The most significant change for art education was that art was integrated with music and performing arts in a learning area called 'Arts and Humanities'.[14] After two years of classroom practice and academic discussions, it was suggested that 'Arts and Humanities' in school education would achieve three main aims of 'exploration & expression', 'aesthetic judgement & understanding', and 'into practice and implementation'.[15]

In the twenty-first century Taiwanese art-teacher education has become 'arts & humanities' education, which includes visual art, music and performing arts. However, art-teacher training still remains in the same art departments of teacher education institutes, because this fundamental change affects compulsory school education but not higher education. This education policy attempted a bottom-up reform from school practice to teacher education, but it did not work well. Recently, there have been more professionals, teachers and parents calling for a return to visual arts and music education instead of integrated learning areas of 'arts & humanities'.

On the other hand, art-teacher education is facing a big challenge. There is no professional certification for art teachers or 'arts & humanities' teachers in Taiwan, only certifications for general teachers. In addition, in August 2005, all normal universities and teachers colleges completely transferred to a general university or to an educational university, which is not responsible for just teacher education. Now, all traditional teacher education institutes are busy finding ways to remodel their roles. In the continuing change of government policy and series of education reforms, art-teacher education has become marginal and more vague than before.

Despite the constantly changing policy during the period of research, underlying cultural and social values have had the greatest impact in the long run, because these influence both policy and the social environment from which policy is formed. Cultural and social values are longer lasting than the vicissitudes of policy, and so this research had to take them into account in developing a conceptual framework and providing recommendations for the future of Taiwanese art-teacher education.

Art-teacher Education Reform in England

In teacher education in England in the 1990s there was an important policy change towards structural reorganization and increased central control.[16] In 1992 the Department of Education and Science (DES) introduced regulations that required all existing teacher training to be delivered through partnerships between teacher training institutions and schools.[17] This virtually removed the control which the universities had had over the training of initial teachers for the last one hundred years.[18] The roles and responsibilities of tutors and teachers were drastically changed, with teachers becoming 'mentors' and taking most of the control of the extensive school-based elements, including assessment of the quality of students' teaching. Tutors had to prepare student teachers for their extended school teaching experience, train mentors and carry out a quality control function to ensure that they were being trained adequately in schools. Assessment became competence-based and focused mainly on the acquisition of classroom

skills over time, and theory of education was subordinated to practice. It follows logically from this that the schools' contribution became at least as significant as the contribution of the higher education institutions involved.

In 1994 the government established a Teacher Training Agency (TTA) to oversee initial teacher education. This agency was intended to contribute to raising standards of teaching and promoting teaching as a profession.[19] In 1998 a National Curriculum for teacher education was established by the TTA with a clear list of competencies to be attained by successful students.[20] The adherence to TTA curriculum and assessment requirements is now monitored by a non-ministerial government department called the Office for Standards in Education (OFSTED) that regularly inspects all teacher education provision and seeks to promote improvement.[21] TTA and OFSTED together exercise a powerful control over teacher education. Where OFSTED is responsible for academic quality control, the Teacher Training Agency exerts financial control of quality through evaluation of the Office for Standards in Education reports. Non-compliance with TTA requirements can result in the withdrawal of funding from an institution.

The shift away from a traditional, theory-before-practice model of teacher education in England towards the more practice-based methods courses of the 1990s was underpinned by the notions of 'reflection-in-action' and collaborative partnerships between university and schools.[22] Addison and Burgess described the components of university-based course and school-based experience in England as 'indivisibly related'.[23] This suggested that there was widespread acceptance in England that partnerships between schools and universities to deliver teacher-education was important, and also the best way to integrate pedagogic theory and practice.

In addition, the General Teaching Council for England (GTC) was launched in September 2000. GTC is the independent professional body for teaching which provides an opportunity for teachers to shape the development of professional practice and policy, and to maintain and set professional standards. The 2002 Education Act gave the GTC further powers: (1) Trainee teachers were required to have provisional registration with the GTC, and (2) The GTC defined suitability to teach.[24] How to determine the GTC influence on art-teacher education needs time for further observation.

Comparison of Art-teacher Education in Taiwan and England

The history of education in England is a long, continuous narrative but in Taiwan it is short and disjointed. Given this state of affairs, I was surprised to discover so many similarities in the two systems. In the 1990s, teacher education was the main priority in the educational reforms being promoted by both governments.[25] The ministries of education in both countries set tight goals for educational provision, prescribed specialist curricula, controlled the channels for training art teachers through legislation and set standards for teacher qualifications. Teacher education courses in higher education institutions were structured so as to include both university and school-based studies. University-based provision was intended to provide the teachers the opportunity to experience the reality of teaching art to children in classrooms and to gain confidence through practice. In addition, both countries had national curricula for school art laid down by government and the expectation was that student teachers would be instructed in how to deliver them.

The 1990s were a period of teacher education reform in both countries. While the British government established the Teacher Training Agency in 1994, and British art-teacher education moved towards structural reorganization and increased central control, the Taiwanese government amended the Teacher Education Law in 1994, which paved the way for more diversification in teacher education in Taiwan. In the late 1990s both art-teacher education systems were responding to postmodern, global trends by emphasizing increased use of new technologies and cultural diversity. However, close examination of the conceptual frameworks underpinning art-teacher education in the two countries showed considerable differences. The disciplined-based curriculum model originating from America predominated in Taiwan, whereas the National Curriculum and examination system in England drew on home-based research and theory for art education. In Taiwan, teaching and learning in art drew mainly on formalist aesthetic theory, whereas in England the theoretical framework for critical studies was more sociological and anthropological.

The research revealed how complex and hazardous it is to state categorically what the similarities and differences really are between two art-teacher education systems, especially in a subject as ill-defined as art. Nonetheless, this study did produce some important differences in the two art-teacher education systems. The differences, which included (1) government regulations and institutional provision, (2) theoretical underpinning, (3) art curriculum policy and conceptual framework for specialist art training delivery, and (4) cultural differences affecting art and professional studies in education; and (5) the schoolteachers' attitudes and values, will now be discussed in more detail.

Government Regulations and Institutional Provision of Art-teacher Education

In Taiwan, the administration of teacher education, including art, is controlled exclusively by the Ministry of Education, while in England the ministry delegates at least some of its power to seven education agencies, operating under the control of the Department for Education and Skills (DfES). On these grounds it could be argued that the operational model is more centralized in Taiwan and more diversified in England. However, the Taiwanese Ministry of Education has gradually reduced its central control. A repeal of martial law in 1987 gradually relaxed government control over the content of school textbooks; the Teachers' Education Law of 1994 diversified teacher education provision and curriculum outlines replaced the more prescriptive National Curriculum 'Standards' in 2001. Meanwhile art education was granted considerably greater institutional autonomy than ever before. There has been a movement towards decentralization and increased autonomy for art teachers in Taiwan since 1987. In England, by contrast, the government has increased its influence on national education since the Education Reform Act of 1988. The National Curriculum was initiated in 1988 and a first version for schools was released in 1992. The United Kingdom government claimed that The National Curriculum lies at the heart of a major national policy initiative to raise educational standards,[26] taking much more direct control in order to establish equality of opportunity and improve quality. It introduced national standards of assessment in teacher training in 1998. Furthermore, there was increased regulation of teacher education in general thorough inspections by OFSTED and other accountability procedures devised and implemented by the TTA. This suggests that different ideologies underpin central government legislation.

In the 1990s, British legislation broadened teacher education provision beyond higher education institutions to include selected school consortia. My discussions with teacher educators during the fieldwork in England confirmed the views expressed in the literature, for example by Smith,[27] that many educationalists mourned the loss of autonomy of higher education institutions at this time and regarded the promotion of teacher training in schools as a deliberate attempt by government to deskill and de-intellectualize the teaching profession. Policymakers and teacher education administrators, however, were critical of the monopoly that higher education institutions had previously held over teacher education. From their perspective, school-based teacher education reforms were long overdue, brought greater diversity and provided a stimulus for improving the quality of teacher education.

The Post Graduate Certificate in Education (PGCE) courses I studied in England operated a partnership model of delivery, with shifting balances of power between institutions of higher education and schools throughout the 1990s. At the time of writing the responsibility for training was often shared equally between partnership schools and higher education institutions. This is very different from Taiwan, where the responsibility is firmly located in higher education. Compared with the partnership model in England, Taiwan operates a top-down approach to teacher education in which university professors are assumed to know more about education than classroom teachers. In England, on the other hand, I observed that the relationship between university tutors, subject mentors and student teachers is triadic and collaborative rather than hierarchical.

Theoretical Underpinnings

A brief historical review of the Taiwanese curriculum revealed that since World War II, art education theory in Taiwan has been underpinned by three kinds of theory borrowed from overseas. These can be grouped as follows: (1) child-centred theories that promote children's artistic development for psychological reasons (as exemplified in the writings of Dewey, Read and Lowenfeld), (2) formalist theory as espoused by the Bauhaus and other influential modernist art educators artists and critics, and (3) the Discipline-Based Art Education (DBAE) curriculum concept. Recently, post-modern theories that favour multiculturalism and the use of new technologies have exerted increased influence on Taiwanese art education. It was apparent that theories and texts emanating from the West continued to dominate Taiwanese art education. Furthermore, an analysis of course documents in art-teacher education used in Taiwan confirmed that the dominant concepts underpinning the art curriculum were derived from western theories of aesthetics, art history and art criticism, especially formalism.

In contrast, the dominant theories and texts used in art education in England when I carried out the fieldwork in England were indigenous and developed by English art educators from practice, or grounded in nationally funded research. Examples are Taylor's *Critical Studies in Art Education Project* (1981–1984) and Addison's strategy for analysing art works[28] which drew on a range of western art theories, including semiotics. From a Taiwanese perspective I understand the movement popularly known as 'critical studies' in English art education as a kind of cross-disciplinary approach to teaching and learning in art. Since its inception it has drawn on traditional approaches to, and methods of, teaching art history and, increasingly, art

criticism and cultural studies, but it has extended its boundaries to include theory and practice from media studies and sociology, which art teachers are using as a means of addressing problematic issues in contemporary English society through the study of contemporary art.

In short, art education theory in England is influenced by a wider range of western art theories, is more up-to-date and is grounded more in individual practical teaching and applied research than in Taiwan. Additionally it is more pragmatic and more closely linked to practice in England. A recommendation arising from the cross-cultural study was that in Taiwan art education theories should be developed. These should draw on a wider range of western theories and be grounded in more research on Taiwanese classroom practice. They should also try to achieve a better balance between local and global ideas.

Art Curriculum Policy and Delivery

A historical review of national curriculum for art in Taiwan revealed that official policy for art education in Taiwan had moved from promoting a utilitarian vocational rationale from 1929 to 1945, to developing good taste and cultivating Chinese national identity from 1945 to 1968, to a child-centred artistic expressive rationale from 1968 to 1982 and finally, to an essentialist discipline-based rationale from 1982 through the 1990s.[29] At the time of writing, an integrated approach towards teaching the visual arts, music and performing arts is being advocated in arts education in the Taiwanese national curriculum. This change of curriculum policy appears to be a manifestation of a desire by government and the public in general to make education, including the arts, a more integrated and holistic experience for pupils.[30] In contrast, the history of the national curriculum for art & design in England only goes back to 1988. Since that time, the statutory orders for the art curriculum have changed from advocating the two attainment targets of 'Investigation & Making' and 'Knowledge & Understanding' in the 1992 and 1995 versions to a single one called 'Knowledge, Skill & Understanding', which integrated the expressive and aesthetic domains, in 1999. However, there remains one subject called 'Art & Design', and there are no plans to integrate arts subjects into one curriculum area in England at the time of writing, as is the case in Taiwan.

Curriculum reform in Taiwan has tended to be implemented in a top-down manner whereas in England it has been more participatory and democratic. While Taiwanese art teachers have tended to operate within a tightly controlled curriculum framework prescribed by the government, English art teachers have had more freedom to interpret government policy. However, the most recent educational reforms in Taiwan are an important move in this direction, because they are informed by a policy of deregulation and they favour increased participation of teachers in curriculum design and delivery. Analysis of the Taiwanese curriculum outline for 2001 suggests that, in future, Taiwanese art teachers, like their colleagues in England, will have more opportunities to experiment with design and delivery of the curriculum, and to select their own teaching materials.

Curriculum delivery in art-teacher education is more teacher-centred in Taiwan overall, whereas the learning I observed in England was more student-centred and teachers there acted more like facilitators or mediators. Their instructions were more open-ended and they offered students

greater autonomy of learning than is normally the case in Taiwan. The favoured modes of delivery in Taiwanese art-teacher education were whole-class lectures, teacher-led question-and-answer sessions and written assignments, whereas in England, I saw a great deal of small group discussion and independent study. Assessment in Taiwan was also more formal, and took the form of knowledge-based tests, examinations and essays. Much of the assessment I saw in England, however, was continuous and made use of visual displays and oral presentations. Some of it was based on observations of classroom practice by tutors and oral feedback in tutorials.

Another important difference is that the content of art-teacher education in Taiwan is informed by separate disciplines, each of which is taught by a professor or lecturer with a different kind of academic expertise. Their different academic standpoints do not necessarily integrate into a coherent pedagogy. Student teachers in Taiwan sometimes complain that relating theory and knowledge about art into their classroom practice is problematic. In England, on the other hand, knowledge about art is acquired more holistically through critical studies in ways which provides more opportunities for student teachers to reflect on and integrate theory with classroom practice.

Cultural Differences Affecting Art Teachers' Attitudes and Values

Masemann, in an essay 'Culture and Education',[31] claimed that culture 'expresses the value system(s) of a particular society or group', and is highly relevant to education. Through conducting this research, I discovered how important understanding the culture of an education system is for determining what is needed in internal or external reform. Having addressed some broad similarities and differences in teacher education at government and institutional levels and theory, policy and practice of art-teacher education, this section focuses on cultural differences between England and Taiwan. In doing so, it reflects on the findings from the fieldwork carried out in England, the interviews with the teacher educators in Taiwan and my own impressions of the learning environment both in England and Taiwan as recorded in my research diary.

Obvious differences strongly affecting student teachers' attitudes to teaching and learning were their educational backgrounds (including cultural factors), application procedures and entrance requirements for teacher education. Whereas most Taiwanese high school graduates enter teacher education aged eighteen by means of national academic examinations, specialist art teachers in England (PGCE) enter teacher education aged twenty-one and over, by means of interviews organized by individual universities which include portfolio assessment. Moreover they have already obtained a BA degree in art and design, or a related subject. The majority also have previous work experience. Not surprisingly therefore, I found them more mature, in the sense that they took more responsibility for their own teaching and learning than their Taiwanese counterparts. The interaction and exchange of ideas between student teachers with specialist knowledge of different kinds gained in BA degree courses, which prepared them to be professional designers and artists, was a positive feature of the PGCE Art & Design courses I studied in England. Perhaps because of this, I witnessed them demonstrating greater ability to make independent decisions and approaching their teaching with greater autonomy, independence and maturity.

Another very important cultural difference affecting art-teacher education in the two systems was the general status of teachers. Teacher status appeared to be very low in England compared with Taiwan.[32] Teacher education in Taiwan in the twentieth century was always closely linked to notions of future national prosperity.[33] In addition, the ancient tradition of teachers being viewed as members of an elite intellectual caste in Taiwan, means they are 'well paid, highly respected, and have high job security'.[34] Moreover, teaching tends to be a profession for life.[35] Because of this long tradition in Chinese society of respecting teachers as well as elders, the relationship between teacher educators and student teachers is at the same time both more hierarchical and more respectful and caring in Taiwan than in England. Not surprisingly, teaching styles are more direct in Taiwan. Whereas relationships between teacher educators and trainees seemed to be less hierarchical and paternalistic in England, effective formal and informal social and instructional relationships were constructed and maintained nevertheless. Instead of functioning as directors of learning like Taiwanese professors, the university tutors in England adopted the role of moderator or mediator and this seemed to work very well. An important finding from my study was that the learning environments provided for student teachers at Taiwanese and English universities are very different. Typically, Taiwanese art teachers are trained at universities of education specially designed for this task. Their campuses constitute a close-knit community in which all the facilities student teachers need for their daily lives, including post offices, dining rooms, a music hall, sports grounds, swimming pools and student accommodation, are provided on site. Some even include teacher educators' dormitories. Taiwanese cultural expectations are such that it is assumed that this special kind of community and lifestyle assists the development of the personality characteristics of 'a good educator'. I saw no evidence of a desire to cultivate the personality or character traits of student teachers in the English teacher education system.

Another important difference that emerged during this research was the finding that English art-teacher education is practice-led and uses the one-to-one tutorial system extensively to encourage students to reflect on their teaching experience in schools. In contrast, Taiwanese art-teacher education is theory-driven and student teachers have less opportunity to practise their teaching during the four-year university based study. In comparison with the vocational emphasis in England, Taiwanese art-teacher education programmes are much more broadly educational. In addition to cultivating students' morals and character, they value theory for its own sake to a much greater degree; whereas English art-teacher education values practice, and developing an individual philosophy of art teaching empirically grounded in reflection on personal classroom practice. Perhaps both systems try to influence student teachers' characters and attitudes as well as develop their teaching skills, but in different ways. National cultural values about education in the two countries seem to have resulted in different strategies for cultivating an art teacher's personality.

Conclusions

According to several experts,[36] the purpose of a comparative study is not to arrive at conclusions about which system is better than the other but to enhance understanding and reassess strengths and weaknesses so as to find ways to improve them. This research tried to gain insights into two art education systems with a view to improving art-teacher education

in Taiwan. After reconsidering the theory, policy and practice of art-teacher education in two countries, the summative conclusions for this research at the macro level were that Taiwanese art-teacher education is moving from a postcolonial period of historical development to one which is less culturally dependent and seeking to achieve a balance between localization and globalization. At a micro level, Taiwanese art-teacher education should develop an indigenous conceptual framework for the curriculum in art. In accordance with Taiwan's history of foreign occupation, its art education derives its theoretical orientation from other countries, the USA in particular. An important conclusion of the research is that the Taiwanese government needs to pay more attention to art-teacher education, and Taiwanese art-teacher education needs to develop its own theories and take account of its own strengths and traditions.

The research was an active process that developed continuously. The most difficult obstacle to surmount was the speed of change in art educational policy in the two countries, but especially in Taiwan. This made it very difficult indeed to describe and interpret what was happening in art and art-teacher education, which is in itself a very complex field of inquiry. In conducting this rigorous research journey, I learned that cross-cultural studies are much more complicated than home-based ones. Difficulties the foreign researcher must overcome include language, cultural differences, getting to know an unfamiliar environment and coming to terms with all this at a considerable distance from home, to say nothing of the costs of travel and accommodation overseas. Furthermore, art-teacher education systems are organized differently for historical, political, social and cultural reasons. I was surprised to find out, while I was conducting this research, that it was easier to locate policy documents and literature about art-teacher education in the English system than the Taiwanese system. I concluded that this was evidence that an educational research culture is still lacking in Taiwan. Until a body of this kind literature exists in Taiwan, research there will continue to be hampered.

Notes

1. Hsieh, W & Chen, P. (1993). *A Study of the Draft for Revised Teachers Education Law in Details.* Taipei: National Taiwan Normal University Education Research Centre.
2. *Ibid.,* p. 1.
3. Fwu, B. (2000) Taiwan, in P.. Morris & J. Williamson, (eds.) *Teacher Education in the Asia-Pacific Region: A Comparative Study.* London: Falmer Press, p. 277.
4. Ting, C. (1997). Reflections and Prospects on Financial System (Government Scholarship versus Private Fees) of Teacher Education, in Association of Teacher Education (ed.) *Teaching Professionalism and Teacher Education.* Taipei: Normal University Bookshops, pp. 171–176.
5. MOE (1994). *Teachers Education Law* (revised 22 Feb. 1994). Ministry of Education, Taiwan (online). Available from URL: www.edu.tw/rules/ index.html (Accessed 15th November 2000).
6. Bureau of Statistics & Ministry of Education (1999). *1999 Education in the Republic of China.* Taipei: Ministry of Education, p. 14.
7. Hwang, R. (1999). The Three-C Approach for Art Education, in National Changhua University of Education & Association of Art Education Development, ROC [Eds] *Congress Proceedings: The Prospects of Art Education in the 21st Century an International Symposium in Art Education,* pp. 483–510; MOE (1999) *The Ministry of Education 1999 Progress Report* (English Version).

Ministry of Education, Taiwan (online). Available from URL: 140.111.1.22/english/index.htm (Accessed 15th November 2000).

8. MOE (2004). *2004 Education in the Republic of China*. Taipei: Hilit, p. 42.

9. MOE (2005). *Teachers Education Law* (revised 22 June 2005). Ministry of Education, Taiwan (online). Available from URL: law.moj.gov.tw/. Scripts/Query4A.asp?FullDoc=all&Fcode= H0050001 (Accessed 28th August 2005).

10. MOE (2004). *Op. cit.*, p. 43.

11. Lo, M. (2003). Comparative Analysis of Art Teacher Education in Taiwan and England with Particular Reference to the Aesthetic Domain. Unpublished PhD thesis, University of Surrey, Roehampton.

12. MOE (2001). *Guidelines for Nine-Year Joint Curricula for Primary and Junior Secondary Schools.* Taiwan: Ministry of Education.

13. *Ibid.*

14. Lu, Y. (1999). Abstract on the Domains of Study in Arts and Humanity & the Concept of Integrated and Interactive Curricular Design, *Journal of Aesthetic Education*, 106, 29–8; Su, C. (2000) Insights of 20th Century Arts Education Associative/Related Contemplation of Studying 'Arts and Humanities', *Journal of Aesthetic Education*, 117, 84–92; MOE (2001) *op. cit.*

15. MOE (2003). *Guidelines for Nine-Year Joint Curricula for Primary and Junior Secondary Schools.* Ministry of Education, Taiwan (online). Available from URL: eje.ntnu.edu.tw/data/kying /20031241215/index.htm (Accessed 28th June 2003).

16. Gardner P. & Cunningham, P. (1998). Teacher Trainers and Educational Change in Britain, 1876–1996; 'A Flawed and Deficient History'? *Journal of Education for Teaching*, 24(3): 231–255.

17. DES (1992). *Initial Teacher Training (Secondary Phase) Circular 9/92*. London: HMSO.

18. Wilkin, M. (1996). *Initial Teacher Training: The Dialogue of Ideology and Culture*. London: Falmer Press; Furlong, J. et al. (2000). *Teacher Education in Transition: Re-forming Professionalism?* Buckingham: Open University Press.

19. SCAA & ACAC (1996). *A Guide to the National Curriculum.* London: The School Curriculum and Assessment Authority; TTA (2001) Teacher Training Agency (online). Available from URL: www. canteach.gov.United Kingdom/home.htm. (Accessed 22nd October 2001.)

20. TTA (1998a). *National Standards for Qualified Teacher Status.* London: Teacher Training Agency; TTA (1998b) *Requirements for All Courses of Initial Teacher Training.* London: Teacher Training Agency.

21. Clay, G., Hertrich, J., Johns, P., Mills, J. & Rose, J. (1998). *The Arts Inspected*, Oxford: Heinemann.

22. Lo, M. *op. cit.*

23. Addison, N. & Burgess, L. (eds.) (2000). *Learning to Teach Art and Design in the Secondary School: A Companion to School Experience*, London & New York: Routledge Falmer, p. 115.

24. GTC (2005). General Teaching Council for England (online). Available from URL: www.gtce.org.uk (Accessed 2nd September 2005).

25. Hsieh, W. & Chen, P. *op. cit.*, Furlong, J. *et al. op. cit.*

26. See, for example, The DfEE/QCA documentation on the National Curriculum (1999).

27. Smith, E. E. (1999). Partnership in Initial Teacher Education: A First Evaluation. PhD thesis, University of Manchester, p. 27.

28. See CSAE (1982). *Broadening the Context. Critical Studies in Art Education Project*: occasional paper no. 1. Wigan: Drumcroon and Addison, N. (2000) Critical and Contextual Studies. In

Addison, N. & Burgess, L. (Eds) *Learning to Teach Art and Design in the Secondary School: A Companion to School Experience*. London, New York: Routledge Falmer, 227–243.

29. Lo, M. *op. cit.*

30. Lu, Y. *op. cit.*

31. Masemann, V. L. (1999). Culture and Education, in R. F. Arnove, & C. A. Torres (eds.) *Comparative Education: The Dialectic of the Global and the Local*. Lanham: Rowan & Littlefield, 115–133, p. 117.

32. Dillon, J. & Maguire, M. (1997). *Becoming a Teacher: Issues in Secondary Teaching*. Buckingham: Open University Press; Fwu, B. *op. cit.*

33. Chang, F. (1992). An Analysis of Ideology of Taiwanese Teacher Education, in Chinese Comparative Education Society & Association of Teacher Education of ROC (eds.) *Comparative Teacher Education in International Perspectives* 359–408.

34. Fwu, B. *op. cit.*, p. 232.

35. Yang, S. (1999). *Forms of Knowledge and Comparative Education*. Taipei: Yang-Chin Book Co.; Fwu, B. *op. cit.*

36. See, for example, Hatano, G. & Inagaki, K. (1998). Cultural Contexts of Schooling Revisited: A Review of the Learning Gap from a Cultural Psychology Perspective. In S. G. Paris & H. M. Wellman (eds.) *Global Prospects for Education: Development, Culture, and Schooling*. Washington, D.C.: American Psychological Association, 79–104; Freedman, K. & Hernández, F. (eds.) (1998) *Curriculum, Culture, and Art Education: Comparative Perspectives*. New York: State University of New York Press; Thomas, E. (2000) *Culture and Schooling: Building Bridges between Research, Praxis and Professionalism*. New York: Wiley.

A Glossary of Research Terms in Arts Education

Words in bold are cross-referenced

Action research
A type of research in which educators examine and reflect upon their own practice and evaluate strategies to improve practice. It is a multi-stage type of research, in which a problem is researched, changes are made, the problem is researched again, more changes are made, and so on through a number of cycles, until the problem is solved. Most action research studies use **descriptive research** designs.

A/r/tography
This term refers to an approach in which art forms are used as part of the research process. Rita Irwin writes, 'A/r/tographers are living their practices, representing their understandings, and questioning their positions as they integrate knowing, doing and making' from Irwin, R. L. and A. de Cosson (2004) *A/r/tography as living inquiry: An introduction to arts-based research in education.* Vancouver: Pacific Education Press.

Art-based research
This refers to research that privileges the visual over the written word. See also **a/r/tography**, above. *Arts*-based research refers to research that privileges all art forms (dance, drama, music, poetry) over the written word.

Attrition
Attrition refers to the reduction in the number of participants during the course of a research project.

Audit trail
Within a **naturalistic** study, an audit trail is the systematic documentation of material gathered that allows others to follow and audit the researcher's thinking and conclusions about the data.

Average

In descriptive statistics, 'averages' are divided into 'mean', 'median' and 'mode', terms used to describe a measure of central tendency. 'Mean' refers to all scores in a set of scores when they are added together and divided by the number of subjects; 'median' is the score that is exactly in the middle of a distribution (i.e. the value above which and below which 50% of the scores lie), while 'mode' refers to the score that occurs most frequently in a distribution of scores.

Axiology/axiological

An axiological concern is a concern with human values; axiology deals with the nature of value and considers the question – what is intrinsically worthwhile?

Bias

Bias is any influence that distorts the results of a research project, but particularly from the researcher.

Bracketing

Bracketing refers to a process used by some phenomenological researchers to identify their preconceived beliefs and opinions about the phenomena under investigation, in order to clarify how the researcher's belief system might influence what is seen, heard and reported.

Bricolage/bricoleur

Bricolage is a term used to refer to the construction or creation of a work from a diverse range of things which happen to be available, or to a work created by such a process. A person who engages in bricolage is a bricoleur: someone who invents their own strategies for using existing materials or ideas in a resourceful, and original way to learn and solve problems through experimentation. It can therefore be used to refer to research which is so conducted.

Case study

A type of qualitative research which studies one or a few cases (a single person, entity or phenomenon) in great detail; it is a data collection method in which a case (for example, an art teacher or a particular child) is studied in depth over a sustained period of time and through a variety of means.

Categorical variable

A variable with a particular value such as gender or ethnicity.

Coding

A procedure for transforming raw data into a form suitable for data analysis. It involves the labelling of a piece of text or a statement, to make sense of it by summarizing it. Depending on the research question, one piece of text can be coded in various different ways.

Constant comparative method

A procedure used in **grounded theory** research which refers to data being continually compared with previously collected data in order to refine the development of theoretical categories.

Content analysis
A procedure for organizing narrative, qualitative data into emerging themes and concepts.

Core category
The central category that is used to integrate all the categories identified in **grounded theory** research.

Correlation
This refers to the degree of association between two **variable**s. A correlation coefficient is a measure of the degree of relationship between two variables: it lies between +1.0 (indicating a perfect positive relationship), through 0 (indicating no relationship between two variables) to -1.0 (a perfect negative relationship).

Critical realism
Critical Realism is a philosophical attempt within social science to argue for the material presence of the social and natural world outside of our knowledge of it. It is concerned with questions of **ontology**, and the deeper structures and relations that are not directly observable but lie behind the surface of social reality. It is seen as a pragmatic development arising from a reaction to **positivism**.

Data saturation
This refers to the point at which data collection can stop. This is arrived at when the information that is being shared with the researcher becomes repetitive and contains no new ideas, so the researcher can be reasonably confident that the inclusion of additional participants is unlikely to generate any new ideas. In a similar way, literature searches can reach a point of closure when references do not throw up any new significant texts.

Descriptive research
A type of research that has the goal of describing what, how or why something is happening.

Descriptive statistics
Statistical methods used to describe data that is collected from a specific sample (e.g. mean, median, mode, range, standard deviation).

Determinism
The belief that everything is caused by specified factors in a predictable way rather than by chance; it is said to be a key assumption within the positivist paradigm.

Emic
An emic perspective (or emic view) is a term used by ethnographers to refer to the insiders' views of their world (see also **etic** perspective).

Empirical research

Empirical research seeks systematic information about something that can be observed in the real world. Empirical information is information based on something that can be observed. Students' achievements, observations of art teachers' use of their own work, and artists' interview responses are examples of empirical information in art education research.

Epistemology

The study of the theory of knowledge

Ethnography

A research **methodology** associated with anthropology and sociology that systematically describes the culture of a group of people. A principal aim of ethnographic research is to understand a culture from the 'inside' – from an **emic** perspective.

Ethnology

Ethnology is a data-collection **method** in which information is collected about a group of individuals in their natural setting, primarily through observations. It is a branch of anthropology that compares and analyses the origins, distribution, technology, religion, language, and social structure of the various distinctive groupings within humans. Compared to ethnography, the study of single groups through direct contact with the culture, ethnology takes the research that ethnographers have compiled and then compares and contrasts different cultures. Not to be confused with **ethology**.

Ethnomethodology

This research approach focuses on how people understand their everyday activities. It is a systematic study of the ways in which people use social interaction to make sense of their situation and construct their 'reality'.

Ethology

Ethology is the study of the evolutionary significant behaviour of people in their natural surroundings. From this perspective, development is examined in terms of the role of evolution and biology, including issues related to the brain and nervous system, as well as hormones and genes. A major theme is that of 'critical' or 'sensitive periods' of development. Critical periods are said to be those times at which we are biologically ready to acquire new behaviour.

Etic

An Etic perspective (or etic view) is a term used by ethnographers to refer to the outsider's view of the experiences of a specific cultural group (see **emic** perspective).

Field notes

Notes taken by researchers in the field which record unstructured observations.

Focus group

An interview conducted with a small group of people to explore their ideas on a specific topic.

Grounded theory

A research approach used to develop conceptual categories and/or theory about social processes from real-world observations, usually from a selected cultural group. The researcher may subsequently make further observations to test out the developed categories/theory. It is seen as an approach to qualitative research where the researchers try to approach a problem with no preconceptions, and to build their theories solely from the data gathered.

Hermeneutics

This used to refer to a method of Biblical criticism: interpreting the whole of a text in the context of its parts, and vice versa. Its meaning is now extended to refer to qualitative research which is concerned with analysing transcripts of interviews and group discussions. It is research concerned principally with interpretation and could be seen as the art of interpreting texts.

Historical research

There are said to be four types of historical evidence: primary sources, secondary sources, running records, and recollections. Historians rely mostly on primary sources (often kept in museums, archives, libraries, or private collections). Emphasis is given to the written word on paper, an example might be an artist's correspondence to another artist. Secondary sources are the work of other historians writing history. Running records are documentaries maintained by private or non-profit organizations. Recollections can be autobiographies, memoirs, or oral histories.

Historiography

This refers to the method of doing historical research or gathering and analyzing historical evidence. Historiographers are careful to check and double-check their sources of information, and this is seen as giving validity and reliability to their conclusions.

Hybrid research – see mixed method

Hypothesis

A statement that predicts the relationship between variables, in particular, the relationship between the independent and dependent variables. A null hypothesis is statement that there is no relationship between the independent and dependent variables and that any relationship observed is due to chance or fluctuations in sampling.

Inductive reasoning

Inductive reasoning moves from the specific to the more generalized and refers to the logical process of reasoning used to develop more general rules from specific observations.

Informed consent

The process of obtaining voluntary participation of individuals in research based on a full understanding of the possible risks and benefits.

Interview

A method of data collection involving an interviewer asking questions of another person (a respondent) either face-to-face or over the telephone. In a structured interview, the interviewer

asks the respondents the same questions using an interview schedule – a formal instrument that specifies the precise wording and ordering of all the questions to be asked of each respondent. Unstructured interviews are where the researcher asks open-ended questions which give the respondent considerable freedom to talk freely on the topic and to influence the direction of the interview. In unstructured interviews, there is no predetermined plan about the specific information to be gathered from those being interviewed.

Longitudinal research
A data-collection strategy in which data are collected from the same participants at different points in time. The purpose is to draw conclusions about individual change over time.

Method
Specific procedures used to gather and analyse research data.

Methodology
Different approaches to systematic inquiry developed within a particular paradigm with associated epistemological assumptions.

Method slurring
This term is used to describe the tendency of some researchers to combine research approaches without adequately acknowledging the epistemological origins and assumptions that underpin the methodologies they are blending.

Mixed method research
In mixed method (or hybrid) research, a qualitative phase and a quantitative phase are included in the overall research study. Proponents of mixed research typically adhere to the idea that quantitative and qualitative methods are compatible, that is, they can both be used in a single research study. Pragmatism indicates that researchers should use the approach or mixture of approaches that works the best in a real world situation. In short, what works is what is useful and should be used, regardless of any prior assumptions. It should not be confused with '**method slurring**' (see above).

Naturalistic (paradigm)
This **paradigm** assumes that there are multiple interpretations of reality and that the goal of researchers working within this perspective is to understand how individuals construct their own reality within their social context.

Negative correlation
A relationship between two variables where higher values on one **variable** tend to be associated with lower values on the second variable.

Observation
A method of data collection in which data are gathered through visual observations. Observation in a research setting can be structured or unstructured; structured observation typically involves

the researcher determining beforehand the phenomena that are to be observed, often using a standardized checklist to record the frequency with which those phenomena are observed over a specified time period. Unstructured observation involves uses direct observation to record things as they occur, with no preconceived ideas of what will be seen; there is no predetermined plan about what will be observed.

Ontology/ontological
Ontology refers to the form and nature of reality and what can be known about it. An ontological perspective considers the question 'what is real?'.

Paradigm
The term paradigm is often used to denote a worldview based on a set of basic values and philosophical assumptions that are shared by a particular academic community and that guide their approach to research. A paradigm can be defined as both a group of beliefs, values and techniques shared by a scientific community and also as the procedures and methods used to solve specific problems.

Participant observation
Participant observation is a method commonly used in **ethnography** and involves the researcher being totally immersed in the phenomena observed. Non-participant observation is less concerned with immersion and more with detachment.

Phenomenology
A research approach which has its roots in philosophy and which focuses on the lived experience of individuals. It is a qualitative research method in which the researcher conducts an in-depth and extensive study of participants' experiences of an event or situation from the participants' perspectives.

Population
A well-defined group or set that has certain specified properties (e.g. all art teachers working full-time in Cambridge state secondary schools).

Positive correlation
A relationship between two variables where higher values on one variable tend to be associated with higher values on the second variable (e.g. art teachers' qualifications and their students' examination performance).

Positivism
This **paradigm** assumes that human behaviour is determined by external stimuli and that it is possible to use the principles and methods traditionally employed by the natural scientist to observe and measure social phenomena.

Qualitative data
Information gathered in narrative (non-numeric) form (e.g. a transcript of an unstructured interview).

Quantitative data
Information gathered in numeric form.

Random sampling
A process of selecting a sample whereby each member of the population has an equal chance of being included.

Reflexivity
Reflexivity refers to researchers' reflections upon their research and their place within it; it requires an awareness of the researcher's contribution to the construction of meanings throughout the research process, and an acknowledgment of the impossibility of remaining outside of one's subject matter while conducting research. Personal reflexivity involves reflecting upon the ways in which our own values have shaped the research and involves thinking about how the research may have affected the researcher. Epistemological reflexivity on the other hand encourages researchers to reflect upon their assumptions about the world (and knowledge of it) that have been made in the course of the research, and about the implications of such assumptions for the study as a whole.

Reliability
Reliability is concerned with the consistency and dependability of a measuring instrument, that is, it is an indication of the degree to which it gives the same answers over time, across similar groups and irrespective of who administers it. A reliable measuring instrument will always give the same result on different occasions assuming that what is being measured has not changed during the intervening period. Inter-rater reliability is a measure of the consistency between the ratings or values assigned to an observed phenomenon and is employed by researchers using structured observation techniques; it is usually expressed as a percentage of agreement between two raters.

Research problem
A research problem is an issue that lends itself to systematic investigation through research.

Research question
A clear statement in the form of a question of the specific issue that a researcher wishes to answer in order to address a **research problem**.

Response rate
The proportion of those invited to participate in a research study who actually do so.

Sampling
The process of selecting a sub-group of a population to represent the entire population. Simple random sampling gives each eligible element an equal chance of being selected, while systematic sampling involves the selection of participants randomly drawn from a population at fixed intervals (e.g. every 10th). Cluster sampling involving successive sampling of clusters from larger ones to smaller ones (e.g. Local Education Authority to school to head of department).

Convenience sampling uses the most easily accessible people (or objects) to participate in a study while purposive sampling refers to a strategy by which the researcher selects participants who are considered to be typical of the wider population. Quota sampling refers to the researcher identifying the various aspects of a given population and ensuring that they are proportionately represented. Theoretical sampling occurs within a naturalistic research study; it is based on emerging findings as the study progresses to ensure that key issues are adequately represented.

Sampling bias
Distortion that occurs when a sample is not representative of the population from which it was drawn.

Significance
In quantitative research, 'significance' has a particular and specific meaning related to statistical analysis. It is used to indicate whether the results of an analysis of data drawn from a sample are unlikely to have been cause by chance at a specified level of probability (usually 0.05 or 0.01).

Survey research
A research approach designed to collect, in a systematic way, descriptions of existing phenomena in order to describe or explain what is going on. Data are often obtained through direct questioning of a sample of respondents.

Theme
A recurring issue that emerges during the analysis of qualitative data.

Theoretical framework
The conceptual underpinning of a research study which may be based on theory or a specific conceptual model.

Theory
In its most general sense a theory describes or explains something. Often it is the answer to 'what', 'when', 'how' or 'why' questions.

Triangulation
Sometimes known as 'methodological triangulation', this term is used in a research context to describe the use of a variety of methods to examine specific phenomena either simultaneously or sequentially in order to produce a more accurate and reliable account of the phenomena under investigation; it does not necessarily refer to 'three' approaches.

Trustworthiness
With reference to **naturalistic** research, trustworthiness describes the extent to which the study has been conducted in a way that gives others confidence in the findings. It can be determined by considering both credibility and dependability. Credibility can be compared with internal

validity in positivist research; dependability of a study is evaluated if it meets the associated criterion of auditability (see **audit trail** above). Auditability is achieved when a researcher provides a sufficiently clear account of the research process to allow others to follow the researcher's thinking and conclusions about the data and thus assess whether the findings are dependable.

Transferability

Sometimes known as 'applicability', transferability is said to be equivalent to the concept of external validity as applied to positivist research. A study is said to be transferable if the findings 'fit' contexts beyond the immediate research situation. In order to judge the transferability of a study's findings, one needs sufficient information to be able to evaluate the extent to which a specific research setting is similar to other settings.

Validity

In research terms, validity refers to the veracity of the data and findings that are produced. Validity can refer to: the concepts that are being investigated; the phenomena that are being studied; the methods by which data are collected; and the findings that are produced. There are several different types of validity, as follows: External validity, which refers to the degree to which the results of research can be generalized beyond the immediate study sample and setting to other samples and settings; face validity, which refers to the extent to which a measuring tool appears to be measuring what it claims to measure and internal validity, which refers to the extent to which changes in the dependent variable can be attributed to the independent variable rather than to other variables.

Variable

An attribute or characteristics of a person or an object that takes on different values (i.e. that varies) within the population under investigation, such as teacher's qualifications or gender. In experimental research, the dependent variable is the variable presumed within the research hypothesis to depend on another variable (known as the independent variable). An extraneous variable is a variable that interferes with the relationship between the independent and dependent variables and which therefore needs to be controlled for in some way.

NOTES ON CONTRIBUTORS

Anne Bamford

Anne Bamford is Director of The Engine Room and Professor at Wimbledon College of Art, University of the Arts London. She has been recognized nationally and internationally for her research in arts education, emerging literacies and visual communication. Through her research, she has pursued issues of innovation, social impact and equity and diversity. As a World Scholar for UNESCO, Professor Bamford researched and wrote *The Wow Factor: Global research compendium on the impact of the arts in education* published by Waxmann (2006). She has conducted major national impact studies for Denmark, The Netherlands, Belgium and Australia. Anne was awarded the Australian Institute for Educational Research, Outstanding Educational Research Award for 2002.

Lynn Beaudert

Lynn Beudert (formerly Galbraith) is Professor of Art at the University of Arizona, Tucson. Her research interests primarily focus on pre-service art education issues and the working lives of faculty art educators. She has published widely and serves on the editorial board of *Studies in Art Education*. Her recent book, *Work, Pedagogy and Change: Foundations for the Art Teacher Educator*, examines the lives and practices of faculty art educators. She is past Chair of the Research Commission of the National Art Education Association.

Fiona Candlin

Fiona Candlin is Lecturer in Museum Studies at Birkbeck College and The British Museum where she set up and now runs the World Arts and Artefacts programme. Following on from her practice-based research she began writing on questions of knowledge and practice in art institutions particularly in relation to access, disability politics and, more recently, touch. She has published in *iJADE, Journal of Visual Culture, Body and Society* and *Third Text* among other journals. Contact address: Faculty of Continuing Education, Birkbeck College, 26 Russell Square, London WC1, e-mail: f.candlin@bbk.ac.uk.

Rafael C. Denis

Rafael Cardoso Denis is Associate Professor at Pontificio Universidade Catolica, Rio de Janeiro. He received his PhD from the Courtauld Institute of Art in 1995 and was formerly Head of Art and Design at Worcester College of Higher Education, with a particular interest in student learning and assessment.

Martyn Denscombe

Martyn Denscombe is Professor of Social Research at De Montfort University. He graduated in sociology and then qualified as a teacher at the University of London. He has a PhD from the University of Leicester for research on the social organization of teaching, and his current research is on perceptions of risk and the health-related behaviour of young people. He is author of The Good Research Guide and Ground Rules for Good Research, both published by Open University Press.

Dick Downing

Dick Downing is a principal researcher at the Northern Office of NFER in York. He has always worked in the arts in education, initially as a drama teacher, then as an actor and director in theatre in education. He was subsequently education officer and then head of planning for Yorkshire and Humberside Arts. After a period as a freelance consultant and researcher he joined NFER four years ago. Since then he has published on the arts in primary schools (Saving a Place for the Arts, 2003) an evaluation of a national project involving galleries and schools (Image and Identity, 2004) an evaluation of a project promoting the arts in teacher education (The Star Project, 2003) and various non-arts studies. Contact address: National Foundation for Educational Research, Northern Office, Genesis 4, Innovation Way, Heslington, York YO10 5DQ. E-mail: d.downing@nfer.ac.uk.

Kristen Ali Eglinton

Kristen trained as an artist, and received a Master's degree in art and education from the City University of New York, City College. She has worked as an artist and educator in both the Bronx and Harlem areas of New York City, as well as in the North West of England. Her research interests include urban and rural youth cultures, ethnography, participatory research, cultural and human geography, and visual-based methodologies. Her contribution to the present book is based on doctoral work at the University of Cambridge. Past publications include Art in the Early Years (Routledge, 2003). Contact E-mail: ke227@cam.ac.uk.

Gabriele Esser-Hall

Gabriele Esser-Hall received her PhD in Art History from the University of Gottingen (Germany) in 1994. She taught aesthetics and art theory at University College Northampton and is currently research fellow at Waikato University, New Zealand. She has published in iJADE on the role of phenomenological hermeneutics in art education. During her visit to Border Technikon, in South Africa, she met staff practising the narrative approach to art teaching. This approach is relevant to her current research which aims to investigate issues connected to narrative theories in art education. E-mail: Gabyesser24@hotmail.com.

Richard Hickman

Richard Hickman is course leader for PGCE Art & Design at the University of Cambridge Faculty of Education and he is Director of Studies for Art History for Homerton College, Cambridge. His teaching experience includes thirteen years as a teacher of art and design and as a lecturer in art and design education since 1985. Richard is author of *Why We Make Art and Why it is Taught* (Intellect, 2005); he edited *Art Education 11–18*, (Continuum, 2004) and *Critical Studies in Art & Design Education* (Intellect, 2005). He has shown his paintings in solo exhibitions in England, France, Singapore and Australia. Contact address: University of Cambridge Faculty of Education, Hills Rd, Cambridge CB2 2PQ. E-mail: rdh27@cam.ac.uk.

John Hockey

John Hockey is a Research Fellow at the University of Gloucester, having worked previously at the Universities of Lancaster, Exeter and Warwick. His research interests lie in the areas of occupational culture and research degree education; methodologically his interests lie in the qualitative paradigm and in particular with ethnography and autoethnography. Contact: Dr John Hockey, School of Education, University of Gloucestershire, Francis Close Hall Campus, Swindon Road, Cheltenham GL50 4AZ. E-mail: jhockey@glos.ac.uk.

Mei-Lan Lo

Mei-Lan Lo is an associate professor and director of Graduate Institute of Visual Art Education, National Hualien University of Education, Taiwan. She completed her PhD at the University of Surrey Roehampton in 2003. Her research includes critical studies, art-teacher education and metacognition in the psychology of visual art. Dr Lo has published several articles in art journals and has presented papers at international conferences, such as InSEA, NAEA and the Annual Cross-Straits Art Education Symposium. Her current interests and efforts are focused on developing concepts of 'aesthetic caring' through action research, with the aim of establishing an autonomous theory and practise of art education in Taiwan. Contact address: 123 Huaxi Street, Hualien City 970, Taiwan. E-mail: mei@mail.nhlue.edu.tw.

Rachel Mason

Rachel Mason is Professor of Art Education at Roehampton University, London. She has taught art and art education in England, Australia and USA and is well known for her research and publications on multicultural, cross-cultural and international art education. She is a former president of the National Society for Education in Art and Design (NSEAD) and Vice-President of the International Society for Education through Art (INSEA) and edits the International Journal of Education through Art. Her books include *Art Education and Multiculturalism*, a second edition of which was published by the NSEAD in 1996; *Beyond Multicultural Art Education: International Perspectives* (co-edited with Doug Boughton and published in 1999); *Por Uma Arte Educação Multicultural* (published in Brazil in 2002) and *Issues in Arts Education in Latin America* (co-edited with Larry O'Farrell and published in 2004).

Dumile Johan Ndita

Dumile Johan Ndita, known as 'DJ', was born on a farm in 1973 in the former Transvaal Province (now Northern Gauteng). At the age of twelve, he started his school career in the

Eastern Cape. He matriculated in 1997 and went on to study fine art at Border Technikon, majoring in ceramics, drawing and art theory. He continued with drawing and art theory as postgraduate majors and completed his BTech Degree in 2003. DJ was later employed by Asante Management Consultants in the Easter Cape town of Umtata, to help establish a training centre for art, craft and related skills. Contact via Jeff Rankin (see below).

Sheila Paine

Sheila Paine (1929–2003) was an academic, artist, teacher and author. Formerly at the University of London Institute of Education, she was a past president and trustee of NSEAD and a co-founder of *JADE*. Her book *Artists Emerging: Sustained Expression Through Drawing* (2000) gives a full account of the case study included in this book. Volume 22, No.3 (2003) of *iJADE* is dedicated to her memory.

Jeff Rankin

Jeff Rankin was born in 1952 in Durban, South Africa. After schooling in South Africa, Zambia and Canada, he completed a Graphics major in fine art (1973) in Durban. This was followed by a year's post-graduate printmaking study in the United Kingdom. In 1976 he began lecturing in the visual arts in South Africa. In1997 he completed an MA in fine art at the University of Stellenbosch. While continuing in arts education, he also practised extensively as an exhibiting artist, political cartoonist and illustrator/designer for various publishing interests. In 1994 he co-founded the School of Applied Art at Border Technikon where he is senior lecturer in fine art. Contact address: Border Technikon school of Applied Arts, PO Box 1421, East London, South Africa. E-mail: jrankin@mweb.co.za.

Nick Stanley

Professor Nick Stanley is director of research and postgraduate studies at Birmingham Institute of Art and Design, University of Central England. He has a background in anthropology but has worked in art and design education for most of his professional life. He served as co-editor of the *International Journal of Art & Design Education* from 1994 to 2001 and was awarded a fellowship of the National Society for Education in Art and Design in 2001 and is a recent Past-President of the Society (2005–2006). He has taught and published in cross-cultural visual studies (including photography, museum studies and issues of representation), the employment of art and design graduates, and has been involved in producing curriculum development materials. The NSEAD has published two books that he has co-authored: *Designs we live by* (1993) and *Planning the Future* (2000); he is also author of *Being Ourselves for You* (1998).

Robyn Stewart

Robyn Stewart is Associate Professor at the University of Southern Queensland and Past-President of the Australian Institute of Arts Education. She is a past president of Flying Arts, Inc, and worked on it Board for twenty years. Her research interests lie in developing visual arts for distance education as well as notions of visuality and its exploration within a multicultural frame. She is an art theoretician and culturalist who is developing courses in cultural aesthetics and visual research methods at undergraduate and postgraduate levels. Address: The University of Southern Queensland, PO Darling Heights, Toowoomba 4350, Queensland, Australia.

INDEX

Author Index